Dalí

© *1982 Ediciones Polígrafa, S. A.*
Reproduction rights S.G.A.E. - SPADEM
Translation by Kenneth Lyons

First published in the United States
of America in 1984 by:

RIZZOLI INTERNATIONAL PUBLICATIONS, INC.
300 Park Avenue South, New York, NY 10010

Second Edition 1989
Reprinted in 1992

Library Congress Catalog Card Number: 83-61925
I.S.B.N.: 0-8478-0522-0

Printed in Spain by La Polígrafa, S. A.
Parets del Vallès (Barcelona)
Dep. Leg.: B. 15.327 - 1989

Ignacio Gómez de Liaño

RIZZOLI
NEW YORK

Just a few days before shutting myself up to write these pages, I visited Dalí at his house in Portlligat. When I found myself once again in that bay, so often caressed by Dalí's brushes, of which Meifrén used to say that it ought to be made the subject of continuous and assiduous practice for painters, I did not see it as a patch of sea but as a lake whose waters reflected, in Dalí's own phrase, 'the dramas of the sky at sunset.'

That bay comes into view like some landscape 'at the world's end'; like a geological eyebrow surrounding the great blue eye of the water; or, to use a surrealist image, like the white of an egg protecting and nourishing the meaty, marine yolk of Portlligat. Portlligat seems to concentrate the essences of Dalí's personality, with its two opposite poles: that of the morning and that of the evening. The first is 'gay, ferociously analytical and structural'; the second, 'morbidly melancholy, grey, motionless.'

In the morning that planetary landscape is simply a happy, light-reflecting strand on which at any moment Ulysses and his fellow sailors might be about to land. In the evening — and it was in the evening that I now made my way to the painter's house — it is the Stygian water that Patinir saw, the Island of the Dead imagined by Böcklin. But do we not always find these two poles in Dalí? The *chiaro* of his lights and his open spaces, the *scuro* of the elongated shadows and the disquieting portents? In his painting is there not always a soft, abysmal ultraromanticism, which is nevertheless controlled, imperiously and categorically, by the rigours of the analysis and the compositive structuring?

Absorbed in these reflections, I had by now come up to the door of the house. As I gazed at the cypress that rises — like an emblem of the place, a sort of *genius loci* — out of an old fishing-boat, I was suddenly reminded of that woman of the village who has now passed into history as the famous Lidia de Cadaqués, from whom Dalí, fresh from his first success in Paris, bought a tumble-down fisherman's shack, the embryo of what was to be the fantastic house in which he and Gala, Gala and he, lived for so long; that house to which they always returned from their travels beyond the mountains or beyond the ocean.

I evoked the figure of that delirious Lidia de Cadaqués, whom the artist once called the 'godmother' of his extravagances, and who was convinced that she was the model for the eponymous heroine of *La Ben Plantada* by Eugenio d'Ors, from whom she believed she received messages in code through the articles that Catalan philosopher and aesthete published in the press; on one occasion, for instance, she thought that an article published by d'Ors under the title *Poussin and El Greco* referred cryptically to two very well-known characters in Cadaqués, one of them nicknamed *Puça* and the other, a Greek diver, *El Grec*. It always pleased Dalí to see in the interpretative delirium of that surrealist Lidia-Dulcinea of the Empordà an excellent example of his own artistic method, based on the systematization of delirious hallucinations.

When I was admitted to the house, Dalí received me in his studio. My eyes went quickly and voraciously all over the room and I was astonished to see how much Dalí had painted since my last visit to him, only three months earlier.

Established at different heights on their respective easels, the pictures seemed to be leaning forward to greet me; they actually seemed to be making signs to me to look more closely at each and every one of them, to try to fathom the depths that merely began on their coloured surfaces. Those pictures were not altogether strangers to me. From Madrid I had followed, though only fragmentarily and at second hand, their birth and development. And from this accumulation of references I had gradually formed an idea of all these works. And now I had them here in front of me, within the white walls of the studio, with their definitive forms and figures — and with that disconcerting feeling, too, that one never fails to experience when one compares the present with what one imagined of it in the past.

I knew that Dalí, having happily recovered from his long illness, had returned to his favourite, inexhaustible themes: Velázquez and the great masters of the Italian Renaissance. And I knew that he had said one evening in a brotherly way to his friend, and fellow painter, Antoni Pitxot: 'You're just getting old enough now to devote yourself to the great masters... When we reach a certain maturity, they should be our best companions.'

First of all, then, I examined the different pictures alluding to, or 'commenting on,' the story of Mercury and Argus as it was represented by Velázquez in one of his most enigmatic works, and the last one he ever painted, which now hangs in the Prado. How can one escape the mysterious, latent, almost furtive attraction of this canvas? Mercury, the conductor of souls, the god of thieves *par excellence,* has already drugged Argus, the demigod who was all eyes, all vision, all alertness, but whom Velázquez presents in the guise of a poor old cowherd. The painter captures Mercury at the moment when the cunning god, having safely put the old man to sleep, is rising furtively with a catlike movement and getting ready to carry off the heifer with the crescent-moon horn (the soul or that unfortunate maiden, Io?) and take her outside the picture, out of the work, beyond any pictorial representation. Not for nothing is the heifer's horn pointing westwards, towards the setting sun.

In the studio in Portlligat I examined Dalí's most recent variations on the theme: Argus and Mercury floating in the clouds, Argus and Mercury lulling each other to sleep and concealing themselves in space and colour.

Apart from these hermetic (and, if I may be permitted a weak joke, Argonautic) pictures, one of the outstanding new works was Dalí's version of the Infanta Margarita as painted by Velázquez in *The Maids of Honour.* But in this Portlligat version, instead of the Infanta's head there is an enormous spherical pearl, shining as brightly as a star. Is this intended to be a kind

of visual pun based on the synonymity of Pearl·and Margarita, the Infanta's name? Well, yes; but it is also more than that, for the fact is that the heads of the different figures surrounding the looking-glass that can be seen in the background of Velázquez's picture correspond exactly to the stars visible to the naked eye in the constellation of the Corona Borealis; and the star corresponding to the Infanta Margarita's head is in fact known to astronomers as Margarita, the same name as the little princess. Allusions to this and other coincidences between astronomy and Velázquez's great work can also be seen in Dalí's picture.

However, the picture that very soon absorbed all my attention was another, the last of those so recently painted by Dalí. One could see — indeed, one could smell — how fresh the oil was still. Dalí had it on his left as he sat there dipping the tip of his brush into the colours on his palette, which he transferred with brief, nervous strokes on to a new canvas, a continuation of the previous one.

This picture, as I say, surprised me and disquieted me. I stood as though rooted to the floor, gazing at it and thinking about it. It was a *Pietà*, inspired in the famous work by Michelangelo which is in St Peter's in Rome. But what a strange *Pietà*! How utterly strange was Dalí's *Pietà*, and what a contrast there was between the background of 'white calm,' in which the sea and the sky blended together and lent each other their colours, and the figures of the Mother and her dead Son, which were painted with the grey of slate or volcanic rock, an Ash Wednesday grey, a storm-cloud grey. The Son's head is bathed in a spectral green light, and the figures seem to be floating in a luminously nuanced space in which they are wrapped as though in a cloak.

The body of the *Mater Dolorosa* is pierced by two great holes — two great holes that are like eye-sockets of a gigantic skull. Through the hole on the left we can see a rock gilded by the sun, the form of which is like a morphological echo repeating that of the reclining head of the dead Son. In those planetary rocks, the rocks of a lunar landscape, like fossils in daydreams, which are the vestiges of some geological collapse at this last appendix to the Pyrenees, the Cap de Creus, or 'Cape of Crosses,' Dalí had once again found the vision of the Sacrificed Son and the Mother of Sorrows, the almost mythical *Pietà*, whose plastic form is that of an ash-grey grotto floating in the solar space.

At that moment I remembered that it was Shrove Tuesday and, therefore, the eve of Ash Wednesday, the grey door that leads into Lent. And Dalí seemed to have been waiting for this to occur to me, for the moment I made some allusion to the date he replied:

'Precisely so. And, if you look carefully, you will see that this *Pietà* is a *carrus navalis*, a "naval carriage."' And he added: 'The word "Carnival," you know, comes from *carrus navalis*, from this "naval carriage."'

This philological observation sounded convincing enough to me and, in fact, reminded me that when I had arrived in Cadaqués a few days earlier I had noticed at the entrance to the village a sort of cart in the shape of a boat, decorated for the festivities and looking rather like one of the solemn 'floats' used in Spanish religious processions, though it was obviously of an absolutely profane character.

It was another evocation or association, provoked by my contemplation of the picture, that finally made Dalí's *Pietà* seem really disquieting to me. For this *Pietà*, from the strictly pictoral point of view, was in fact a kind of echo or replica of that other canvas which, over half a century ago now, when the artist was only twenty-

five years old and had just set out on the great adventure of Surrealism in Paris, he painted during a stay in Figueras and entitled *The Enigma of Desire*. In the 1929 picture we can also see in the sculptural block — which is again reminiscent of the rocks on Cap de Creus — two enormous holes, like eyes, and an allusion to the painter's mother that is repeated like a call or a supplication. Almost a hundred times we read, written on the rocky mass, the words *ma mère, ma mère, ma mère...*

I felt that that exclamation uttered in 1929, with all the insistence of a litany, could also be half-heard in the 1982 canvas, in the figure of the Mater Dolorosa with the Son sacrificed on the cross resting on her lap. Rock and grotto of ashes. *Carrus navalis* of the pagan procession of Carnival.

Then Dalí stopped painting, pointed at the picture of the *Pietà* again with his brush and said, simply and firmly:

'It is a disguise. If you look properly, you will see that it is a disguise.'

Indeed, the two great open 'eyes' in the centre of the sculptural group did give it something of the character of a mask. It was a strange model for the masks that are usually worn at the Carnival parties and fancy-dress balls. Dalí, then, was not prepared to abandon his disguise, to take off all those masks that have so prodigally and for so long abounded in his life. Disguises which, in fact, are the result of the long hours that Dalí has spent ever since he was a boy in the contemplation of the metamorphic rocks of Cap de Creus, of which he has written: '...as though they were ghostly quick-change artists of stone, I discovered in that perpetual disguise the profound significance of that modesty of nature to which Heraclitus was referring in his enigmatic phrase: "Nature likes to conceal herself." And in this modesty of nature I perceived the very principle of irony. Observing how the forms of those unmoving rocks could "shake," I meditated on my own rocks, those of my thought.'

But in these new rocks, these rocks seen by the painter from the imposing vantage point of the years, there is one small detail of difference: the mask for Shrove Tuesday in 1982 is really the disguise of Ash Wednesday. It is neither more nor less than the *Pietà*, the group formed by the Mother of Sorrows and the Son who lies lifeless on her lap.

The Theatre of Memory

Two days after the visit referred to in the preceding section I was packing my bags to return to Madrid. I telephoned to Portlligat to take my leave of the painter and to know whether he had any further remarks to make to me regarding the book I was preparing to write about him and his work. When I asked him this, Dalí at once said, with the utmost clarity:

'Write a lot about the Museum. I want you, above all, to write about the Museum.'

There was no need to say any more. I knew perfectly well what he meant when he spoke of the 'museum,' for it was a subject that had frequently occupied our summer conversations in Portlligat, since the day — about five years ago now — that I told him, after visiting the Museum-Theatre in Figueras, that one of the things about it that had most surprised me was that it constituted a true Theatre of Memory, just like the one designed during the Renaissance by the Venetian

humanist and hermeticist, Giulio Camillo. But this point is one that needs some elucidation.

What did Giulio Camillo's Theatre of Memory consist of? Viglius Zuichemius, who was staying in Padua in the year 1532, wrote a letter to his friend Erasmus, the famous Dutch humanist, in which he told him that everybody there was talking about a certain Giulio Camillo and his Theatre of Memory, the building of which — never finished, on account of financial difficulties — was being paid for by the King of France, Francis I. At a later date Camillo was to reveal the hermetic secret of his Theatre of Memory to the Spanish Governor in Milan at the time, Alfonso Dávalos (that Marqués del Vasto who was the patron of the poet Ariosto and was the subject of a portrait by Titian).

'Giulio Camillo calls his Theatre,' writes Zuichemius to Erasmus, 'by many names: he is as likely to say it is a mind structured or constructed as that it is a mind and soul with windows. He maintains that all the things that the human mind can conceive, and that cannot be seen with our bodily eyes, can be expressed by means of certain material signs in such a way that the spectator can instantly perceive with his eyes everything that would otherwise remain hidden in the depths of the human mind. And it is because of its physical aspect that he calls it a Theatre.'

I immediately realized that Dalí's Museum-Theatre in Figueres complies with the two fundamental rules of the art of memory which inspired the theatre of Giulio Camillo: the rule of places and the rule of images. According to the art of mnemonics — invented by the lyric poet Simonides of Ceos and the sophists, continued by the Roman rhetoricians, reformed by the Schoolmen of the Middle Ages and renewed by the Renaissance humanists — certain *images* and, in general, *places* have the power to arouse memories, which anybody's own experience can confirm, as when, on returning to a place from which we have been absent for a long time, by the mere fact of being there again many things that we thought we had forgotten come crowding back into our memory.

Camillo's great achievement consisted in the fact that he gave organic shape to the symbolic contents of the memory in a theatre of the Vitruvian type, which he had previously adapted to the peculiar character of his intentions. The Theatre of Vicenza, designed by Palladio, can give us a very fair idea of what the materialization of Camillo's Theatre of Memory might eventually have looked like. Perhaps we should attribute to some hermetic-mnemonic origin the strange 'metaphysical' atmosphere that pervades Palladio's theatre, of which Dalí himself has written that it is one of the three places that have produced the most profound impression of mystery in his spirit — 'the Theatre of Palladio, in Vicenza, the most mysterious and divine "aesthetic" place' (the other two being the staircase of the 'Chabanais' and the subterranean entrance to the tombs in the Escorial).

The Theatre of Figueres — or of Figures, I am tempted to write — in fact constitutes a system of mnemonic places analogous to those imagined by Giulio Camillo in order to give a face to the mind, to make patent what lay hidden, to open windows in the soul, and thus to make that soul a place of enduring consistency.

The second great rule, or master key to the art of memory, has to do with the images of the things we want to remember. These images must be carefully positioned in the different places in the Theatre of Memory; besides that — all the writers insist — they must be strange and unusual, surprising and emotive, in order that the things we wish to fix in our memories by their means may not be easily effaced. Certainly, nobody can doubt for a moment that the 'images' that people Dalí's Museum-Theatre are strange and unusual, surprising and emotive! They create aesthetic atmospheres, they awaken psychic resonances with their scenography. Frequently they are ineffaceable.

Dalí once told me that when (in his Paris days) he painted one of his most famous works, which was in fact entitled *The Persistence of Memory* or *The Soft Watches,* when he showed it to Gala he asked her: 'Do you think that three years from now you will have forgotten this image?' To which Gala replied: 'Nobody who has ever seen it will ever be able to forget it.' Is it not the same case with many of the images invented by Dalí, many of the images that go to make up Dalí's Theatre of Memory?

Dalí's museum is related not only to the Renaissance Theatre of Memory but also, and even more explicitly, to the 'Combinatorial Wheels' in the *Ars magna* of Ramon Llull, the great 13th-century Majorcan philosopher and visionary. By means of a symbolic artifice, which I will explain at a later stage, Dalí has *set his Theatre in motion,* making it revolve like a wheel in combination with other similarly revolving wheels, in such a way that all the figures in the Theatre of Figueres gaze at themselves in all the others, and with all the others entwine and combine.

The road through Dalí's memory

The road on which we are now about to set out is a symbolic itinerary. The territory it crosses is that of the Museum-Theatre of Figueres, a region over which Dalí has deposited down through the years all his basic artistic and psychological experiences, rather as though they were the alluvial sediments left by a great river at its mouth.

The first thing that attracts our attention — before we have even begun our tour, at milestone zero as it were — is the sculpture that stands, all alone, in front of the Museum-Theatre. It stands precisely between the Theatre and the Church. And this church, as a matter of fact, is the parish church of Figueres, in which Salvador Dalí was christened with a name that, for the artist himself, was to represent a whole programme of 'salvation of art.' For Dalí, once he had properly digested the avant-garde experience and gradually begun to settle into his own work and the memory of history, set his sights on 'the perenniality of the acanthus' and committed himself to the quixotic enterprise of saving art from the impoverishment, trivialization and primitivism into which it had been cast by the constant rush and other circumstances of this age of the masses which is the 20th century.

The sculpture with which our itinerary begins, stands in a no-man's-land, in the smooth public space between the two great dramatic scenographies of Time. It is a hieroglyphic figure which announces the Theatre and, with the empty eyes of its ovoid head, gazes meditatively at the Church.

Its body is formed from an ancient olive tree with a twisted trunk, like entrails or like the dragons that guard the underworld. The breast of the sculpture is outlined by little figures in relief representing the men of the people; and protruding as its heart — a heart out in the open — we see the head of a Roman patrician. Above it is that of the Empordà philosopher Francesc Pujols.

On the back, in the penumbra of the collar bone, smiles the remote countenance of Ramon Llull, a blend of algebra and mysticism, of combinatorial rotation and ascent by the ladder of being. (Is not the olive the Llullian tree of the species?).

The Figure is in the symbolic posture of Melancholy, the temperament of the philosopher and of the man who remembers, the saturnine humour of speculation and reminiscence. Its powerful hand strokes the head, or egg, from which all comes forth.

And now our eyes can inspect the façade of the Theatre. In the centre a Diver, with the diving-suit-lantern as a celestial vault or Neptunian dome. This idea of penetration and immersion is repeated and multiplied by the female figures on the balconies accompanying the Diver. They are women whose torsos and bellies are pierced with amoeba-shaped holes: dematerialization of the body in pure space and energy. Giulio Camillo called his Theatre of Memory 'a soul with windows.' The figures in the Theatre of Figueres are bodies that open like windows, that become windows.

While the Diver represents the visitor who will be plunging into the abyssal spaces of the Museum-Theatre, the female Figures are the space itself, the multiplied and penetrated place itself. The long loaves of bread that they bear on their heads (a motif that is as important in Dalí's painting as that of the perforations) open and satiate the appetite: bread is matter and communion. They are leaning on crutches (another essential motif in Dalí's work) which should be seen as 'crutches of that reality thanks to which they remain, in a way, suspended above the earth during sleep.' Like the Pythagorean Y, which, according to Dalí, expresses 'the mystery of bifurcation', about these crutches our painter from Figueres has said: 'And ever since then (he is referring to a childhood experience) that anonymous crutch has been for me, and will always be till the end of my days, the *symbol of death* and the *symbol of resurrection.*'

Above the Diver and the female Figures stretches the series of suits of armour, with their allusion to external appearance, to the skin as carapace, to exhibition — an armed exhibition of strength, for the Museum-Theatre is also a set of exhibitions, in which is represented that which is frequently inhibited in the spirit.

Above this again — in the serrated outline of the façade — there are figures waving a greeting, welcoming us.

The vehicle for our itinerary is parked in the Patio-Garden. Its interior is watered with secret rains. It is the intestinal lust of the jungles and the ocean depths. I call it a 'hepatic vehicle,' because the liver — the pictorial viscus *par excellence,* which gives the eyes a golden tinge — constitutes the roots of the human plant, the seat of dreams. On the bonnet of the car rises the opulent, colossal figure of Mnemosine-Ester, the goddess of profound memory. Mnemosine has her arms open and is gazing at a figure without a body, a figure which is only clothing, placed at the middle window of the hemicycle (in front of the stage). This figure's dress is made up of miniature patches or squares of memory. Its being is nothing but externals. Its being is only appearing. The Dress-figure is flanked by two Chain-figures, which personify the practice of connecting or linking the different places in the Theatre of Memory. The Renaissance philosopher and mnemonicist Giordano Bruno recommended this practice, and added that all magic is condensed in the art of establishing links.

Crowning the Patio-Garden there is a frieze of twenty-five washbasins: attestation for an attentive and well-attended act of purification.

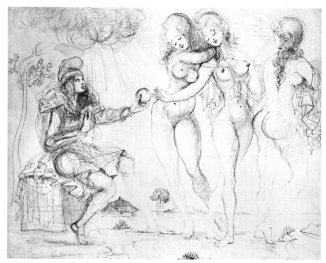

Judgment of Paris. 1950. Drawing in India ink, 62.2 × 76.5 cm. Countess Guerrini Moraldi Collection, New York.

What drama is performed in Dalí's Theatre of Memory? What mystery is celebrated there? The great backdrop to the stage is sufficiently explicit. It represents the bust of a man. In his breast there is a heavy open door, of Mycenaean or Egyptian appearance. This figure, with its sorrowfully drooping head, resembles the one that the artist used, in his illustrations for Dante's *Divina Commedia,* to represent the logical Demon (Canto XXVII of the *Inferno*). But in the Theatre of Figueres a certain dreaminess has softened the figure of that infernal character who, like the Greek god of Time, crushed human limbs between his jaws.

What does one enter by this heavy door of the backdrop? One enters the interior of an Island. The Island is a Garden. The Garden is a Labyrinth. Sharp-edged cliffs separate this intimate place, this Böcklinian island, from the ocean swell, from the continuous attacks that come from outside, while long lines of cypresses pierce the night sky with their lugubrious lances. This drama of solitude, drama of isolation, is modulated by the remaining images that can be seen on the stage: bullrings, in which the audience is a heap of skulls — the animal is sacrificed and carried off on a grand piano, followed by a train of prelates, mitres and night-flying birds. Bullrings as the frame for the double image of Venus and the Matador.

There we can see the valiant knight, Sir Roger, with his long, sharp sword, killing the dragon who has carried off the fair Angelica. There, too, we can see, on an altar, a soft Christ crucified. The stage of the Museum-Theatre is the arena, altar or grotto where the passion and death of Appearance are performed. The crystal cupola that covers this space (seen from the patio, it reflects the tower of the church) proclaims through its shape — a geodesic dome — that the drama is taking place in 'The great theatre of the world.'

And now our tour takes us up to the First Floor. There we find: Newton, the pendulum. Velázquez, the ruff from the *Maids of Honour.* A female torso is transformed into a face. Perseus blends into Christ. Above all this, a self-portrait of Dalí. On the opposite wall, a portrait of Gala. Under her, a little boy wearing a warlike helmet.

On the vaulted ceiling of this noble drawing-room, the Palace of the Air, a sky painted by Dalí — reminiscent of those created by the Jesuit painter of the Baroque age, Pozzo — with some of his best-loved themes and

memories. The hands of a man and a woman, Dalí and Gala, are holding up this sky, this Palace of the Wind. Next to them, the bust of the 'Logical Demon,' wheels of triumphal chariots or Llullian combinations, Danaean showers of gold, the plain of the Empordà...

In a prominent position opposite the entrance door to this room hangs the painting that represents an ancient river-dweller. Beside the three great goddesses — the Three Graces — he pours the water from his inexhaustible pitcher. This is Time. On the other side of the partition on which this picture of Time hangs, in the room that gives on to the central balconies of the façade, complicated relationships are being woven around 'genetic imperialism.' There we see Dalí's huge, heavy book, *Dix recettes d'immortalité,* with its interior multiplied in mirrors that take in the gilded fishbone-throne, which, equidistant from the two covers of the volume, ascends as though it were a staircase, with vertebrae for steps.

As though echoing this throne, on the other side of the room, there is the portrait of the King of Spain, Juan Carlos I, in naval uniform. He is surrounded by different images alluding to 'genetic imperialism': helicoidal towers arising out of the dream, like structures of deoxyribonucleic acid. Next to Jacob's ladder, the tree of Jesse, the genealogy of Christ and the motto *Tetracedron abscisus vacuus.* The common denominator of this room is immortality through genetic transmission and its imperial legislation.

Now we return to the apartment that is the Palace of the Wind. In the room on the left a great number of slippers have left their prints on the ceiling and the glass screen through which we can perceive a Wagnerian love scene. Prints of passion? Dangling from the ceiling of this room, like a serpent or a helicoid, is a string of teaspoons (Dalí's favourite gnostic symbol), at the bottom of which a little female face smiles at us with an Art-Nouveau smile. Looking at this face is the molecular whirler of the atomic head, while in distraction, like the famous *Thornery* of the Island Garden in Aranjuez, a woman on the beach, painted by Bouguereau, extracts a thorn that has entered the sole of her foot. Image of distraction: the eye lets itself be submerged by the non-spatial point of the thorn. Distraction is the only experience that admits no reflection on itself.

In front of this room, and on the other side of the Palace of the Wind, we come to one of the key spaces in this Theatre of Memory of Dalí, this Museum of Dalí's memory. It is presided over by a tapestry representing *The Persistence of Memory.* The soft watches seem to be saying to us: This is the decisive moment, this is the Time of this Theatre. Only the soft endures. The hard does not last. The soft is time: the wave. 'As for the watches, they must either be soft or not exist at all!' Dalí has said. The soft watches hang in the picture like a couple of fried eggs. And fried eggs, in Dalí's imagination, constitute the earliest of all memories of prenatal life, as well as being the expression of the incessant movement of the retinal phosphenes.

Let us pause for a moment in front of *The Persistence of Memory,* for this work is connected — like the cogwheels of a watch — with the rest of the Museum-Theatre. The principal motif of the picture is a watch hanging flaccidly from the branch of a tree standing beside the sea in a sort of *finis mundi,* or land's end, a lonely landscape of cliff and shore. And the watch hanging from the tree has adopted the exact shape of a famous theme of legend that has been very frequently depicted in painting, above all in Spanish painting: I refer to the theme of the Golden Fleece. The soft watch

hanging from the tree, then, is a metaphor of that Golden Fleece that Jason went in quest of with all those other great Greek heroes, the crew of the good ship Argo, when they set sail for Colchis, in the region of the rising sun.

The soft/hard semantic duality that constitutes the structural principle of the representation, is rather like an echo of another morphological duality: the hardness of the horn of the ram and the softness of his skin. As a metaphor of time, the Golden Fleece represents the sun rising in the sign of Aries — the Ram of the zodiac — and is tinged with heraldic eroticism, since the origin of the Order of Knighthood of the Golden Fleece, the supreme grand master of which is the King of Spain, is associated with the pubic hair of a maiden who took the fancy of Philip the Good, Duke of Burgundy. The wool trade and the dewy fleece of Gideon round off the semantic constellation in which the Order of the Golden Fleece is situated.

In the same way as the dial of the watch, that instrument emblematic of royalty, the Golden Fleece, or ram's skin and wool, expresses superficiality in the pure state, the realm of pure appearance, without which painting would not exist.

The marine background of the picture is echoed by the great bed that we find in this room. It is in the form of an enormous shell supported by four dolphins, those warm-blooded aquatic mammals so highly esteemed by the Greeks, who saw in them the beings that reincarnated the souls of shipwrecked sailors.

The enigmatic theme of the sphinx appears in different elements in this room. In the corner beside the balcony the eye is caught by the skeleton of an anthropoid. Its bones are covered with gold leaf; they are sublimated. Underneath the vertebrae, in the hollow of the breast-bone, we see Bernini's head of St Teresa in ecstasy. In this ensemble Dalí has endeavoured to harmonize contraries.

Quite recently Dalí has hung a new picture here which completes the symbolic value of this room of *The Persistence of Memory.* It is a picture of some Llullian wheels, their rotation being achieved by means of the movement of the phosphenes provoked by an optical contrast of colours. With this picture, placed on top of a poster that represents *Le visage de la chance,* Dalí is clearly affirming that his Museum-Theatre is a Theatre of Memory that revolves around itself like Ramon Llull's combinatorial wheels.

To the right of the stage there is a corner with scenography that constitutes a complicated reflection on the theme of the Golden Fleece. Hanging from the ceiling, above an elongated bone armchair with a figure reclining on it of which only the head can be seen, there are a great many buckets, of the type used for drawing water from a well. The theme of the fleece-watch is represented here by the ropes, cloths and draperies that descend in the typical curve of the catenoid. And on the wall we see the actual horns of a ram. Beneath them there is a sword, which is an allusion to the imperial function, to the civil power. The curve of the horns is repeated, in stylized form, in the moustaches of the warriors and in other motifs in this *locus memoriae.*

But let us continue our tour of the images in this Theatre. The polymorphic power of images may be observed in 'the face of Mae West which can be used as a drawing-room.' In this room the image becomes a place. The hair becomes draperies. The eyes, landscapes. The mouth, a sofa. The nose, a fireplace. Another instance of this polymorphism of the image, of its transformation into a place, can be found in the showcase devoted to the wheelbarrow in Millet's *Angelus,* the pic-

ture that was used by Dalí as the motif for the initiation of his paranoiac-critical method.

Above Michelangelo's *Moses,* which is on the left of the stage, we can see an octopus, and above the octopus the threatening head of the rhinoceros (its horn is a characteristic example of a logarithmic curve, as frequently employed by Dalí). Here once again we find the contrasting duality of soft/hard, terrestrial/aquatic, visible/invisible. At the feet of the *Moses* we see Ramon Llull's combinatorial wheels. Like Moses on the top of Mount Sinai, Llull had his moment of illumination on the top of Mount Randa, in Majorca. From there the land all around looks like a vast revolving wheel.

And, exactly as though by Llullian wheels, the Theatre of Figueres is surrounded by three circular passages. One is called *rue Trajan,* the street of Trajanus — thrice Janus — that Spanish emperor who set out from Triana (Traiana) to conquer Rome and to create Rumania (the ancient Dacia). One of these circular corridors is presided over by a great picture by Antoni Pitxot entitled *Allegory of Memory* (it is also known by the name of *Journey to the Centre of the Earth,* doubtless because of the deep grotto depicted in it).

Three female figures, whose limbs are anamorphoses of rocks, stand out in the centre of the resounding grotto. They form the classic group of the Three Graces, a chorus in which the oneness of Venus is tripled. But their respective placing (one of the figures stands apart from the other two and is repeated in the back of the grotto and in the foreground) differs from the classical version, which expressed the three operations of Liberality — give, receive, return — or the Neo-Platonic trinities — commented on by Marsilio Ficino and Pico della Mirandola — of Beauty, Chastity and Pleasure (in Botticelli's *Spring,* for instance) or of Beauty, Love and Pleasure (as, for example, in the Medal of Pico della Mirandola). The figure that is repeated three times, and which is very clearly separated from the other two, undoubtedly symbolizes Memory. The key to Pitxot's interpretation may be found in Ramon Llull's *Book of Contemplation,* in which the three powers of the soul are embodied in three noble and beautiful young ladies. The great Majorcan philosopher describes their operations as follows:

'The first remembers what the second understands and the third desires; the second understands what the first remembers and the third desires; the third desires what the first remembers and the second understands.'

In Dalí's Museum-Theatre there is a room, communicating with the stage, which is very properly known as *the treasure,* because it contains images which can be of assistance to the visitor on his mnemonic journey through the Theatre. Presiding over this room is the famous *Bread-basket,* which speaks to us of the nutritious character of the images exhibited in the Museum, and also of the communion of art.

It is true that the Museum-Theatre of Figueres, with its delirious flowerings, has much of the character of a hell, but it is a hell that has become aurified, transcendental, transfigured. To this it has come by the ways that explore the labyrinthine confines of consciousness and bring out into the light of day all that we keep hidden in the most secret corners of our psyches. The Theatre, therefore, is a work of publicity. A colossal window.

The pictures and images of the memory, however, prepare one to forget just as much as they help one to remember. What happens with these images is what happens with contraries that resolve their differences in unity: in the harmonized unity of opposites there is a serene comprehension that resembles memory in its presence, but resembles oblivion because the soul is soothed and calmed in an infinite absence.

But the Museum-Theatre is a place of transformations and one in transformation. One day it may be possible to specify the colours and frames of the *loci memoriae.* Another day may see the unwinding of a chain, or Ariadne's thread, that will link the places together and help anybody who is lost in space to find himself in time. On yet another day Phrygian caps may be distributed among the visitors, to teach them that the object and the goal of the journey through memory is the conquest of the Golden Fleece, the Soft Watch.

But Mnemosine-Ester still awaits us in the Patio-Garden-Stalls. The bonnet of the surrealist vehicle is pointing to the door, to the way out. The way out? Can one, then, go out of the place one is in?

The first thing we see is the collar bone of Melancholy, the head of Ramon Llull. Turning left, we go round the Museum, and we raise our eyes to the statue of Meissonier, the meticulous painter of Napoleon's retreat from Moscow, with the wheelruts of the carts and the hoofprints of the horses on the snow. Meissonier is standing on dark pedestals formed by tractor wheels. And one recalls the phrase one heard spoken by Dalí himself, the day before this itinerary, in the shelter of the white-walled patio in Portlligat:

'The positons, neutrons and protons must not be left out.'

'Of course they won't.'

Eatables

Man's most philosophical organs are his jaws. This sentence of Dalí's is not a resumé of the philosophy of Count Keyserling, according to which the driving force of human life and culture is to be found in hunger, but reveals one of the most profound bases of the artistic personality of Salvador Dalí.

Perhaps it may not be altogether gratuitous to explain that in the Castilian language the words *sustancia* ('substance') and *médula* ('marrow' or 'pith') are concepts that are just as valid for metaphysics as for gastronomy. The 'richness' of a broth is its substance, in the same way as the substance, on the metaphysical plane, is what forms the ontological foundation of a being. Unamuno preferred to speak of the medulla or marrow of beings, as though he were talking about a Castilian stew, of the stock from which it is often said that it would 'revive a corpse.'

In Dalí the eatable is frequently confused with the real. The most real is the most eatable. The most real is the *richest* food. His painting, therefore, has to be supremely eatable: the most substantial food, the most exquisite viands for the ravaged palates of the 20th century, in which he has endeavoured to infuse the salivary secretions of the Homeric banquets, those feasts that not infrequently included the roasting of whole herds of Mycenaean oxen.

Dalí has told me that when he was still a child he saw all the objects of his consciousness as though they were sweets and all sweets as materialized objects of consciousness. Thus his first childhood ambition was to be a cook, from which he passed to the stage of wanting to be Napoleon. And so a synthesis of Dalí might be that of a cook-Napoleon, that of an aesthetic glutton brought up among the unbending and imperial rigours of the Escorial. As a matter of fact, one of the 'thinking machines' invented by Dalí is based on the idea of the

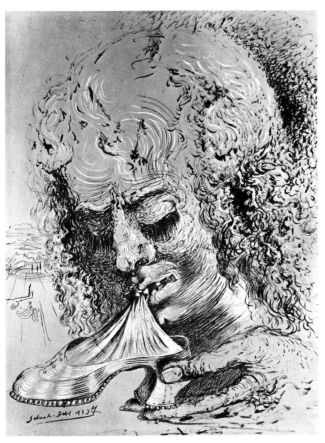

Cannibalism of Objects. 1937. Ink and gouache on paper, 63.5 × 48.2 cm. Edward James Foundation, West Dean, England.

'eatable Napoleon,' in which, Dalí himself says, 'I have given material form to those two essential phantoms of my childhood — oral delirium of nutrition and dazzling spiritual imperialism.'

That is why Dalí has not the slightest objection to declaring that fifty little glasses of warm milk hanging from a rocking chair have the same significance for him as the plump thighs of Napoleon.

It is, perhaps, in the astonishing illustrations that Dalí did in the early nineteen-thirties for *Les chants de Maldoror* by Lautréamont that one may most overwhelmingly perceive this identification that Dalí establishes between Napoleon and eatables; the identification, too, of our age with meat, with the carnality that makes one's mouth water, stimulates the secretion of the salivary glands and even arouses aggressiveness. According to Dalí, the marrow of the bone, or medulla, possesses the value of truth, but ..., before that sublime moment of spirit-eatable is reached, what a singular and tenacious battle between the molars and the bone!

Viscera and bones, shreds of flesh and flayed muscles, limbs that have been chopped up or are slashing pieces out of themselves, fragments of physiognomies, transformations of facial features into concretions of bones or intestinal pulp, knives, scalpels and viscera-watches: all of these abound in the aforesaid illustrations by Dalí to *Les chants de Maldoror,* in many aspects the key work of Dalí's Surrealism in the thirties. In his preface to the exhibition of that work, at the Galerie des Quatre Chemins in 1934, Dalí says:

'No image is capable of illustrating Lautréamont — and *Les chants de Maldoror* in particular — so "literally" or in such a delirious way as the one that was created some seventy years ago by the painter of the tragic, cannibalistic atavisms, the painter of the ancestral

and terrifying encounters of sweet, soft, high-quality meats: I am referring to that immeasurably misunderstood painter, Jean-François Millet. Millet's tremendously famous *Angelus* is exactly what, to my mind, would be the equivalent in painting of the celebrated and sublime "Chance encounter, on a dissecting table, of a sewing-machine and an umbrella"...: the fork bites into that real and insubstantial meat that tilled land has been for man down through the ages; it sinks into it, I say, with that ravening intentionality of fertility peculiar to the delirious incisions of the scalpel, which, as everybody knows, in the dissection of any corpse is only seeking secretly, on various pretexts of analysis, the synthetic, fertile, nutritious potato of death.'

In the same preface we also read: '... and not so much as a raw chop, taken as an average model of the eatable signs, has been placed on the table of the male, when the silhouette of Napoleon, "the starving man," is suddenly formed and drawn in the clouds on the horizon.' Between the cook and the starving man, between the creator of tastes and the recipient of 'savoury' experiences, we find the basic figure of Dalí's personality, an oral figure on an imperial triclinium, sublimated in art.

In Dalí's pictorial philosophy the eatable is broken down into different but interrelated phenomena: the mouth, the bread, the meat, the milk (as in the case of Vermeer's *Maidservant Pouring Milk* and the interest Dalí has always shown in that work), the bones and the softness of the bones converted into meat and marrow, the act of chewing, often performed in Dalí's paintings by a skull, which reveals the relationship between nourishment and death — in other words, the mortality of the corporeal. Sometimes the terms nourishment-death-sex-aggressiveness are linked together, as is the case in the picture entitled *Atmospheric Skull Sodomizing a Grand Piano,* in which the action of sodomizing is performed by the jaws of a skull.

The beloved mythical woman, so important if we are to understand the psychography of Dalí, may take on the attributes of certain eatables. Thus, to a journalist who was surprised that the artist should have painted a portrait of his wife with two grilled chops balancing on her shoulder, Dalí replied: 'I like chops and I like my wife; I see no reason why I should not paint them together.' A year after this episode, in the 1934 painting *The Spectre of Sex-appeal,* an enormous sausage, semicircular in shape, forms the upper portion of a female torso.

The two canvases that best synthesize the occult character of the eatable, which is what relates it to death, destruction and war, are the ones entitled *Soft Construction with Cooked Beans (Premonition of the Spanish Civil War),* painted in 1936, and *Cannibalism in Autumn,* which was done in 1936-1937. In the first of these two pictures we see a dark, savage hand squeezing a dry nipple, while a tongue, like one of the soft watches, dangles from a fleshy excrescence, and there are beans at the feet of the figure — or, rather, of the monstrous mechanism of flesh. In the other picture Dalí has painted, with hallucinatory exactitude, a macabre banquet, well supplied with knives, forks and spoons, at which there is no lack of meat or fruit. The marvellous landscape that wraps the 'cannibal' figures in the soft golds of an autumn evening is a powerful contributory factor in giving the whole scene the unmistakable characteristics of a hallucinated reality.

Of particular importance in Dalí's work for their plastic and symbolic values are two eatables, bread and fried eggs, and two kitchen utensils, the cup and the spoon.

We find the fried egg in several important works by Dalí. In the 1937 *Long Siphon* it is matched, simultaneously, with the carapace of a turtle and a woman's breast. In *Fried Egg without a Frying-pan*, done in 1932, it appears as the sole motif of the picture, hanging from a string, which places it in morphological connection with motifs like that of the soft watches or that of the Coca-Cola bottle hanging from a string in the 1943 *Poetry of America*. In *The Sublime Moment*, painted in 1938, a couple of fried eggs like two bulging eyes appear on a plate under a telephone, another characteristic element in Dalí's painting in the thirties (the telephone may sometimes be replaced by a lobster, and in *Poetry of America* it hangs from the Coca-Cola bottle, in a very evident example of 'reduplication of suspension,' a device Dalí is very fond of using in his pictorial compositions).

For Dalí the fried egg is undoubtedly the paradigm of all matter that is at once soft and consistent. A traditional symbol of birth and cosmogenesis, in Dalí's painting it is also tinged with erotic suggestion. In the passage headed *Intrauterine memories* (Chapter II of *The Secret Life of Salvador Dalí*) the artist explains the symbolic meaning and values the fried egg possesses at his deepest level of thought. He writes: 'The intrauterine paradise was the colour of hell, that is to say red, orange, yellow and bluish, the colour of flames, of fire; above all, it was soft, immobile, warm, symmetrical, double, sticky. Even as long ago as that, for me all pleasure or enchantment was in my eyes, and the most splendid, impressive sight of all was that of a couple of fried eggs in a frying-pan; that is probably the reason for the confusion and excitement I have felt throughout my life since then in the presence of this unfailingly hallucinatory image. The eggs that I saw before I was born — fried in a pan, without a pan — were magnificent, phosphorescent and very minutely detailed in the folds of their slightly bluish whites.'

It is no part of my intention, of course, to ascertain whether Dalí did not did not in fact have prenatal sensorial experiences which left traces in his memory, or even whether what he tells us is true or false. What really matters to us in the present instance is that the lines transcribed above provide us with the clue to the symbolic function performed by the fried egg in the imaginary universe of Dalí, within the fundamental category of 'the eatable.'

Bread — and particularly the loaf of bread — is at the opposite pole of Dalí's system of 'eatables.' It is the 'hard' counterpart of the 'soft' fried egg. 'Bread,' says Dalí, 'is one of the oldest themes of fetishism and obsessions in my work; the first, in fact, and the one to which I have been most faithful.' The artist goes on to compare the bread-basket that he painted in 1926, when he was only twenty-one years old (in the interior of this basket we see, on one side, the bread cut into slices and, on the other, the crust or heel of the loaf) with the somewhat barer, more meticulous version done in 1945 (here the crust of the loaf clearly resembles the horn of a rhinoceros, a morphological structure much studied by Dalí and one which he used a lot in his work, especially from the nineteen-forties onwards). And he says: 'By making a precise comparison between the two pictures, everybody can study in them the whole history of painting, from the linear enchantment of primitivism to stereoscopic hyper-aestheticism.'

In the picture entitled *Two Pieces of Bread Expressing the Feeling of Love*, painted at Arcachon in 1940, the central — almost the only — theme is, in fact, two hunks of bread and some crumbs. It is the 'hard'

counterpart of the 1932 *Fried Egg without a Frying-pan*. Whereas in this picture of the fried egg what matters is the curving form, in the picture of the stale baked bread the most important morphological feature is the phenomenon of crumbling. In speaking about this picture in his *Salvador Dalí* (1973), Robert Descharnes tells us that Marcel Duchamp, who was staying with the Dalís at the time, played an anecdotal part in the execution of this picture. 'Gala and he,' Dalí told Descharnes, 'used to play chess every afternoon, while I concentrated on painting these slices of bread. I was trying to get a very smooth surface on which rough-textured crumbs alighted. Very often things would fall on the floor — the pawns, for instance — and one day, before they were put away in their box, one of the pawns was left standing in the middle of my model for a still life. After that they had to look for another pawn to go on with their game, for I had now used that one and didn't want it to be taken away.'

So it is thanks to this incident involving Duchamp that in the work we are now studying we see a chess pawn standing between the two hunks of bread, giving the painting a certain metaphysical air to add to the mystical corporeity of the bread itself and inevitably reminding us of the still lifes, at once symbolic and realistic, of painters like Sánchez Cotán and Zurbarán.

Bread also makes an appearance, of course, in religious paintings by Dalí, like his *Last Supper* and the *Madonna of Portlligat,* both painted in the nineteen-fifties. In these pictures the presence of the bread has a more clearly religious tone, but this must be super-imposed on, or combined with, the meanings already referred to, the basic one being perhaps a way of regarding paint as a sort of flour that is baked, is browned, acquires consistency and serves both as food and for communion. As a metaphor of the pictorial operation, the fried egg represents the 'soft' stage, meaning the application of the oil to the canvas, while the bread turning into a stale hunk expresses the stage at which the oil dries and acquires consistency.

Other eatables characteristic of Dalí's painting are cherries — particularly cherries in a pair, a grouping that Dalí connects with the peasant couple in Millet's *Angelus,* and which undoubtedly expresses to some extent 'the mystery of bifurcation,' like the crutch or the Pythagorean Y — and clusters of grapes. The cluster of grapes, with its various morphological echoes, constitutes the central theme of the picture *Outskirts of the Paranoiac-critical City; Early Afternoon on the Shore of European History,* painted in 1936. The cluster of grapes, whose shape — like that of a molecular model — could not fail to captivate Dalí, is cryptically repeated in two other motifs on the same canvas: the rump of a sturdy horse and a skull with huge eye-sockets.

The two utensils connected with eatables that are most typical of Dalí's imaginary world are the cup and the spoon. Two pictures painted in 1932 are good examples of this. In the one called *Agnostic Symbol* a spoon with an inordinately long handle marks the diagonal of the picture along almost its whole length. This handle is bent to curve round a pebble, the form of which recalls the heel of a long loaf of bread, and in the bowl of the spoon we see a diminutive pocket watch, similar to the ones in *The Persistence of Memory.* In this painting, at once simple and baroque, the spoon takes on the attributes of a road, or of a snake with a hyper-attenuated body.

In *The True Picture of 'The Island of the Dead' by Arnold Böcklin at the Hour of the Angelus,* painted in 1932, on the left-hand side of the canvas we see a stone

cube, on the cube a cup and, sticking out of the cup like a pole, the extremely long handle of a spoon, the bowl of which is hidden from us in the cup. It is said of this picture that when its former owner, Baron Von der Heydt, showed it to Hitler, it made a very strong impression on him. In 1944-1945 Dalí painted a new version of this work and gave it the title *Half a Giant Cup Suspended with an Inexplicable Appendage Five Metres Long.* The islet that can be seen in the background is inspired by the Illa de la Rata, off Cap de Creus. Regarding the very pure geometric composition of this work, we are told by Robert Descharnes in his above-mentioned book on Dalí: 'This composition was painted in New York and California, at the time when Dalí was having a series of absorbing conversations with Prince Matila Ghyka, a Rumanian who was a professor of aesthetics at the University of South California. Dalí was well acquainted with Ghyka's works — *The Geometry of Art and Life* and, more particularly, *The Golden Number,* an essay on Pythagorean rites and rhythms in the development of western civilization, which was published in 1931 — because he had read them in Paris before the war. The whole construction of this picture is organized on the basis of the development of a strict logarithmic spiral whose starting-point is to be found in the handle of the cup.'

Structurally close to this coupling of cup and spoon, in other pictures by Dalí — the 1936 *Solar Table,* for instance — we find the grouping of glass and spoon (in the work mentioned the table and glasses are inspired in those of the casino in Cadaqués). And in yet other pictures the glass/spoon arrangement is replaced by one consisting of an inkpot and a pen. A drawing done in 1938 and entitled *September Septembered,* which was later used as an illustration in *The Secret Life of Salvador Dalí,* exemplifies different morphological relationships of such elements as a glass and a spoon, an inkpot and a pen, a girl and a bell, a cluster of grapes and a seated wet-nurse, etc.

In the *Portrait of Picasso,* painted in California in 1947, we see coming out of the Malaga painter's mouth a spoon with an extremely long handle — like the one in *Agnostic Symbol* — in the bowl of which there is a tiny lute or guitar. It should be observed that the function performed in this portrait by the spoon and the carnation is entrusted to the crutches and a slice of grilled ham in the Dalí self-portrait done in 1941, a work that is much less emphatic and much less baroque than the Picasso portrait.

I need hardly say that the morphological pattern of the cup and spoon, apart from its alimentary implications, possesses certain sex-symbolic values. But Dalí, who has always been a great reader and admirer of Freud, never confines himself to painting symbols 'in the raw,' but endeavours to give them additional nuances and flavours; and he always manages to place them in a network of original meanings.

In the border areas between eatables and living animals we may observe Dalí's preference for lobsters and other crustaceans worthy of the gourmet's attention, whose organisms constitute veritable marrow-bodies, or at least hard structures protecting a soft, nutritious mass. Sometimes the lobster appears in Dalí's imagination as a double for the telephone, not only on account of its shape but also because the hard structure of the telephone receiver encloses a soft or verbal structure. In the first chapter of *The Secret Life of Salvador Dalí* the artist develops some of his ideas regarding 'eatables' and in particular those that refer to crustaceans:

'The direct opposite of spinach is armour. That is why I am so fond of eating armour, and especially the smaller varieties, that is to say shellfish. By virtue of its armour, since that is what its exoskeleton really amounts to, the shellfish is a material realization of the extremely original and intelligent idea of wearing one's bones on the outside rather than the inside, contrary to the usual practice. In this way the crustacean can use the arms or weapons of its anatomy to protect the soft, nutritious delirium of its interior and keep it sheltered from all profanation, shut up like some solemn, hieratic vessel which should be left vulnerable only to the highest form of imperial conquest in the noble war of decortication: that of the palate.'

Dalí then goes on to establish a comparison between the skulls of little birds, with their savoury brains, and shellfish, even speaking in this context of the armour painted by Paolo Uccello:'... and he did it with a charm and mystery worthy of his truly birdlike nature, to which he owed his name.'

In Dalí's systematic arrangement of eatables, the shellfish or the crustacean combines and comprehends the softness of the fried egg and the hardness of the crust or stale hunk of bread. It is, therefore, the eatable 'of the perfect palate,' the most substantial of all foods. Besides, it is an eatable which, unlike fried eggs or bread, contains the idea of combat, cutting up and weapons (since its tasting comes only after the armour of the carapace has been dismantled, *almost* as when a telephone receiver is taken to pieces).

That is why the figures of the gluttonous cook and Napoleon, the man of blood, are associated in Dalí's imagination; and also why, at the limits of the eatable, we are suddenly confronted with bloodthirsty hunting: *The Tunny Catch,* painted in 1966-67, is the canvas that best represents this border area. Of this picture, one of the largest and most ambitious ever painted by Dalí, Robert Descharnes has said: 'In this great canvas, painted in Portlligat, the artist has brought together all his tendencies: Surrealism, 'Quintessential Pompierisme,' Pointillism, Action Painting, Tachisme, Geometrical Abstraction, Pop, Op and Psychedelic Art; [it is] comparable in importance to the great *Persistence of Memory.*'

In the explanation he himself gives us of this picture, which is subtitled *Homage to Meissonier* and was inspired by a description of tunny fishing delivered by his father with a 'Homeric' intonation, as also by an engraving by a dull, academic Swedish artist that hung in his father's office, Dalí relates his painting to the cosmology of the Jesuit theologian Teilhard de Chardin: 'I realized then that it is, in fact, this very limitation and contraction of the cosmos and the universe that makes energy possible (...). *The Tunny Catch,* therefore, is a biological spectacle *par excellence,* since according to my father's description the sea — which is a cobalt blue that ultimately turns absolutely blood-red — is the super-aesthetic force of modern biology. All births are preceded by the marvellous spilling of blood, *blood is sweeter than honey,* blood is sweeter than blood. And in our time it is America that holds the privilege of blood, for to America has fallen the honour of producing Watson, the Nobel prizewinner who was the first to discover the molecular structures of deoxyribonucleic acid.'

Descended from *Cannibalism in Autumn,* but with more abundant and more sharply contrasted stylistic correspondences, in its crudity and baroque character *The Tunny Catch* — a sadomasochistic orgy of blood — brings to mind the description given by a certain friar,

13

one Gerónimo de la Concepción, in a book entitled *Emporio del Orbe* (1690), in which he is speaking of the tunny-fishing grounds off the Cadiz coast, where thousands of tunny fish used to be driven inshore to be killed, chopped up and salted. The sight of this bloodstained spectacle inspired Fray Gerónimo to comment, with ill-concealed relish:

'So pleasurable is the spectacle, whether in the strength of the brutes, in the variety of harpoons and nets with which they are caught and killed, or in the way they stain the sea blood-red, that no bullfight could hope to equal it.'

At the opposite pole to the bloodstained butchery of tunny fishing in Dalí's imagination are those hard (though softened in the cooking), eatable, ordinary everyday beans, which constitute one of Dalí's favourite dishes. Indeed, he even gives the recipe for them to the readers of his secret autobiography: 'They must be cooked with ham and *botifarra* (a Catalan sausage), and the secret consists in adding to this mixture a little chocolate and a bay leaf.'

Although the shellfish, as we have seen, is the 'canonical eatable' in Dalí's imagination, the 'fundamental eatable' is bread. The 'revelation of bread,' and of its aesthetic-symbolic potentialities, came to the painter one day early in the thirties when, after a meal at which he had eaten to satiety of a dish of beans, he began to look, idly but pertinaciously, at a piece of bread. Unable to take his eyes off it, he tells us, he picked it up, kissed it at one end, sucked it to make it soft, stood it vertically on the table (like the famous egg of Columbus) and there and then decided 'to make surrealist objects with bread.'

When he returned to Paris, his motto was: 'Bread, bread, always bread, nothing but bread.' This bread of Dalí's, however, was not to be the soft bread of charity, nor yet (at least not to begin with) the transubstantiated food of the Christian communion; it was 'a ferociously antihumanitarian bread, it was the bread of the revenge of imaginative luxury against the utilitarianism of the rational, practical world, it was the aristocratic, paranoiac, refined, Jesuitical, phenomenal, paralysing, hyperevident bread that the hands of my brain had kneaded during those two months in Portlligat.'

This denaturalization of surrealist bread — its transformation into a luxury for the palate and an aristocratic revenge — reminds me of the use Dalí made of milk in an object of symbolic functioning (a 'thinking machine') in the year 1932, a use which was violently opposed by the communist poet Louis Aragon, then an active member of the Surrealists, on the grounds of certain moralistic and supposedly humanitarian considerations which had nothing to do with the matter being discussed, however respectable they may have been from the viewpoint of moral principles and in the field of social economy. Aragon, in fact, quite seriously and to everybody's astonishment, said: 'I am totally opposed to Dalí's project; glasses of milk are not intended for the manufacture of surrealist objects, but for the children of unemployed workers.'

The operation of eating, its material and its complements constitute the basic nucleus of relationships in which we must place Dalí's personality as an artist — with, of course, the nuances proper to his particular case. Painting is, in this sense, cooking. Looking at a picture is eating. The taste for art is the counterpart of hunger and the gastronomic palate. Eatables and their principal utensils are thus the models for the specific pictorial product, a spiritual and sensorial fruit *par excellence,* which Dalí, after the fashion of Vermeer, will leave to ripen slowly until it reaches the golden point of maturity.

Not only painting, but also poetry, was seen by Dalí in the guise of eatables. During the time he spent in Madrid in the twenties, when he and Federico García Lorca were inseparable friends, the Catalan painter's favourite word was 'eating.' The impression the poetry of Lorca made on Dalí's spirit could not have been more 'eatable.'

'Lorca had a tremendous impact on me,' Dalí tells us in his autobiography. 'The phenomenon of poetry, in its entirety and "in the raw," suddenly arose before me in physical shape, confused, with bloodshot eyes, viscous and sublime, vibrating with a thousand fireworks and flames of subterranean biology, like all matter endowed with the originality of its own form. I reacted by immediately adopting an attitude rigorously opposed to the "poetic cosmos." I said nothing that could not be defined, nothing of which the "outline" or "law" could not be established, nothing that could not be "eaten" (this was already my favourite word). And when I felt the incendiary, communicative fire of the poetry of the great Federico rising in frenzied, riotous flames, I tried to quench those flames with the olive branch of my anti-Faust premature senility, while I prepared the grills of my transcendental prosaicness, upon which at daybreak, when only the glowing embers of Lorca's initial fire were left, I would come to cook the mushrooms, chops and sardines of my philosophy (...), to satisfy for another hundred years the spiritual, imaginative, moral and ideological hunger of our age.'

The poetry that Dalí personifies in Lorca is eatable, no doubt, but in Dalí's way of thinking it is, above all, the fire that the artist will use to cook his artistic result. We might say, in other words, that the relationship between poetry and art is analogous to the one between fire and the food that is cooked with its help. In the artist's job, therefore, there are two essential moments: that of the incendiary fire, which is communicative and anarchical, and that of the 'laws' of cooking, i.e. the moment of the specific, definable materiality of the work. Thus, in the human eatable we have the harmonization of the most ancient impulse of the organism and the most precise legislation of the understanding. The eatable is not only a function of the blind organism but is also, though without losing that character, a function of the creative, civilizing intelligence. To paraphrase a well-worn phrase, we may assert without irony that Dalí was a cook before he was an artist or, which comes to the same thing, that he has never ceased to explore the eatable roots of art and of aesthetic apprehension. This and no other is the basis of the praise Dalí lavishes on saliva and dribbling. 'Yes, when I'm asleep or when I'm painting, I dribble with pleasure,' he says. And then he adds: 'It cannot be denied that every good painter dribbles. It comes from the concentration of his attention and from the satisfaction afforded him by the visions that pass before his eyes...' But the painter's dribbling is paradoxical; it belongs to the canonical order of the 'crustaceans,' for it is a fluid which is transformed at the corner of the mouth into 'a veritable quarry of scales or flakes, rather like those of mica.' Dalí, as Gilbert Lascault has said, lets himself be fascinated by the idea of a sort of dry and to some extent geometrical saliva, the paradigmatic expression of which would be the 'quintessential dribbling of the spider.' Dalí, undoubtedly, is on the side of the spider's saliva — as against that of the dog. He is on the side of a saliva that is thread, line, exactitude.

I must point out, however, that Dalí's painting is not only eatable but also, and more particularly, a convertible eatable.

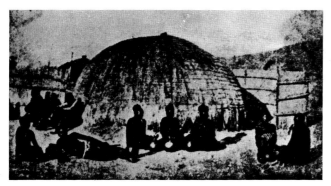

Postcard that turns into a Picasso-like woman's head (André Breton thought it was the face of the Marquis de Sade with a powdered wig).

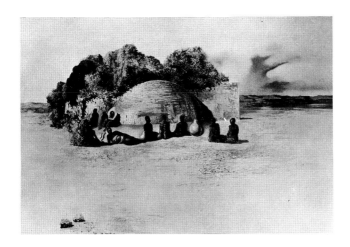

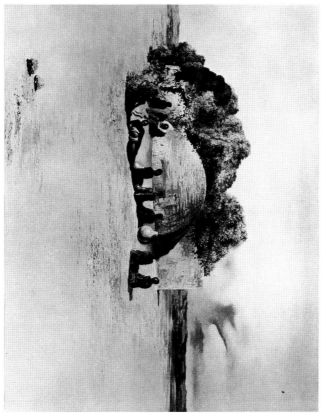

Paranoiac Face (based on the preceding illustration). 1935. 62 × 80 cm. Edward F. W. James Collection, Sussex.

Convertibles

Ever since the nineteen-twenties one of the most typical and personal characteristics of Dalí's painting has been the presence in it of pictorial motifs taken from reality which are themselves and, at the same time, *something else:* a watch that *is* a round of Camembert, a horse that *is* a woman's body or a cluster of grapes, a cloud that *is* a countenance, a rock that *is* a motor-car, a bust of Voltaire that *is* a couple of old ladies, a Venus de Milo that *is* the face of a famous bullfighter, and so on.

Things are themselves and something else; they are what they are at first sight, and also what they are made by the illusive play of perception. Reality, in conclusion, is surreality, and vision is, at bottom, the reality resulting from the play of perception. While Velázquez painted things, not as they are but as they appear on the painter's retina, so that it has been said of his art that it is painting in the first person, Dalí, for his part, paints things neither as they are conventionally nor as they impress themselves on the retina of the person who is looking at them, but as realities that play with the eye, deceiving it and seducing it, and set off in the spirit at the same time a train of psychic associations and the shrill, disquieting whistle of their echoes and intimate resonances.

If the eatable is the matrix-pot in which Dalí cooks his art, the convertible is the condiment with which he seasons it. To play with the paranomasias of language, we might say that in Dalí's painting the eatable is the substance and the convertible the essence.

In works like *The Invisible Man,* painted between 1929 and 1933, or the 1938 *Infinite Enigma,* the painted reality is the equivalent of a strange sort of puzzle: the reality can be broken down and recomposed; it is a game of composition. Painting, then, means composing a visual reality on the basis of the elements in play. Painting in the surrealist fashion means recomposing those pieces; it means assembling the reality in accordance with the particular laws of the systematizing paranoiac delirium.

The systematizing-delirious process has been described and studied by Dalí with remarkable brilliance in his most important theoretical work, *The Tragic Myth of Millet's Angelus,* written in the early nineteen-thirties. Dalí's thesis — and it was to be confirmed by Jacques Lacan, who made no bones about letting himself be 'instructed' by Dalí in his own field — is that the active character of paranoia places it at the antipodes of hallucination. Contrary to the automatism of early Surrealism as preached by André Breton, the paranoiac process presupposes a method and a criticism. Lacan, like Dalí, was to confirm the fact that the interpretation to which the data of perception are submitted by a paranoiac subject forms part of the hallucinatory delirium. The psychiatrist and the artist thus reached the same conclusion: that the phenomenon of paranoia is of a pseudo-hallucinatory type. Dalí, for his part, was to choose the 'double image' as his example revealing the fact of paranoia, since the double image (as, for instance, the perceptibles in *The Invisible Man* or in *Infinite Enigma*) can cause to appear, quite clearly and sharply, 'the consubstantiality of the delirium and the fact of interpretation,' as Patrice Schmitt expresses it.

Linked up with the paranoiac process, the double image is, in Dalí's own words, 'the representation of an object which, without the slightest figurative or anatomical modification, is at the same time the representation of another subject which is absolutely

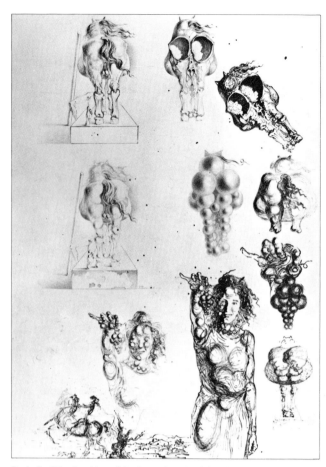

Study for 'The Outskirts of the Paranoiac-critical City.' 1935. Ink and pencil on paper, 32.5×20 cm. E. F. W. James, Esq. Collection, West Dean, England.

different.' Dalí adds that it is on account of the lack of coherence with reality, and the element of gratuitousness in their character, that simulacra can easily adopt the form of reality. 'And we cannot tell whether it is not, in fact, behind the three great simulacra — namely rubbish, blood and putrefaction — that the yearned-for "land of treasures" is hidden.'

In Dalí's painting the double image is the fundamental vehicle for ghosts; a vehicle that crosses the territories of destruction and reunification, of breaking things down and building them up again. Its active presence in psychism makes one realize the high proportion of the phantasmagorical that there is in reality and thus imposes on the mind the conclusion that reality is reversible and the objects of reality convertible. Psychism, therefore, is in this sense the nucleus of relationships in which the universal convertibility of the real takes place, and for that very reason the real, in the depths of its being, is full of fantastic possibilities.

In *Le Surréalisme au service de la révolution* (Paris, No. 3, December 1931), Dalí relates how he discovered his 'Paranoiac face':

'In the course of some studies, during which I had become obsessed by a long reflection on the faces of Picasso, and particularly those of his Negro Period, I happened to be looking for an address in a pile of papers when I suddenly came across the reproduction of a face, utterly unknown to me, which I thought was by Picasso. Then, in a moment, this face was effaced and I realized the illusion (?)'

When he later showed the 'face' to Breton, the latter thought it was a portrait of the Marquis de Sade, a conclusion which fitted in with the sort of subject by which he was preoccupied at the time. The image in question, however, was really a photograph of a large hemispherical African hut with a group of negroes sitting or lying about in front of it. The 'hallucination' came about because, if the photograph is laid on its side, it seems to be reconstructed with surprising verisimilitude in the form of an elongated head with something of a Cubist air about it. That reproduction of the form had 'objectified' the subconscious desires and yearnings that Dalí was feeling at the moment when his eye fell on the photograph, and this led him to speculate about the ability possessed by our subconscious longings, our most intimate desires, to recompose reality. The double image merely makes material and evident this reality-structuring power that has its roots in the impulses of the subconscious.

From the *Face of Mae West which can be Used as a Drawing-room,* a work that hangs in the Museum of Figueres, to the *Hallucinogenous Bullfighter,* Dalí has never ceased to explore, develop and execute artistically the potentialities of the double image, the most extreme example of which is to be found, perhaps, in *The Great Paranoiac,* painted in 1936. In the same line are *Perspective* (1936-37), *Woman's Head in the Form of a Battle* (1936), *Spain* (1938), and others.

It is true that behind these representations there is the historical memory of those anamorphic pictures that were so fashionable among certain Baroque painters of the 17th century, such as Arcimboldo. But with these painters this was an exercise of their virtuosity that we should consider in the light of such clichés as 'life is a dream' or 'reality is receptive,' which were immensely popular in that age, whereas what we have in Dalí is a voyage of exploration through the hidden contents of the subconscious, an investigation in depth of the fantastic, delirious roots of reality, and one carried to such lengths that reality appears to be nothing but the useful, conventional setting of a fantasy.

The fundamental category in which we must place the phenomenon translated by the double image — an object that is also something else — is that of convertibility, which we find recorded for the first time in Heraclitus' maxim: 'Everything is converted into fire, and fire into everything, just as gold is bartered for merchandise.' Other maxims of the philosopher of Ephesus, as well as the anthropology of the Platonists, develop this theory, according to which the human soul is converted into that which occupies it, while reality is the matter on to which the soul projects its own activity. The Neo-Platonists of the Renaissance — Pico della Mirandola and Giordano Bruno in particular — went so far as to see man as a being placed amidst all the possibilities of reality, from which he receives an influence.

It might be said that Dalí's exploration of the 'double image,' of the 'dualism of reality,' is a direct descendant of that anthropology — initiated with Heraclitus and Plato and, in the Christian era, with St Augustine — according to which man is a double being, made up of worldliness and transcendency, and the natural world is nothing but a breeding ground or seedbed of the spirit.

In the biography of Salvador Dalí, however, our attention is at once atracted by certain anecdotes which may be of assistance in explaining those features of his personality that predisposed him to the discovery of the double image and to its later exploration in painting.

'I was twenty-two years old,' Dalí tells us, 'and I was studying at the School of Fine Arts in Madrid. My constant desire to do, systematically and at all costs,

exactly the contrary of what all the others were doing, led me into extravagant behaviour that soon became notorious in artistic circles. In the painting class one day we were told to paint a Gothic statue of the Blessed Virgin directly from the model. Before leaving the room the teacher had told us repeatedly that we were to paint exactly what we "saw."'

The young Dalí ended up painting, instead of the Gothic Madonna, a pair of scales copied from a catalogue. He countered the astonished comments of his teacher and classmates with a laconic 'You may see a Madonna, like everybody else, but what I see is a pair of scales.'

In later life Dalí was to 'explain' this particular vision by adducing the association of ideas between Virgo and Libra in the signs of the zodiac, professing to see in this mythicization an anticipation of his future philosophy of painting; 'that is to say the sudden materialization of the image suggested, the all-powerful fetichist corporeity of visual phantoms.'

In his *Secret Life* Dalí tells us how at the age of nine, during a summer spent in Cadaqués, he discovered the phenomenon of protective colouring when he observed, among some plants growing in profusion along the shore, a tiny insect with the appearance of a leaf. 'The discovery of this insect made an enormous impression on me, for I thought I had found the key to one of the most mysterious, magical secrets of nature. And there is not the shadow of a doubt that this sensational discovery has had its influence since then on the crystallization of the invisible, paranoiac images that fill most of my present pictures with their ghostly presence.' Elsewhere he adds: 'Much later, when the Great War broke out and I saw my first camouflaged ships sailing along the horizon off Cadaqués, in my book of personal impressions and reminiscences I wrote something like the following: "Today I found the explanation of my *cuntsnout* (for that was the name I had given my little leaf-insect), when I saw a mournful convoy of camouflaged ships passing. What was my insect protecting himself from when he adopted his camouflage, his disguise?"'

Disguising himself, as a matter of fact, was one of the painter's most absorbing passions in his childhood; a passion, incidentally, which was to grow even stronger with the years. Paraphrasing Dalí's own words, we may wonder: what is Dalí protecting himself against when he adopts a camouflage, when he disguises himself? And should one speak of it as camouflage, or rather as exhibitionism? Is not all exhibitionism a disguise, a double image, of the reality being exhibited? Is it not, perhaps, that the protective camouflage is the counterpart of the Napoleonic necessity the ego feels to make its presence felt by exhibiting itself?

Whatever the answers we may give to these questions, a modicum of doubt will always remain as to the authenticity, not of the fundamental experience of the double image but of those others in which the painter's mechanical virtuosity and his powerful imagination may perhaps play too great a role. Can we accept at their face value assertions like 'I cannot understand why, when I order a grilled lobster in a restaurant, they never bring me a boiled telephone?' And then Dalí is always saying things like 'chilled telephone, peppermint telephone, aphrodisiac telephone, lobster-telephone, telephone with a black case for the dressing-tables of mermaids that have nails provided with ermine covers, Edgar Allan Poe telephones (with a tiny dead mouse inside each), Böcklin telephones installed in the interior of a cypress (and with an allegory of death inlaid in silver on the back), walking telephones and moored telephones, screwed to the back of a living turtle..., telephones..., telephones..., telephones...'

Is there any genuine artistic experience in the 'recomposition of reality,' the reprocessing of objects, as exemplified in the preceding paragraph? Or is it not, rather, a mere combinatorial process that is set off as one starts up a mechanism? It is not easy to decide when there is a genuine artistic experience, and when what is set before us is nothing but the aseptic result of a combination of elements. The answer, however, might be found in the fact itself of paranoia, in which the delirious experience is closely bound up with the psychic activity of an interpretative (or semantic) mechanism, which informs the consciousness of the phenomena of perception *in a paranoiac way*. To put it in other words, the hallucinatory delirium and the interpretative mechanism are the two complementary faces of one and the same psychic fact.

The most important contribution Dalí has made to Surrealism — and one of the most important made to the art of our time — consists, to my mind, in the creation of enigmatic images that are capable of arousing concealed or forgotten meanings in our conventional vision of things and of thereby provoking the apparition of extremely elaborate symbolic and associative structures.

And thus the good offices of the paranoiac-critical method have succeeded in making Dalí's 'convertible eatable' one of the most exquisite, attractive and energy-giving foods with which to satiate the hunger and need our society feels to consume new symbolic realities and to discover the secret mechanisms that regulate them.

An autumn afternoon in Portlligat

Not so long ago, one afternoon early last autumn, the painter Antoni Pitxot and I went to visit Dalí at his house in Portlligat. As we had done on previous occasions, we went straight into the oval drawing-room around which it might be said that — like one of those Llullian wheels with which the painter is so obsessed — the whole house revolves; that house which, like a dazzling white flight of steps, climbs up the steep rocks round the bay in the direction of the old watchtower, a not infrequent motif in Dalí's painting.

This oval drawing-room, the strange echoes in which one cannot fail to perceive, is Gala's favourite room, perhaps — the notion now occurs to me — because the painter's wife identifies herself there with the spatial figure which in ancient Greece symbolized the goddess Hestia, divinity of the home and of the private life of women, as against the square shape of arenas and agorae presided over by Hermes, god of commercial exchanges and gossip in the market-place.

Opposite the fireplace in this room, which is embellished with a rustic ogee arch and flanked by two elephant's tusks, there is an icon of the Black Virgin of Kazan over the lintel of the door by which one enters. Among the numerous objects that fill all the available space in the room — particularly worth remarking is a vitreous head of the adolescent Nero — my attention was drawn that afternoon to an egg of enormous proportions finely drawn in black lead with the theme of *Leda and the Swan,* so familiar in Dalí's work, and also with a loving inscription. The model for the Leda, needless to say, was Gala herself. As I gazed at this drawing I let my fancy stray into the game of analogies,

17

which led me to compare the shape of the egg with that of the room we were sitting in, so that I decided to christen this apartment in my thoughts the 'room of the egg'. Do we not know, after all, that the egg occupies a pre-eminent place among Dalí's pictorial 'eatables?' The evocation of the Temple of the Egg, in Anatolia, which I first saw depicted in G. R. Hocke's *The World as a Labyrinth,* certainly came later.

We had hardly been sitting there chatting to Gala for five minutes when the door opened and in came Dalí, in radiant humour. In that voice of his that is hoarse rather than olive-smooth, he was lilting snatches of songs: old folk-songs of the region, Cadaqués carnival ditties, probably from the turn of the century and long since forgotten — though Dalí remembered the lyrics, usually either satirical or salacious, with infallible accuracy. The same simple, catchy tune, rather better suited to a *palais de danse* than to the echoes produced by the acoustics of the oval drawing-room, served to accompany the different lyrics, all of them alternating the humorous and the ribald: voyages 'across the sea to Naples,' monks misbehaving, references to establishments that were all the rage in Cadaqués in the early years of the century, like Casa Laris.

After these ditties Dalí, still in this magnificent humour, recited a famous Catalan poem and then some Aragonese quatrains, two of which struck me particularly. The first, which breathed a certain air of what we might call folk-palaeofuturism, ran:

> Wheel rolling up,
> Wheel rolling down;
> The first thing you see
> Is the tillygraph pole.

The other dated, presumably, from the time when Dalí joined the ranks of the Surrealists, and went as follows:

> The painting of today
> Is the Surrealist kind,
> And Don Salvador Dalí
> Gives it most of its fame.

The musical prelude had finished. With a sudden change of subject, Dalí asked us all: 'What is it that most differentiates animals from man?' It was an enigma according to all the rules, possibly like the one the legend tells us caused the death of Homer, mortified by his inability to solve the riddle — to do with lice — that he was asked by some children playing on the beach. In the silence that followed the question, Gala, Antoni Pitxot and I looked at each other. One of us ventured the idea that what most differentiates animals from man is intelligence, or perhaps memory — an answer which, when you really come to think of it, is not altogether convincing, since undoubtedly there are some animals (like the elephant) endowed with pro-verbially excellent memories; and, as regards intelligence, we may frequently see certain animals performing actions that presuppose syllogistic reasonings or another type of indifference.

Dalí repeated his question, and the rest of us sat puzzling over it again. When we finally gave up, Dalí said emphatically: 'What most differentiates animals from man is suicide.' And he added: 'Animals never commit suicide.' His three hearers, however, at once fell into the temptation of casuistry and began to argue the cases of the scorpion and the beaver, which do on certain occasions take their own lives; but in the end none of us could maintain that these were cases of authentic suicide. For not only is suicide a voluntary act, which in itself would be a differential feature between man's possibility of suicide and that of the scorpion or the beaver, but in a person committing suicide there is also the desire never again to have a desire of anything. There is, therefore, a will that rebels against itself. An animal, we concluded during this conversation, lives in satisfaction and in being, whereas man lives in dissatisfaction and in a strange mixture of being and nothingness.

Dalí repeated: 'The idea of killing themselves does not occur among animals.' And then he said: 'The brain of an animal cannot send out the signal of self-destruction.' Continuing along these lines, we spoke of man's singular imaginative capacity and of the peculiar 'sickness' entailed in being a man. And Dalí gave greater force to this idea with a veritable aphorism: 'The artist is an authentic sickness.' Was it not Dalí who discovered in the thirties that a critically controlled paranoiac process can be an invaluable method of artistic creation, of explanation of the subconscious capable of being materialized in art?

In contradistinction to the situation of animals, which do not possess that most characteristically human possibility of killing themselves, Dalí quoted the case of 'that Greek philosopher who threw himself into the volcano to kill himself.' He was referring, of course, to Empedocles, whose personality and philosophy we discussed for a while. Dalí saw Empedocles' supreme act of hurling himself into the crater of Etna as an imperiously human action. Then Gala intervened, suggesting the possibility that Empedocles threw himself into the volcano, not in order to disappear but because, convinced that he was not going to disappear, he was seeking an enduring legend in which to perpetuate himself by such a death.

At this point Dalí said, speaking with great emphasis: 'In the Torre Gorgot there will be a lay figure that kills itself.' In the last few days Dalí's mind had evidently been playing with that idea of the legendary last action of Empedocles, and at that moment, when discussions were going forward regarding the enlargement of his Museum-Theatre in Figueres by the acquisition of the Torre Gorgot, he may have been trying to free himself from that idea with the simulacrum of a lay figure killing itself. Thus suicide had been exorcized, and the subject that now began to absorb our attention was that of the Torre Gorgot. 'In that tower,' said Dalí, 'we can have all the things that have to do with the Llullian Wheels.' He was, of course, speaking of one of his favourite themes, one which had occupied us on previous afternoons and to which I have already referred in the present text.

As a matter of fact, the first afternoon I visited him in the early autumn he welcomed me with a little speech that went approximately as follows: 'I am going to tell you where it was that Ramon Llull discovered the Theatre of Memory. It was when he galloped into a church on his horse and there raped a naked woman, whose body he opened and found among the viscera a cancer. That cancer was the Theatre of Memory, and I have painted the Llullian wheels of memory that you can see over there.' As he said this he pointed to a corner of his studio behind me. Turning round, I saw a picture on which a green circle was painted within a broad red circular crown, after the fashion of Llullian wheels. In the centre one could make out, like a faint shadow, the face of a woman. The surprising thing was that, on account of the phenomenon of perception originated by

the contact of the complementary colours red and green, the wheels seemed to be 'really going round', without stopping for a moment. 'Even if you take your eyes off them,' added Dalí, 'you will go on seeing how the wheels go round.' This was so, in effect, and one could also feel that one perceived them when, after taking one's eyes off the picture, one fixed them on the white wall that served as a background for the painting. The only comment that it occurred to me to make to the painter at that moment was that he had discovered the *perpetuum mobile,* or eternal circular motion, and that the most curious feature of the case was that this movement was not caused by the force of a machine but by the structure of our perception.

'The movement of the wheels in this picture is incessant,' rejoined Dalí, 'thanks to the phosphene they irradiate, which never stops. The phosphenes are in perpetual motion and are a simulacrum of the shower of gold that is represented by my Museum in Figueres. In the painting of the ceiling on the first floor there is a representation of the golden shower of Danaë. In case you didn't know,' he added, turning to Gala and Antoni Pitxot, 'I must tell you that there are threads hanging from the ceiling with real coins attached to their ends.' I have not been able to ascertain whether this is so, but it occurred to me that it might well be regarded as an 'aerial' version of the ancient custom of burying some gold coins *(telesmata)* when laying the foundations of a house or any other building.

The picture that gave rise to this conversation was to be hung in his Museum by the painter himself a few days after this visit — a ceremony which was duly reported in the press at the time. After trying various different positions, he finally followed the suggestion proffered by his wife and hung it in the room on the first floor which contains the tapestry of *The Persistence of Memory,* over a large-scale poster painted by Dalí for the French National Lottery, so that under the 'Dalinian-Llullian' wheels with their phosphenic movement one could read the description of the poster: *Le visage de la chance par Dalí.* Thus were memory and fortune, fortune and memory combined in the Llullian wheels of the Theatre of Memory. Nor was this placing an insignificant detail, for since the picture of the wheels had been situated on the first floor, or *piano nobile,* and (as Dalí pointed out) 'noblesse oblige,' these same wheels laid an 'obligation' — like an Ariadne's thread interwoven with a game of perception — on the rest of the Museum-Theatre, obliging it in fact to become a rotatory apparatus of memory, analogous to those designed by Giordano Bruno in his *De umbris idearum.*

But let us return to that afternoon when Dalí brought up the subject of suicide in the form of a riddle, and then went on to talk about the Torre Gorgot. His very words, as we have seen, were: 'In that tower we can have all the things that have to do with the Llullian Wheels.' Later on we will see exactly what 'all the things' alluded to by Dalí were, and with that we will be entering into the subject of the relationship between literature and painting, into the terrain of *picta poesis,* in which we will undoubtedly find important clues that will help us to understand the artistic personality of Salvador Dalí.

Suddenly the telephone rang. Dalí was anxious to learn the decision arrived at by the Board of Trustees of the Museum, who on that very afternoon (the feast of Our Lady of Ransom) were to meet to discuss the enlargement that involved the Torre Gorgot. From the other end of the line came the word that it had been decided to acquire the tower. Delighted with this good news, we all shook hands with one another and Gala ordered pink champagne to toast the happy event. Dalí, as usual, confined himself to dipping his middle finger in the bubbles.

We were still celebrating this good news, and about to go on with our conversation, when some unexpected visitors were announced. The newcomers had hardly got beyond the drawing-room door when Dalí seized me by the arm and asked me to accompany him to his studio, so as to go on with our conversation there; so we slipped out, leaving to his wife the task of entertaining the visitors. After passing through the photograph room — in which the walls are entirely lined with photographs taken at different stages in the painter's career — and going down several staircases that threaded their way through the extremely intricate geography of the house, we finally arrived at the studio. Then Dalí said: 'That man we've left upstairs wants to show me some slides made by madmen. But naturally,' he added with a touch of irony, 'I haven't the slightest interest in seeing them, for I know rather more about the subject than he does. What I want is a more human communication.'

In the studio we began to talk about Jason, the Argonauts and the Golden Fleece, themes to which we had already devoted several hours of conversation and which, since they frequently recur more or less explicitly in his work, are capable of evoking a great many artistic and literary associations. Then I brought him a reproduction of a picture by a painter of the school of Rubens called Erasmus Quelinus, the original of which is in the Prado. It represents the moment when Jason is making off with the Golden Fleece, which he has just stolen in Colchis with the help of the king's daughter, Medea, that magic, passionate woman who fell in love with the foreign hero from far-off Greece.

As we were looking at this reproduction, Dalí called my attention to the attitude of Jason. 'You can see what a hurry he is in,' observed the painter. 'He has just had the shock of seeing the statue of Mars, looking down at him from his altar with a reproaching, threatening air.' Dalí then told me that he intended to paint the Golden Fleece in a special way, with real gold, and that on Jason's other arm he would place a paraboloidal mirror — at least I think that is what he said — that would act as a shield. Since he wanted to show me more clearly the meaning he wanted to give to this theme and the way it would appear on the canvas, he asked me to find him a piece of paper to draw the figure on. As it happened, however, while I was looking all over the studio for some paper I came across a leather-bound book that was lying on the floor. When he saw me with this book in my hands, Dalí exclaimed: 'Oh! Give it to me! I have been searching for it for ages and couldn't find it anywhere.'

When I put the book in his hands, Dalí decided that we must examine, one by one, the many engravings it contained. This book was a volume of medium format, and certainly of rather singular characteristics, beginning with its title, which was *Highway of the Cross.* The original author's name was Hercino, but this was a Spanish translation published in the latter half of the 18th century.

Dalí seemed very pleased indeed to have the book in his hand, and said: 'It is like the Stations of the Cross, but it is something more: it is the Highway of the Cross.' After a pause he added: 'I will make enlargements of the engravings to put in the Torre Gorgot, like the engravings of Piranesi's *Carceri d'invenzione* in the Museum.' As he opened the book he said: 'It will be the Highway of the Llullian Wheels, a highway that will

finish at the big pool there.' It was Dalí's intention to transform that pool into an authentic pool of the Llullian specula of the Cross. Then he told me that Gala had found the book in a second-hand bookshop and that it contained some really surprising engravings, all of them accompanied by verses expressing the feeling of the drawing and a pious meditation corresponding to the scene depicted.

I was at first unable to see how this Highway of the Cross could be used as Llullian Wheels, but the painter dissipated my doubts by telling me that every engraving in the book presented a theme relating to the cross — as I was at once enabled to confirm for myself — so that it might be said with absolute exactitude that the cross was combined, in rotation as it were, with all those images. Not only, however, are the images combined with the different crosses which, in their emblematic passage through the book, end by creating a veritable forest (like the one imagined by Ramon Llull when he saw the universe of knowledge and the sciences in the form of a wood), but besides that, together with the cross there are two other figures that are unfailingly repeated in all the engravings: that of the Soul and that of Jesus, represented respectively by a child and a child with a halo, as had been the custom in religious emblems since the 16th century. Thus the Soul, Jesus and the Cross would travel in perpetual combinations and permutations along that Highway of the Llullian Wheels of the Cross, as Dalí was so pleased to inform me.

As we made our way through the *Highway of the Cross,* we came to an image that appealed to Dalí particularly: it showed the Soul in the attitude of renouncing music (in the form of a lute), the pleasures of the senses (represented by a goblet brimming over with fruit and flowers), human love (symbolized by a heart, which the Soul is treading underfoot) and even knowledge and science (a book thrown on the ground). When he showed this engraving to Gala and Antoni Pitxot later, Dalí exclaimed, as though in unanswerable elucidation: *'La musique à la merde, les plaisirs à la merde. Tout pour la Croix.'*

In these remarkable 18th-century 'Stations of the Cross' that we were inspecting, there were scenes such as the one that showed the Child Jesus with a cudgel belabouring the Soul, who is hanging from a cord as though he were a length of cloth hung out for fulling. In some of those engravings, indeed, there were scenes that might easily have been dreamed up by an ardently surrealistic imagination. Nor was cruelty lacking — a mystic form of cruelty, naturally — on that Via Dolorosa, that extremely eventful road of the cross. Was there not one scene that showed the Child Jesus, seconded by an angel, barbarously nailing the Soul to the sacred wood? And another with the Child Jesus himself nailed to the cross and — which was the stupefying feature — with two heads, one of which was that of the Soul? And what can one say of that other image in which on one and the same cross we see the Soul nailed to one side, while on the other the devil peers out, his face that of a pagan satyr? Then there was a cross used by the Child Jesus as a wheelbarrow, which inevitably reminded me once again of the paranoiac-critical analyses Dalí makes in *The Tragic Myth of Millet's Angelus* of the wheelbarrow, laden with sexual evocations, that appears in the French painter's famous canvas.

But in the whole of the *Highway of the Cross* there were three engravings in particular that appealed to Dalí — and, I should add, to me — much more than any of the others. In one of them the Child Jesus appeared

using the cross as though it were a drawn crossbow, a complicated, powerful bow such as Apollo himself would not have disdained to use in that famous passage in the first book of the Iliad. Then, in counterpoint to the crudity of this crossbow-cross, there was an engraving the subject of which was neither more nor less than Jesus using the cross as though it were the harp of David. In both engravings — the crossbow-cross and the harp-cross — the drawing was excellent; they made me think of that sentence in Heraclitus that says: 'The name of the bow *(bíos)* is life *(bíós)*; its function is death,' and even more of that other one that runs: 'They do not understand how in diverging it converges on itself: the harmony proper to a stretching in opposite directions, as in the case of a bow or a lyre.'

Undoubtedly these images constituted an adaptation of the mechanical and utilitarian toys that found such favour in the Age of Reason to pious ends that did not neglect the taste for such ingenuity that characterized the Baroque age. Since they were also strange, unusual figures which, in their ability to impress the imagination so strongly, conformed to the precepts of mnemonic art, these images would be excellent pious reminders and milestones along the Highway of the Cross. And were they not at the same time very evident examples of double images: objects that are both themselves and something else?

'I want to get to the ship,' said Dalí suddenly. 'I want to get to the ship,' he repeated, seeing my surprised expression — understandable enough, however, seeing that only a few days before, during the visit to the Museum-Theatre mentioned above, I had said to Antoni Pitxot, while my thoughts were still running on the ship Argo: 'There is no ship; there should be a ship in the Museum, if the symbolic quest for the Golden Fleece is to have a suitable instrument.' And what a ship we found just a few pages further on in the *Highway of the Cross*! What a ship it was that Dalí discovered for his rotating Theatre of Memory! What appeared in the book was a vessel with a mast in the shape of a cross, in which the Soul plied the oar, which was also in the shape of a cross, while the Child Jesus piloted the craft, which he did with a very odd-looking tiller, for it, too, and now for the third time, was in the shape of a cross. The Church is often spoken of figuratively as a ship (perhaps on the analogy of the 'ship of state'); well, in this case we had that ship before our very eyes, quite literally crucified.

Our 'way of the Cross' was interrupted by the Mayor of Figueres, who telephoned to confirm the decision arrived at regarding the Torre Gorgot. Dalí took the call himself, and when he hung up he said to me: 'You heard me speaking to the Mayor, eh? I've been speaking to the Mayor.' A few minutes later we returned to Gala and Antoni Pitxot, who were still in the oval drawing-room. And all four of us travelled once again that 18th-century itinerary, combinatorial, delirious and crucified. A proper king's highway. An itinerary travelled by the memory through a Tower-Museum already enlarged in our imagination. It is a pity that I did not record in my memory (that Simon the Cyrenian of the intelligence) the pious verses that accompanied the images in the *Highway,* for had I done so I could now advance *in vivo* the paraphrase of Horace's *ut pictura poesis* that I would now like to expound, in the certainty that it will help us to gain a more thorough understanding of some important aspects in Dalí's work, which become intelligible only when one measures in all its vastness the poetic or literary contagion suffered by painting in this century — and particularly by Surrealist painting.

Picta poesis

The separation — for it is a question of separation rather than divorce — of painting and poetry, arts of design and literary arts, is a fairly recent phenomenon which, although it has spread considerably in the last few decades, cannot really be said to be an accomplished fact. It is a phenomenon, moreover, which has not prevented the proliferation of the intellectual figure of the art critic, who, besides taking over from the poet and endeavouring to perform, after painting, the role the poet played before painting, fills the pages of newspapers and reviews with his facile prose and ubiquitous presence, so that sauces may not be lacking for the viands regularly served up in the galleries devoted to the exhibition and sale of works of art.

In view of the silence of abstract art — in which the artist is usually almost totally convinced that the world begins and ends with him, and in which his urge to achieve supreme originality throws him into the expressionistic jungle of primitivism if not into wastelands marginal or previous to the word, since his world is the mere spectre of colour and space — the only possible response is the word, poetical or not, in the second act of the performance, that in which the writer will officiate as a priest whose principal function is to baptize the newborn babe before tossing it into the mass of what are called spiritual assets.

And yet an atmosphere heavy with literature was always to hang over Surrealism and its painters. But in this school, as we will see later on, the voice invoked was analogous to that which, according to André Breton, 'made Cumae, Dodona and Delphi tremble'; and the fusion of 'the two arts' which was the aspiration of that grand master of the order of the surrealists was to be understood as entailing the ascendancy of painting over poetry or, to use Breton's own words, 'it appears to be in painting that poetry has found a broader sphere of influence.' Later on we will examine this curious phenomenon glimpsed by Breton. For the moment I will simply say that in the same passage Breton speaks of Dalí as an artist in whom the two arts are blended and says that 'the reading of some fragments of his poems produces only the effect of giving life to a few more visual scenes, which, surprisingly enough, are endowed by sight with the glow peculiar to this artist's pictures.'

The definitive — or supposedly definitive — separation between painting and poetry only came about when the painter, in emulation of the poet in his endeavours to attain the extreme of pure poetry, sought to rid himself of his intellectual impedimenta and, in all the arrogance of his beautiful colours and his abstract lineaments, proposed himself and his work as an altar without a saint, as an asset in themselves, as a pure, angelical being whose nature, instead of being intellectual, would be simply material and tangible. These artists had forgotten the prophetic words written two hundred years earlier by Jean Jacques Rousseau, in his *Essai sur l'origine des langues,* with its suggestion of Utopian visions, of the exploration of unknown islands and of antimechanistic polemics. I cannot resist the temptation to transcribe the following long but pithy passage from Chapter XXXI — *De la mélodie* — of that work.

'Imagine,' writes Rousseau, 'a country in which the very idea of drawing was unknown, but where many people spent their lives combining, mingling and relating colours, and believed that doing so made them outstanding painters. If you spoke to them of the emotion aroused by beautiful pictures and of the delight of being moved by a poetical theme, their sages would at once begin to go deeply into the subject, comparing their colours with ours and trying to determine whether our green was tenderer or our red more glowing; they would seek those combinations of colours that can move men to tears or excite them to wrath. The Burettes of that country would assemble in a patchwork of rags a few distorted pieces of canvas from our pictures; and then they would ask themselves in astonishment what it was that was so wonderful about those colours.'

After this description of the art of a country whose love of analysis, optics and sensualist philosophy has led it to the most academic sort of abstract art, Rousseau, who is letting himself be won over by this enlightened taste for Utopias and the exploration of unknown lands, adds:

'If somebody in a neighbouring country began to form strokes, the outline of a drawing, some sort of figure however imperfect, it would at once be regarded as an absolute daub, a capricious, Baroque attempt at art, and for the sake of preserving good taste they would continue to abide by that simple beauty that really expresses nothing, but brings out the brilliance of beautiful nuances, great sheets of colour, spreading gradations of tone without a single stroke of drawing.'

Rousseau then goes on to propound the hypothesis, in that country of scientific artists and abstract canvases, of a scientist coming to the experiment of the prism and the decomposition of light, and giving a lecture to his colleagues that might be summed up as follows:

'All that mysterious talk about drawing or the representation of figures is just the charlatanism of the French painters, who believe that their imitations transmit heaven knows what motions of the soul, when everyone knows that there are only sensations. They will tell you all sorts of wonderful things about their pictures, but you just let yourself be guided by these nuances of mine.'

Certainly Dalí's art is poles apart from the art that Rousseau foresaw and vainly attempted to exorcize, but neither can it be said by any means that it corresponds to the Geneva-born philosopher's own taste in painting or to that of the century he lived in, for except in his most literally realistic pictures Dalí's painting contains a great deal of pure research into what we might call pictorial physics, and a great deal, too, into the type of energy that corresponds to each type of representation; and in his art — at least in his most significant works — there is also a sort of symbolic-poetical saturation that is capable of touching hidden registers in the psyche and the perception to a degree rarely if ever attained in the history of painting.

I have elsewhere studied the relationship between painting and poetry in the Renaissance and the Baroque, within the context of Dalí's work, since I am of the opinion that in this Catalan painter's work we can find a great rapport with the cultural memory of those centuries; it would be as well, however, not to go too far with analogies between Dalí's art and that of those ages, for his work also teems with elements expressive of our own age, with all its discoveries and conflicts.

To pinpoint the relationship between painting and poetry, let us turn to a classic in the field: Lessing's *Laokoon.* Poetry and painting resemble each other, according to the great German aesthete, inasmuch as both of them 'put absent things before us as though they were present; they show us appearance as though it were reality; they both deceive, and their deception pleases us.' Well now, while the painter can only paint the reality of a moment or a moment of reality, since the figures

he creates are static and impervious to time, the poet, on the contrary, can avail of that recourse (denied to the traditional painter) which consists in being able to show us the flowing line traced, between situations and conflicts successively opening and closing, by the development and manifestation of human reality, one of the fundamental components of which is time. The painter imagines states of things, the poet actions, which does not prevent our glimpsing, or being able to glimpse, in the states painted by the former the action that has put them there or the action that may spring from there. The poet, on the other hand, is obliged to represent his actions through the composition of a series of states linked to one another, whose correspondences are temporal, in accordance with the laws of linguistic discourse.

While the poet possesses the faculty of representing two types of action, the visible and the invisible, in the painter's work everything must be translated into the language of visible, static images, which for that very reason usually have a more intense capacity of impressing the sensibility.

What is it that radically differentiates painting from poetry? The use of different media of expression. The pictorial signs are colours and figures arranged in space; those of poetry are articulated signs that follow one another through time. In one the procedure consists in the juxtaposition of the elements in space; in the other it is a question of their succession in time.

There are boundary areas between painting and poetry. When poetry attempts to emulate painting, we have descriptive poetry. When painting in turn attempts to emulate poetry, we have — Lessing tells us — the allegorical and hieroglyphical painting so typical of the Baroque.

With regard to Spanish painting in what Spaniards call their Golden Age (i.e. the 17th century), in which the general opinion has always been inclined to see the dry, bare, authentic vision of a realism without any tricks or trompe l'oeil (a rather *sui generis* realism, it must be admitted, peopled as it is with rogues, court jesters, mystics and dour princes), the art historian Julián Gállego insists that 'the picture is meant to be read; all the other merits of painting are simply the support that gives greater brilliance to this intellectual and visual content.' Nor is this author, in his *Vision and symbols of Spanish Painting in the Golden Age,* attempting 'to find rules for deciphering'; but in that study he does offer us 'valid interpretations of certain elements in Spanish painting of the 17th century,' and indicates 'the existence of a mechanism of reading.'

This complicity of the poetical and the pictorial which was so fashionable in the 16th and 17th centuries (those periods in whose mirror Dalí is so fond of looking at himself and his work) reappeared, buoyant and all-pervading, in Surrealism, with the elements proper to our own age. No other '-ism' can compare with Surrealism in its aspiration to fuse 'the two arts'; while Surrealist pictures have an air of pictorial hieroglyphs, Surrealist poems can sometimes constitute veritable literary ideograms, in which not even the use of different types of lettering is neglected, in order to transmit an iconic image intermingled with the poetical one.

In a way similar to that of Romanticism, whose love of the exotic, the anti-classical and the subjective made it in so many aspects the forerunner of Surrealism, this latter movement endeavoured 'to go back — as Breton said — to the sources of poetical imagination and, which is still more difficult, to remain close to them.' The great revelation that the Surrealists wanted to make to the world was neither more nor less than the radical revelation of the Image, of which Pierre Reverdy said: 'It is a pure creation of the spirit.'

Considered in aesthetic terms, the Surrealists' contribution to art can be summed up as a radical scheme for forcing the poetry/painting analogy in order to bring about — with its unforeseeable consequences — the embrace of two realities that are distant from each other. To quote Reverdy again: 'The more distant and exact the concomitances of the two realities to be brought together, the stronger the image will be and the more emotional force and poetical reality it will have.' This delving into the sources of the imagination and worship of the power of the creative imagination and the strength of the image — already advocated, among the Romantics, by Coleridge, and earlier still by Plotinus and the Gnostics — were the requisites and components of a new poetic and a new aesthetic; and they also established the stratigraphic plane that makes it possible to discover — like a treasure hidden at a depth of many fathoms — together with the principle of the fusion of the poetical and the pictorial, the dividing line that separates these categories from 'the regulatory intervention of reason' or from morals.

The possibility of reconciling terms so distant from each other, if not opposed, was the hypothesis on which 'the free exercise of reason' rested, according to the ideas of Breton and the Surrealists. Theirs was a radical position, which entailed the need for a multidirectional dialogue between things and their representations. That is why the Surrealist venture has with equal facility led to discoveries of great importance and incomparable examples of the trivial and the meaningless.

It is in *Situation surréaliste de l'objet, situation de l'objet surréaliste,* written in 1935, that Breton expounds most clearly his theory of the fusion of painting and poetry. 'To tell the truth,' he writes, 'it seems to be in painting that poetry has found a broader sphere of influence; poetry has taken root so firmly in painting that the latter can in our day aspire to share with poetry to a great extent the vastest objective of all that can concern it, which is — to use Hegel's words again — that of revealing to the consciousness the faculties of spiritual life. At the present moment there is no difference as to fundamental purposes between a poem by Paul Éluard or Benjamin Péret and a canvas by Max Ernst, Miró or Tanguy. Released from its preoccupation with basically representing forms of the external world, painting now uses in its turn the only external element that no art can dispense with: inner representation, the image present in the spirit.'

It should be observed that Breton refers the assimilation of the poetical and the pictorial to the image, the common denominator of the two arts. Since painting, according to Breton, is in closer contact with the sources of the image, it therefore follows that poetry acquires a vaster sphere of influence in painting. It should also be observed that that image is not the mere mental correlative of external objects, nor yet a sort of platonic idea, but the spontaneously produced and productive fruit of spiritual life, of the psyche. Following the example of Marcel Proust, who saw the operation of writing as the act of translating the mysterious book that is written with hieroglyphical characters in the interior of the soul, the Surrealist artist was to endeavour to pour into the glass of a tangible — i.e. spatial and chromatic — language the mysterious signs that spring spontaneously from the depths of the spirit. And so, according to the Surrealists, it is painting that is particularly called upon to perform the feat of revealing the faculties of the spirit to the consciousness, and it will only be able to

do this by 'transubstantiating' itself into poetry, by in fact becoming poetry itself.

It is a few lines below this passage that Breton declares: 'The fusion of the two arts usually takes place in so integral a fashion today that for men like Arp or Dalí it is a matter of indifference — and I use this expression advisedly — whether they express themselves through the medium of poetry or that of painting (...). Painting is the first art that has succeeded in ascending many of the steps that separated it, as a mode of expression, from poetry.'

Just as the twelve-tone system swept away the tonal arrangements of earlier music, so Surrealism was to declare the suppression of the differences which, according to Lessing, separate poetry from painting and vice versa simply because they use different media of expression. Poetry is no longer the be-all and end-all of art, for painting can boast of sharing with it the sceptre of spiritual creations, and even with certain advantages that raise it above its erstwhile superior. In this way the painter, if he abides by the Surrealist aesthetic, runs the risk of becoming the translator who gives shape on a flat surface to the ideas of the poet, by whose substance he is nourished.

It is this very attempt to blend the poetical and the pictorial that is, in general terms, the source of the facility with which the Surrealist painter engenders monsters and places on one and the same plane the pleasant and the repulsive, the beautiful and the deformed, the trivial and the magnificent. While the painter trained in the classical tradition accepted unquestioningly certain beautiful and unambiguous types for representing realities, so that in his pictures Venus is always depicted as a ravishingly seductive creature, Juno is stately and matriarchal, Minerva arrogant and rather mannish, and so on, for otherwise his pictorial figures would be unrecognizable, the poet has always been able to permit himself the liberty of presenting us with a combative Venus of gigantic stature and ferocious attitude, with reddened cheeks and bloodshot eyes, without the poetical imitation thereby suffering any great impairment, since this melodramatic image only occupies a moment, a single instant in the flow of the literary discourse. This vision I have sketched of Venus, or of any other reality that corresponds pictorially to a formal type, 'is only (Lessing tells us) a moment for the poet, since he has the privilege of linking it with another episode in which the goddess is Venus and nothing but Venus, and linking it, I say, so nearly and precisely that we, the readers, never lose sight of the goddess of love, even in the form of a fury.'

Well, it is this privilege of the poet that the Surrealist painter has attempted to take to himself, transforming what was only a moment in the poetic discourse into a full-blown picture, and without being daunted in this undertaking by the lack of the 'connection' insisted on by the Neoclassical aesthete.

Dalí's ability, as observed by Breton, to express himself with equal success in poetry and painting has been proved again by the Catalan artist several times in the course of his life, as for instance in his singular *Secret Life of Salvador Dalí*, or in the Author's Prologue to his novel, *Hidden Faces*, in which he wrote: 'But as long ago as 1922 the great poet Federico García Lorca predicted that I was destined for a literary life and suggested that my future, in fact, lay in the "pure novel."' Later on he says: 'One day in 1927, as I was sitting in the spring sunshine at a table outside the Café Regina in Madrid with the late Federico García Lorca, we planned to compose together an opera of great originality (...). That day in London when I heard the news of the death of Lorca, the victim of blind history, I told myself that I would write our opera on my own.'

Although that opera, as far as I know, has never been composed, what cannot be doubted for a moment is that Dalí is one of the painters of our century who have written most and best, this alternation of brush and pen being entirely spontaneous in him. Breton included him in his *Anthologie de l'humour noir,* and before that his writing had made a powerful impression on writers of the quality of Lorca. In the following chapter we will be analysing Dalí's poem *Saint Sebastian or Saintly Objectivity,* not only because it is a text that exemplifies the relationship between poetry and painting, but above all because in it are expounded two categories that are vital to our understanding of Dalí's aesthetic.

My theory of the literary contagion in the pictorial will enable us to find an explanation of the more disquieting presences to be found in Dalí's painting, such as the double images or the convertibility of objects.

An image — any image — is, when considered as such, a phenomenon quite inconsistent with any sort of 'convertible' fickleness, since immobility is essential to it. Only when that image is linked to, or forms part of, the psychic process of apprehension, of the discourse of semantic interpretation, can it be said to be at once itself and something else. In other words, only when the image becomes an element in a poetical process — using this term in its fullest sense — is it transformed, without ceasing to be what it is itself physically, into a pictorial text that must be read, presenting itself as a puzzle for solving. For that very reason the convertibility we have observed in the objects in Dalí's paintings cannot be explained in exclusively pictorial terms, but as a component of an interpretative and therefore literary system.

Even the 'eatable' nature of Dalí's painting can only be understood within the framework of pictorial-poetic references that I have proposed. We have seen how Dalí's 'eatables' constitute symbolic structures and belong to a system for interpreting reality. That is why the representation of a fried egg hanging from a cord, or of two crumbs of bread and a chessman, or some beans, or a cup with the handle of a spoon — all these representations, in short — are meritorious not only on account of their pictorial qualities but also because those pictorial qualities express an idea that can be transmitted through words. There is no predominance of the poetical over the pictorial, but a fusion of 'the two arts.'

This poetical-interpretative contagion in Dalí's painting thus accounts for Surrealist pictures like the one with the 'soft watches,' in which time is represented plastically through the viscosity of matter, since time is a fluid wave. All Dalí has done is to transfer to the object — the watch — the 'fluid' attribute with which time is usually represented. The other symbolic values of the object should also be seen from the same viewpoint of the fusion of the literary and the pictorial.

Besides, as soon as we have accepted the intrusion of the poetical at the very core of the pictorial, we can have no more talk of 'monstrous figures' in the traditional sense of the expression, for since all are potentially monstrous no single one is so any longer. The problem will not lie in avoiding or softening the deformed and monstrous, but in making it poetically significant, without the pictorial fact losing thereby the aesthetic qualities that belong to it.

A fact that should be taken into account in this regard is that Salvador Dalí is among the great painters of this century who have done most in the way of illustrating literary works (*Les Chants de Maldoror, La Divina Commedia, Don Quixote, La vida es sueño, Tristan and*

Isolde, etc.); and not in any superficial or marginal way either, for some of his most important paintings have sprung from the reading of such works. For all these reasons I think it may be affirmed that Dalí is the author of the best-known 'mute poems' or 'speaking pictures' of our age, as well as being an evident *exemplum* of what has come to be called 'the civilization of the image.'

Quite recently Dalí himself afforded me confirmation of what I have here described as 'literary contagion in the pictorial,' when he told me the genesis of his latest picture, on which he was still working when I wrote the above lines (22 June 1982).

In the conversation I had with Dalí in the castle of Púbol on 19th June last, after examining the picture entitled *The Three Glorious Enigmas of Gala,* which hung before us in the drawing-room where we were talking, he told me that the picture he was then painting was called *Rome.* Seeing that the title intrigued me, he added that he had called it that because it was a historical picture, 'and history is Rome.'

In this picture we can see — or will see, when it is finished — a Roman head much battered by blows of stones, and an arm hanging like that of Marat in David's celebrated picture. At first I did not quite see the connection between the figure of the dying revolutionary and the other, 'Roman' elements. Then Dalí explained:

'The relationship lies in the fact that Rome means persecution, martyrdom, which is what my figure represents.'

After a pause he added:

'This picture is connected with my tragedy, which is entitled *Martyr.*'

Then he sent for the blue folder in which he keeps everything he has written in the last few years with a view to inclusion in that unfinished tragedy. He asked me to read one of the papers aloud, a scene in which the character of the Heresiarch apostrophizes Rome in solemn, superb Alexandrines. Dalí then went on to tell me the plot of the play.

To sum up, then, this is a case of a literary theme at the basis of a pictorial motif or subject. *Rome,* of course, is not simply a translation into visual terms of the tragedy *Martyr,* but we cannot doubt for a moment that the tragedy is at the genesis of the picture and that we may therefore speak of an equivalence between the pictorial and the literary, of a way in which the phenomenon Breton called 'the fusion of the arts' may occur. The literary and the pictorial form two lines following a parallel course in Dalí's artistic personality and creative work: two lines which at this moment can be given the names of *Martyr* and *Rome.*

Saint Sebastian and the Putrefied Beings

Saint Sebastian or Saintly Objectivity is a long poem, dedicated by Dalí to his friend Federico García Lorca, which in July 1927 appeared in the first number of the review 'El Gallo,' edited in Granada by Lorca himself. A testimony of capital importance to the mutual contagion experienced by poetry and painting in Dalí's work, it is a poem of great visual power and at the same time a detailed description of a picture, in which we already find foreshadowed the main lines of the painting Dalí was to produce in the heyday of his Surrealist period — in Paris in the thirties.

And it is something else: this poem constitutes a veritable statement of aesthetic principles, in which, by a process of opposition and integration, the aesthetic of rigorous precision, transcendentalized geometry, ironic

nakedness and agonistic elegance is harmonized with what Dalí calls 'the aesthetic of putrefaction' — which, localized in late Romanticism, takes the form of an over-sentimental, lachrymatory and affected vision of the world. The singular quality of *Saint Sebastian or Saintly Objectivity* did not escape García Lorca, who wrote enthusiastically to the painter's sister, Anna Maria: 'I have received "L'Amic de les Arts" and have seen your brother's prodigious poem. We have translated it here in Granada and it has made an extraordinary impression. Especially on my brother, *who did not expect it,* in spite of what I told him. It is truly a new prose, full of unsuspected relationships and extremely subtle *points of view.* Seen now and from here, it acquires in my eyes a charm and a light of the most brilliant intelligence which redouble my admiration.'

A reading of the poem will assure us that it was not only the warmth of his friendship that made Lorca write in such fervid terms. In this poetical text we are presented with Dalí's aesthetic in a full-length study as it were, and in it we can find key elements that the artist was later to develop in that fundamental text of Dalinian Surrealism, *The Tragic Myth of Millet's Angelus,* which with its critical-systematic rigours of paranoiac delirium was to cause a revolution within the Surrealist revolution. For Dalinian Surrealism was to be composed of large doses of that 'putrefaction' which he so shrewdly discerned in the decadent art of the late 19th century and its post-Romantic plaintiveness, and also of large doses of heliometrical ultra-precision, of the Saintly Objectivity needed for fixing the medusan, piliform, filamentous, fluid volumes of turn-of-the-century art.

That Dalí perceived 'things rotten' as a dialectical contrast to Saintly Objectivity is a conclusion that can be quite clearly reached from the poem, the last paragraphs of which concentrate, in fact, on putrefaction. They read, partly, as follows:

'Putrefaction: The opposite side of the Saint Sebastian multiplying glass corresponded to putrefaction. Through it all was anguish, obscurity and tenderness still, because of the exquisite absence of spirit and naturalness. Preceded by some verses or other of Dante, I gradually saw the world of "things rotten": the tearful, transcendental artists far from any light, practising in all the genres and ignorant of the exactitude of the calibrated double decimetre. The families that buy artistic objects to put on the piano, the clerk from the office of public works, the associate committee member, the professor of psychology... I couldn't go on. The delicate moustache of a booking-office clerk moved me greatly. I felt in my heart all its exquisite, Franciscan poetry.'

Despite the complexity of the poem and the disconnection of some of its parts, the text can be divided into two main sections: an introduction and the vision of Saint Sebastian. The introduction may be summed up in a phrase: 'Irony (as I have said) is stripping; it is the gymnast hiding behind the pain of Saint Sebastian. And it is also this pain itself, because it can be counted.'

The possibility of counting — precisely measuring — something so 'soft' and unamenable to mathematics as the feelings was one of the central elements, if not the principal one, in Dalí's aesthetic at that time. This desire to be able to count the martyr's pain, the wish that his suffering should be artistically enumerable, is analogous to the zeal for exactitude the artist displayed in the seascapes he was then painting. In these it was a matter of the greatest importance to Dalí that the waves should be countable, for thanks to that possibility of achieving mathematical exactitude art was raised above nature and it could consequently be affirmed that the painted sea

was more sea than the one viewed by our eyes, the physical sea. The irony Dalí speaks of consists in the moment at which the pathetic becomes geometric. In other words, it is the moment at which the sainted martyr, already stripped, is transformed into a gymnast. This ironic nakedness of Saint Sebastian as a gymnast is related by Dalí, at the beginning of the poem, to Heraclitus' phrase, 'Nature likes to conceal herself,' which he interprets, in accordance with an excellent passage written by Alberto Savinio in 1918, as a phenomenon of modesty on the part of nature with an ethical tradition. (We have already seen, earlier in the present text, how Dalí, in a sentence taken from his *Secret Life,* invoked the above phrase from Heraclitus in referring to his contemplation-interpretation of the metamorphic rocks of Cap de Creus, 'ghostly quick-change artists of stone,' in observing which 'I meditated on my own rocks, those of my thought.'

In this same introduction to his *Saint Sebastian,* Dalí compares the martyr's sublime patience to the elegance — or perhaps we should say the phlegm — of Velázquez; and it is in terms of saintly patience that he interprets, on the one hand the slow mellowing of the pictures of Vermeer and, on the other, the exquisite death throes of the saint.

After the introduction comes the *Description of the figure of Saint Sebastian.* I will mention only schematically — almost stenographically — the most important themes, which are at once poetical, pictorial and aesthetic: an Italian space with geometrical tiling, reminiscent of Piero della Francesca; pure, aseptic light that is like that of Florentine quattrocento painting, a light which, like the *tramontana* blowing through Cadaqués, reveals the smallest details and makes them appear vitrified; duality of the saint's head: one of the parts, 'completely transparent,' is formed of a sort of jellyfish substance and supported by 'an extremely fine circle of nickel,' the other part 'was occupied by a half-face that reminded me of somebody very well-known.'

The pain of the martyr is not felt by Dalí in any pathetic way, but is *seen* by him as 'a mere pretext for an aesthetic of objectivity.' This aesthetic of objectivity that now made its appearance was the womb from which later writings of Dalí (published in Paris) were to come — writings, for instance, like the 1935 essay entitled *The conquest of the irrational,* in which we may read: 'That the world of imagination and specific irrationality should possess the same objective obviousness, the same consistency, the same hardness, the same persuasive, cognitive and communicable thickness, as the external world of the reality of phenomena. What matters is what one desires to communicate: the specific irrational theme. The media of pictorial expression are placed at the disposal of this theme. The illusionism of the most abjectly parvenu and irresistible imitative art, the slick tricks of paralysing *trompe l'œil,* the most analytically narrative and discredited academicism, can all be transformed into sublime hierarchies of thought on approaching the new exactitudes of scientific irrationality, as the images of specific irrationality approach the reality of phenomena and the corresponding media of expression approach those of the great realistic painters (Velázquez and Vermeer), etc.' Well, that association of exactitude and delirium, mathematics and hallucination, distorted vision and systematization of the distortion, which was to typify Dalí's Surrealism, is already present, mature and clearly outlined, in the poem we are paraphrasing.

As regards the 'objectivity' of *Saint Sebastian,* in the text Dalí deploys a rich panoply of themes, ranging from high-precision apparatuses, such as heliometers for the deaf and dumb ('an instrument of high physical poetry formed by distances and by the relationships between those distances,' which is used to 'measure the Saint's death throes') down to test-tubes made of the finest glass and things with a futurist — if not absolutely Pop — air about them, like 'charleston and blues dancers who saw Venus every morning in the bottom of gin cocktails at pre-apéritif time, film close-ups, polo players, greasy mascara, a *Supérieur Petit Beurre* biscuit, barmaids playing *Dinah* on a little gramophone and mixing martinis for motorists, a race between blue Bugattis seen from an aeroplane as a day-dreamed movement of hydroids, white gloves on black piano keys, Tom Mix, Adolphe Menjou, Buster Keaton, post-mechanicist boulevards, Florida, Le Corbusier, Los Angeles, the cleanliness and eurhythmy of standardized tools, aseptic, anti-artistic stage shows, white laboratories and clinics, a chloroformed scalpel and American magazines with GIRLS, GIRLS, GIRLS, and the sunshine of Antibes and Man Ray, and a show-window full of shoes in the Grand Hotel, and mannequins, above all mannequins: 'mannequins, standing passively in the electric splendour of the shop-windows, with their neutral sensualities, their disturbing mechanicisms and articulations. Live mannequins, delightfully silly, walking with an alternating, contradictory rhythm of shoulders and hips, and squeezing their arteries into the new, reinvented physiologies of their clothes.'

In contrast to this parade of modernity, with its alternation of nickel and bakelite, perspex and high-precision speedometers, the new drinks and rhythms, which Dalí embodies in the ironic, naked elegance of the dying athlete or martyr, the other side of the cocktail is a proliferation, like dark, sticky larvae, of things rotten and their swarm of tender, transcendental laments, their kitsch vases placed on the piano, not to mention the Franciscan clerks' moustaches, so different from the Velázquez-inspired, hyperfine, ultramodern antennae that Dalí himself was to affect in later years.

The poem *Saint Sebastian or Saintly Objectivity,* first published in 'L'Amic de les Arts' in the month of July 1927, records the experiences of the exact painting of previous pictures, like the two 1925 portraits of his sister in the Spanish Museum of Contemporary Art in Madrid, or *Woman at the Window in Figueres* (in which we can see a very pre-Pop Ford advertisement), painted in the same year, and consolidates and reflects the paintings

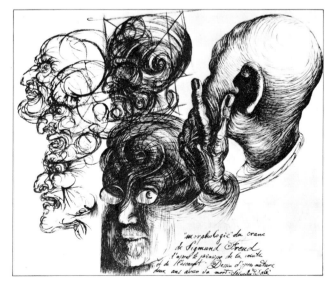

Portrait of Freud (illustration for *The Secret Life of Salvador Dalí*). Ink on paper. Private collection.

Dalí did in 1927 and 1928, such as the 1927 *Apparatus and Hand* and the 1928 *Inaugural Gooseflesh*. Observe in this last work — which marks the inauguration of Dalí's Surrealism — the mixture of 'putrefied,' 'visceral' forms and geometrical numberings and pinpointings. In this canvas the painter goes so far as to number the shapeless elements with figures and letters, and to trace straight lines in perspective which indicate the position of the amorphous lumps in the space.

It may well be affirmed that decisive elements in Dalí's Surrealism are contained, like seeds or DNA molecules, in the poetical, aesthetic prose of *Saint Sebastian*, for Dalí's Surrealism combines the exactitude of the look with the irrational putrefaction of what is looked at, the soft viscera of sentimentality with the enamelled hardness of geometry, and even of radiography. The projection on to the canvas of such a combination produced many of Dalí's great pictorial creations, among which I will mention only *The Persistence of Memory*, with its time-measuring apparatuses made of soft materials, which hang like golden fleeces — 'time is gold' — from the bare bough of the tree or from the rigorously cubic platform.

Between Maldoror and Dante

The tearing of flesh, savage, bloody sacrifice, hunger and its accompanying butchery, appear over and over again in *Les Chants de Maldoror*, that poem in which the almost adolescent Euro-American, Isidore Ducasse (Lautréamont), set out to denigrate Man and the Creator, and to sing of vice and crime, though he did explain to his publisher, Lacroix: 'Of course I have heightened the tone to create something new in the sense of that sublime literature which sings of despair only in order to torture the reader and make him desire good as a remedy.'

Whether he accomplished this purpose or not, the fact is that the barest list of some of the images that appear in the *Chants* constitutes a copious gallery of truculent paintings, very close in spirit to Dalí's Surrealism, particularly the works done in the nineteen-thirties. For at the beginning of that third decade in our century Dalí discovered in the Montevideo-born poet a congenial artistic comrade, well fitted to excite his imagination to the point of a delirium of the most metamorphic cannibalism, one who could even encourage the Catalan painter in his zeal to confer on painting the exactitude of a geometrical enamel. In the tenth section of the second *Chant*, Lautréamont exalts the excellences of mathematics: 'Oh, severe mathematics! Never have I forgotten you since your wise lessons, sweeter than honey, filtered through to my heart like refreshing water; from my very cradle I yearned instinctively to drink from your springs, older than the sun, and I still continue, the most faithful of your initiates, to tread the sacred atrium of your solemn temple.'

I have elsewhere drawn up a list of the images appearing in that hymn to 'the delights of cruelty' which is Lautréamont's poem, with particular attention to those most closely connected with Dalí's painting. Here are some of them: a man with the unmoving eyes of a fish, omnibuses crammed with corpses, characters formed of eroded stones, rivers of blood fed with cannon fodder, the Creator on a throne of excrement, voluptuously devouring human bodies and wagging a beard spattered with brains; insect-men, philosopher-adolescents with claws and sucking organs; lice-men, blocks of lice-men, that are being sliced with an axe;

clouds of locusts descending on the city; immense solitudes in which the human imagination is exalted with inconceivable games; gangrened breasts like torrents of rocks; shipwrecked sailors from whom the sharks make 'eggless omelettes'; skies with membranous forms; sadistic stabbings of babes-in-arms; legions of winged octopodes; gnawed skulls, which in the presence of crocodiles leap up in a repugnant vomit.

When Maldoror is about to quarter a little girl, the poet tells us, 'he prepares without a qualm to poke resolutely into the unfortunate creature's vagina. From that enlarged opening he withdraws in swift succession the internal organs: the intestines, the lungs...' The poet takes quite a long time over this nauseating description, which culminates in the moment at which he sees the girl as 'a drawn chicken,' which proves even more repulsive since the description is put into the mouth of the poor little girl's mother.

But we need not go on with this parade of images, in which the poetic analysis of human carnality goes as far as the ablation of viscera, the flaying of muscles and the most monstrous metamorphoses. Over these realms of Maldoror glided Dalí, with an attitude like that he expresses when he says that 'the cyclotron of Dalí's philosophical jaws hungered to grind everything, to crush and bombard with the artillery of its interatomic neutrons...,' or when he observes that Freud's skull is a Burgundy snail: 'The consequence of that is therefore evident: if one wishes to eat his thought, one must pull it out with a pin. Then it comes out whole. If not it breaks, and there is nothing to be done about it.'

And thus we come back to Dalí's 'eatables,' to that highway formed by the mouth and the alimentary canal, with its traffic of foodstuffs — raw, stewed, boiled, fried, rotten, roasted, etc. But what we find, along with this Maldororian Dalí, is the 'eatable of cruelty,' the eatable that is the result of a bloodstained sacrifice. With this Dalí seems to be trying to tell us that art is the terrible fruit of a ruthless quartering of reality, of an implacable analysis of phenomena and, at the same time, of a refined cuisine that is capable of transforming the viscera stolen from a corpse into an exquisite dish.

Osip Mandelstam, in one of the most brilliant essays of interpretation ever written on Dante and the *Divina Commedia*, says that, 'if the rooms of the Hermitage suddenly went mad, and the paintings of all its schools and artists were unhooked from their nails, to blend, mingle and fill the air of the galleries with futurist howls and all the colours in violent agitation, the result would be something similar to Dante's *Commedia*.' Not greatly different are the sensations aroused by the *Divina Commedia* illustrated by Dalí, in which the painter presents us with a sort of compendium of his whole artistic career. In Dante's journey through Hell, Purgatory and Paradise, Dalí undoubtedly saw his own artistic itinerary from the most convulsive avant-garde to the most illuminist traditionalism. The most Mannerist of attitudes and the most tremulously sublime landscapes of Symbolist Romanticism, the most violently Baroque glory and the most twisted, distorted of monsters among the images of Surrealism, the most gluttonously abstract of stains and the most ruthlessly exact of drawings: all of these have their place in Dalí's infernal and paradisiacal journey, his spatial Odyssey of colour and drawing.

The incessant impulse towards the creation of forms that may be observed throughout the *Divina Commedia* ('The poem is a strictly stereometric volume, the syllabic development of a calligraphic theme,' says Osip Mandelstam) is of the same sort as that which possesses Dalí in his polarized creativeness as painter and poet.

Gli occhi lor, ch'eran pria pur dentro molli
Gocciar su per le labbra...
(*Inferno,* XXXII, 46-47)

On the subject of the above lines, Mandelstam comments: 'Thus the suffering goes through the organs of the senses, creates hybrids, produces the labial eye.' This labial eye, this suffering that creates hybrids, is not only a stimulating image of the relationship between painting and poetry — the eyes and the lips — but a perspicacious way of regarding Dante's poem, and one that also serves to define Dalí's poetical-pictorial genius. This labial eye may quite fittingly be attributed to Dalí, who in his artistic work does not confine himself to merely occupying the visual imagination, but above all intensifies it, as though it constituted a monument wrought with rare materials which, apart from exalting the man to whom it is dedicated, honoured the materials of which it is made.

In the same way as Dante's poem, Dalí's illustration of it — and, in general, his whole painting *œuvre* — is imbued with all the forms of energy known to modern science, all of which make an appearance in the course of an itinerary that goes from the most slithering, line-twisting Surrealism of the *Inferno* to the most nuclear or abstract-expressionist explosion of the *Paradiso;* for as he makes his way through Dalí's illustrations to the *Divina Commedia,* the viewer cannot help noticing that, while the starting-point is situated in the most specific irrationality, i.e. the obstinate insistence on drawing in the *Inferno,* little by little — above all in the *Paradiso* — the artist succumbs to the temptation of flights through space, in the course of which reality is presented in the form of airy stains, veined and iridescent; in the form of flashes and waves, as though in this flight the painting were seeking to rid itself of its corporal crust and, dematerialized, to become a pure interplay of levitating colours, culminating — on reaching the final goal of the *Paradiso* — with the three circles of three colours and a single dimension, all of them substantiated in light.

Lautréamont and Dante, *Les Chants de Maldoror* and *La Divina Commedia,* represent two extremes of Dalí's artistic personality. The corsair 'with long, fair hair and lips of jasper,' and the seer with the hawklike profile, are the two genii of Dalí's aesthetic. The faces Dante gave to the Middle Ages have been conferred by Dalí on the Atomic Era. Between the adolescent poet, creator of bestiaries and anatomist of swamps, and the theologian poet, discoverer of hells and revealer of heavens, Dalí has revolved with the concentric flights of his art, from putrefaction to Saintly Objectivity, from the viscera or intestines to the most refined clothing or jewels, from science to delirium, like an adolescent hybridized with an anti-Faust theologian, who exclaims in a sudden outburst: 'My mystique is cheese! Christ is cheese! Does not St Augustine tell us that in the Bible Christ is called "montus coagulatus, montus fermentatus," which must be taken to mean a veritable mountain of cheese?' A strange mystique, you may say. The mystique, in any case, of a strange world.

The perenniality of the acanthus

Once again I walked along the lane that leaves the cemetery of Cadaqués and curves down towards the little bay of Portlligat.

This time I was visiting the painter on All Souls' Day. Perhaps it was thanks to this chronological circumstance that the melancholy bay, that lake which reflects 'the dramas of the sky at sunset', made me think more than ever of Böcklin's *Island of the Dead.* The weather was damp and the first signs of winter were in the air.

When I entered the painter's studio, Gala politely closed the book she had been reading to Dalí, who was absorbed in the painting he was working on. He seemed rested and unworried. While he went on painting the picture on the easel in front of him, we spoke again of the Torre Gorgot and of his plan for a leaning, liquid tower. We also spoke about that wonderful Baroque poem, *Paradise closed to many, gardens open to many,* by the Granada poet Soto de Rojas, in the approbation of which we may read: 'I admired the vegetative eloquence, the studious plants, in whose green leaves one could read fables truly, their composition seeming, rather than a book, a garden.'

Dalí, who did not cease to use his brushes throughout our conversation, must have noticed some sign of surprise in my face, since the picture he was painting was a monochrome oil, black and white being the only colours. He said: 'It must be because today is All Souls' Day that I am painting this picture in black.'

In the picture I saw a road starting out from the foreground at the bottom of the canvas, which it occupied entirely, and gradually losing itself — two perfectly straight converging lines — in the wooded background of the distant horizon. Once again the Highway. Like milestones on the route, a great number of sacks (reminding me of the ones lying in the wheelbarrow in Millet's *Angelus* and, in the way they were arranged, of the amorphous figures in *Inaugural Gooseflesh*) lined the two sides of the road. At a certain point on this road the sacks ascended in the same order into the sky, so that they seemed to be returning, on a higher level, to the foreground of the picture. Once again a circular movement, a Llullian combinatorial movement. Were they sacks of coal, sacks of potatoes, sacks of energy? Dalí told me that they were 'sacks laden with information.'

I do not know whether it was because of All Souls' Day, but the fact is that the melancholy feelings induced by that date stirred me to seek the antidote and contrast of clearer, happier, more hopeful spaces; and then I thought of that hymn to the victory and perenniality of the acanthus that appears in the closing chapters of the *Secret Life,* in which Dalí says: 'But at the very moment when nobody was thinking of it, we behold the acanthus reborn, green, tender and shining, among the cracks of a flamboyant ruin. And it is as though all the catastrophes of history, all the suffering of mankind, all the upheavals, storms and chaos of the western soul, were destined, with their transitory, tempestuous appearances and disappearances, simply to come at all times to nourish the perenniality of the acanthus, simply to maintain the ever renascent immortality of that tradition that is unfailingly green, fresh, virgin and original...' Might not those sacks in the monochrome painting be laden with acanthus?

When I took my leave, Dalí was still adding nuance to nuance, piling distance upon distance, travelling once more over his royal and combinatorial highway. The last image that I took away with me that evening was that of the faintly-seen, distant mountains in the background, pierced like a wood transformed into a target, by the swift, straight arrow of the road.

CHRONOLOGY - Life and work*

1904 Birth, in Figueres on 11th May, of Salvador Felipe Jacinto Dalí, the son of Don Salvador Dalí i Cusí, a notary by profession, and his wife, Doña Felipa Domènech. His childhood is passed between Figueres and Barcelona and in Cadaqués, where his parents have a house. His involvement with the scenery of the whole Empordà region, and especially those parts of it near Figueres (Cadaqués, Cap de Creus), is to be of fundamental importance both in his life and in his work. His first work, a landscape, is dated in 1910.

1914 Dalí starts his secondary education at the Marist Brothers' school in Figueres and shows a precocious interest in painting, an interest which he discovers and nourishes at the home of the Pitxot family, friends of his parents. He begins to take an interest in Impressionism through the works of Ramon Pitxot (1872-1925), who exhibited at the Salon d'Automne in Paris with the *Fauves* and whose coloured etchings were enthusiastically praised by Apollinaire in his *Chroniques d'art*. Most of Dalí's works of this period are oil paintings with landscapes of Cadaqués and genre scenes of peasants and fishermen.

1918 His interest in Impressionist brushwork yields place to an overwhelming thirst for colour. He is now mainly drawn to the masters of *l'art pompier*, particularly Mariano Fortuny (1838-1874) and Modest Urgell (the Spanish Böcklin), but finally opts for pointillism. Meanwhile he studies drawing, engraving and painting with Juan Núñez. On 2nd May of this year he shows some canvases for the first time, at a show of local artists' work held at the Teatre Municipal in Figueres. The *Crepuscular Old Man* is painted around this time.

1919 The review "Stadium," published by the Figueres *Institut* (state secondary school), begins to receive contributions from Dalí. His regular articles on art are devoted to the painters he most admires (Michelangelo, Leonardo da Vinci, Dürer, El Greco, Goya and Velázquez). The last-named is already in his eyes 'one of the greatest, perhaps the greatest of all, Spanish painters, and one of the first in the world.' He also contributes to the humorous review "El Señor Pancracio." His literary interests are also much in evidence by this time.

1921 Dalí is enrolled in the San Fernando School of Fine Arts in Madrid, where he studies drawing, painting and sculpture. At the Students' Residence, where he lives, he meets Lorca, Buñuel and Eugenio Montes. The Disciplinary Council later decides to expel him from the School for a year, accusing him of inciting his fellow students to rebellion against the school authorities. Throughout this period he is influenced by Bonnard, the Italian Futurists and Eugène Carrière. He paints cubist canvases in his room and openly shows his opposition to the official teaching he receives. Around this time he paints *Self-portrait with Raphael's Neck*.

1922 In October of this year he shows eight of his works at the Galeries Dalmau in Barcelona. Paintings done at this time include *Still Life with Fruit, Cadaqués Seen from the Inside* and *The First Days of Spring*.

In Paris André Breton, together with Picabia, Max Ernst and Man Ray, has formed the first Surrealist group.

1923 On returning to the School in May he is arrested for his anarchist tendencies and is imprisoned for 35 days in Figueres and Girona. His interest in Cubism grows (largely through the works of Juan Gris), as does the influence on him of the Italian Metaphysical School (Carlo Carrà and Giorgio de Chirico), though this does not lead him to neglect the Pointillists. Works done at this time include *Girls, Cubist Self-portrait* and some landscapes of the countryside around Cadaqués.

1924 He enrols in the School of Fine Arts again and resumes his relations with the most avant-garde groups there. Meanwhile, in Paris, Breton issues his first Surrealist Manifesto and the review 'La révolution surréaliste.'

1925 Lorca pays his first visit to Figueres and Cadaqués. He reads *Mariana Pineda* to the Dalí family, who are all delighted with it. November: first one-man show, at the Galeries Dalmau in Barcelona, which arouses Picasso's and Miró's interest in Dalí. The critics do not fail to notice the repeated references to Ingres in the catalogue. Dalmau himself brings 'La révolution surréaliste' to Dalí's notice. December: Dalí

embarks on a remarkable collaboration, which is to last until February 1929, with the Barcelona review 'L'Amic de les Arts.' Lorca writes his *Ode to Salvador Dalí*. Among Dalí's paintings of this year are *The Barcelona Mannequin, Still Life with Mauve Moonlight* and *Large Harlequin with Small Bottle of Rum*.

1926 With his sister and his aunt, Dalí visits Paris and Brussels for the first time. His attention is wholly absorbed by Hieronymus Bosch, Brueghel and Vermeer (above all the last-mentioned). Among the people he visits in Paris is Picasso, who is impressed by the works Dalí shows him. October: Dalí is definitively expelled from the School of Fine Arts, after refusing to recognize his teachers' competence to examine him. Later in the year Miró visits him in Cadaqués. December: second one-man show at the Galeries Dalmau. The work that arouses most interest, among critics and public alike, is *The Bread-basket*.

1927 February: Dalí joins the army to do his military service. June: first performance of Lorca's *Mariana Pineda*, presented by Margarida Xirgú and her company at the Teatre Goya in Barcelona, with décor and costumes by Dalí. He spends the summer with Lorca and Regino Sáinz de la Maza in Cadaqués. There he writes his poem *Saint Sebastian*, which is published in 'L'Amic de les Arts' and later translated into Castilian by Lorca, who publishes it in the Granada review 'El Gallo.'

1928 Lluís Montanyà, Sebastià Gasch and Dalí issue the *Yellow Manifesto*:
'In the present manifesto we have eliminated courtesy of any kind from our attitude. All discussions with the representatives of contemporary Catalan culture — artistically negative, though efficacious in other fields — have proved useless. Tolerance or good manners lead to deliquescences and lamentable confusions of all sorts of values, to the most unbreathable spiritual atmosphere, to the most pernicious of influences. For instance: "La Nova Revista." Violent hostility, on the contrary, situates values and positions clearly, creating a hygienic spiritual state.' Thus begins the 'anti-artistic' Manifesto, in which they denounce, among other things, 'the absolute lack of youth among our young people,' 'false period architecture,' 'decorative art that does not follow standardization' and 'the fear of new events, of words and of the risk of making a fool of oneself.'

He is influenced by Miró, Arp, Ernst and Tanguy. His most important works of this year include *Anthropomorphic Beach, Putrefied Birds, Inaugural Gooseflesh* and *Naked Torso*. October: three pictures by Dalí are shown at the 27th painting exhibition of the Carnegie Institute, Pittsburgh.

1929 Dalí's second journey to Paris, in connection with the shooting of Buñuel's film, *Un Chien Andalou*. The painter's work on this film is of the first importance. Miró introduces him to the Surrealist group and he soon makes the acquaintance of Arp, Magritte and the art-dealer Camille Goemans, who in turn introduces him to Paul Éluard. Goemans and Éluard, accompanied by the latter's wife, Helena (Gala), visit Cadaqués during the summer, after which Gala is never again to be separated from Dalí, becoming his most constant counsellor and model. The showing of *Un Chien Andalou* causes a sensation while Dalí is already working on *L'Age d'Or*, another film by Buñuel, in which his participation was considerably reduced in comparison with the earlier work. 20th November: Dalí's first exhibition, presented by Breton, at the Galerie Goemans in Paris. December: through an article by Eugenio d'Ors the Dalí family are made aware of the existence of a print of the Sacred Heart on which is written: 'Sometimes I spit on my mother's portrait for pleasure.' This, in conjunction with the recent initiation of his liaison with Gala, provokes a break with his family. Dalí is not to see his father again until his return from New York in 1948. In this year he paints *Spectres of Two Automobiles, Portrait of Paul Éluard, Enlightened Pleasures, The Great Masturbator* and *The Lugubrious Game*.

1930 Dalí works on his canvas *The Invisible Man*, which he is to leave definitively unfinished three years later. At the same time he writes, illustrates and publishes *The Visible Woman*, which he dedicates to Gala. March: in exchange for a sum of money to be used for the purchase of a little fisherman's house in Cadaqués (the one which successive extensions and alterations have transformed into his present home), Dalí offers the Vicomte Charles de Noailles one of his pictures, to be chosen from among those done in the following year (the

* I wish to thank Juan José Herrera for the assistance he has given me in drawing up this *Chronology*.

choice is to fall on *William Tell in Old Age*). July: 'Le Surréalisme au service de la révolution' publishes *Rêverie,* one of Dalí's most important texts. And 'Ediciones Surrealistas' publishes *El amor y la memoria.* November: 10 works by Dalí are shown in what should be regarded as the first Surrealist exhibition in the United States, which is held in Hartford. In Paris the reactions aroused by Buñuel's second film are so violent that the Commission de Censure finally forbids it to be shown (though it has already been authorized). December: publication of Dalí's text *L'Âne pourri,* in which he lays the foundations of his paranoiac-critical method. Of this method Breton and Éluard write: 'What Dalí calls paranoiac-critical thought, which is a combination of dialectical and psychoanalytical thought, is the most admirable instrument that has as yet been proposed for passing through the immortal ruins the ghost-woman, with her face coated with verdigris, her mocking eye and her stiff ringlets, who is not only the spirit of our birth — i.e. the Modern Style — but the abidingly more attractive phantom of our evolution.' Dalí begins to reflect on the problem of the double image. His *Vertigo* is painted in this period.

1931 The first of the three exhibitions which are to be held over the next three years at the Galerie Pierre Colle. André Lhote writes, in the 'Nouvelle Revue Française': 'His harmonies are those of the anatomical print, in which the blood reigns supreme.' Among the works shown is *The Persistence of Memory.* The statements he makes at this time about Catalan Art Nouveau are full of eulogies of Gaudí: 'The church of the Sagrada Familia is the first great achievement of Mediterranean Gothic. The sublime Gaudí, who visited the Cap de Creus as a boy, fed his art on memories of the rocks, soft and baroque, hard and geometrical, of that divine place.'

1932 *The Persistence of Memory* (also known as *The Soft Watches*) arouses enormous curiosity among New York gallery-goers on the occasion of its first showing, in a group exhibition at the Julien Levy Gallery. The success of Dalí's works in the United States has only just begun and is to reach unsuspected heights. July: his book *Babaouo,* in which he expounds his conception of the cinema, is published in Paris. October: Dr Jacques Lacan publishes his thesis *De la psychose paranoïaque dans ses rapports avec la personnalité.* Works painted during this year include *The Birth of Liquid Desires, Portrait of the Vicomtesse de Noailles* and *Atmospheric Fried Eggs.* He also does illustrations for Breton's *Le révolver à cheveux blancs.*

1933 Dalí signs a contract with Albert Skira (to whose review, 'Minotaure,' he is to contribute several articles, among those published being *The paranoiac-critical interpretation of the obsessive image of Millet's Angelus*), undertaking to do forty etchings as illustrations for Lautréamont's *Les Chants de Maldoror.* June: at the Galerie Pierre Colle he shows his *Gala and Millet's Angelus.* Writing of this exhibition in 'Beaux Arts,' Georges Hilaire says: 'As against imaginative painting, he prefers the detailed, eatable anecdote, the "objective randomness" of dreams, "object-actions" (...) This paranoiac possesses the spirit of geometry. Dalí is obsessed by the idea of fineness. It is his ambition to restore "academic fineness" as one of the properest means of channelling the "proximate deliria of rational exactitude."' November: first one-man show at the Julien Levy Gallery in New York. December: Dalí exhibits at the Galería d'Art Catalònia in Barcelona.

1934 At the Salon des Indépendants Dalí shows *The Enigma of William Tell* and *The Cannibalism of Objects.* The Julien Levy Gallery in New York presents his collection of drawings and engravings illustrating Lautréamont's *Les Chants de Maldoror.* The 42 etchings commissioned by Albert Skira are presented at the Quatre Chemins bookshop in Paris in the month of June. Dalí has spent over a year on them. 20th June: exhibition at the Galerie Jacques Bonjean. Writing of this show in 'Art et Décoration,' Louis Chéronnet says: '(...) and to paint all this Dalí dreams that he possesses the brush of Millet or that of Meissonier. The most admirable feature of the business is that, *in appearance,* he manages to succeed.' October: the Catalònia bookshop in Barcelona presents a personal exhibition of Dalí's works which, according to Alfred Barr, 'stirs up the effervescence of a rapidly expanding Surrealist group.' At the painting exhibition of the Carnegie Institute in Pittsburgh Dalí is awarded an Honourable Mention for *Enigmatic Elements in a Landscape.* At the Zwemmer Gallery in London he has his first one-man show in Britain. November: Gala and Dalí, on board the Champlain, arrive in New York for the first time. On the 21 of this month an exhibition of his work opens at the Julien Levy Gallery — an exhibition which, in the words of 'The Sun,' is 'fashionable, very controversial and difficult.' December: in a letter to a friend, Dalí talks about his arrival in America: 'Apart from

suffering from an enormous inferiority complex, the people here do not understand very well, which obliges them to confront phenomena with a great amount of good will, unlike the *pretentious,* ironic self-sufficiency you so often find among the Paris critics.' 18 December: Dalí gives a lecture to an audience of two hundred people at the Wadsworth Atheneum in Hartford, in the course of which he says for the first time: 'The only difference between me and a madman is that I am not mad.' Paintings of this year include: *The Spectre of the Libido, Atavistic Traces after the Rain, Spectre of Vermeer which can be used as a Table, Atmospheric Skull Sodomizing a Grand Piano.*

1935 January: Dalí gives a lecture at the Museum of Modern Art in New York under the title *Surrealist paintings and paranoiac images,* in which he defines his paranoiac-critical method in the following words: 'To tell the truth, I am nothing but an automaton recording, without judging and as exactly as possible, the dictates of my subconscious: my dreams, the hypnagogic images and visions, and all those concrete, irrational manifestations of the obscure, sensational world discovered by Freud (...). The public must take their pleasure from the limitless resources of mysteries, enigmas and anguish that such images offer to the subconscious of the viewers...' February: Gala and Dalí leave New York, after attending the fancy-dress ball given in their honour by Caresse Crosby (Dalí dressed as a shopwindow, with a little drawer-brassière, and Gala wearing a dress of red cellophane, with a celluloid doll and lobsters). December: after illustrating Éluard's book, *Nuits Partagées,* Dalí publishes *The conquest of the irrational* (the work in which he further defines his paranoiac-critical method: 'Spontaneous method of irrational knowledge, based on the critical-interpretative association of the phenomena of delirium') in Paris and New York; in the latter city the 'American Weekly' also publishes a series of his drawings, presented as Surrealist impressions of the city. At this time, too, he illustrates Tristan Tzara's book, *Grains et issues,* and participates in the Surrealist exhibition in Tenerife, sponsored by 'Gaceta de Arte' and Oscar Domínguez, a singular episode in the history of Surrealism in Spain. In an article published in 'Cahiers d'Art' (Nos. 7-10), under the title of *Les Pantoufles de Picasso,* he applies the paranoiac-critical method to literature for the first time: Picasso and the contemporary political and cultural world appear in a text by Sacher-Masoch, *Les Pantoufles de Sapho,* with minimal modifications introduced by Dalí.

1936 May: the Surrealist exhibition of objects presented at the Galerie C. Ratton, in which Dalí participates with his monument to Kant·and the aphrodisiac jacket, marks the 'officialization' of a new expression of Surrealism. June: apart from his contributions to the review 'Minotaure,' Dalí continues to publish important articles in 'Cahiers d'Art,' an example being his *Honneur à l'objet.* He also illustrates a poem by Edward James, who is a buyer of Dalí's most important works up to 1938. 4th December: one month after his arrival in New York, his photograph appears on the front cover of 'Time.' 15 December: Dalí exhibits at the Julien Levy Gallery again and, after this, in a collective show at the Museum of Modern Art in New York entitled 'Fantastic Art, Dada and Surrealism.' Among the works painted during this year are *The Great Paranoiac, Couple with their Heads Filled with Clouds, The Chemist from Figueres who is not Looking for Anything at All, Geological Justice, Solar Table* and *Soft Construction with Cooked Beans (Premonition of the Spanish Civil War).* After the victory of the Popular Front in February, General Franco's military rebellion marks the beginning of the Spanish Civil War. Lorca is murdered in Granada.

1937 Dalí's interest in the Marx Brothers grows, and he paints a portrait of Harpo, as also some drawings for a film which is never made. March: he publishes an article entitled *Je défie Aragon,* in which he says: 'The authentic laboratory in which we carry out the systematic exploration of the unknown regions of the human spirit is "surrealism." Why not use it, then, to experiment on something — the history of art — to which it would lend itself fairly well?' After participating in a collective exhibition at the Jeu de Paume ('Origin and development of Independent International Art'), he flees from the war and settles in Italy, where with Edward James, at whose home he is staying, he improves his acquaintance with the Renaissance and the Baroque. He is later to publish his paranoiac poem *The Metamorphosis of Narcissus,* while at the same time collaborating with Elsa Schiaparelli on designs for hats, materials and dresses. Notable among the works painted during this period are *Metamorphosis of Narcissus, Dream* and *Cannibalism in Autumn.*

1938 January: he participates with his *Rainy Taxi* in the Surrealist exhibition at the Galerie des Beaux-Arts in Paris. In London he is introduced to Freud by Stefan Zweig; this introduction leads to some portraits of the psychiatrist, in which Dalí compares his skull with a snail. He does a goblet in engraved crystal for Steuben Glass. Throughout this period his studio has two branches: the residences of Lord Berner and of Coco Chanel, in Rome and Paris respectively. He also collaborates with Coco Chanel on several ballet designs for the Ballets de Montecarlo. Among the canvases painted during this period are *Spain* and *The Infinite Enigma*.

1939 Dalí travels to New York again, for an exhibition of his work at the Julien Levy Gallery which opens on 21 March. The impression produced by this show is described in 'Life' as follows: 'No exhibition has been so popular since Whistler's *Portrait of the Artist's Mother* was shown in 1934. The crowds gazed, open-mouthed...' Some days earlier Dalí has broken a window in the Bonwit Teller department store. Most of the reviews of this show express curiosity about the presence of telephones in many of Dalí's works. He signs a contract with the New York World's Fair, undertaking to execute a personal creation to be entitled *The Dream of Venus* — though on account of his differences with the sponsors Dalí would have preferred *Nightmare of Venus*. Later, when his plan to put a fish's head on Botticelli's *Venus* is prohibited, he publishes his 'Declaration of the independence of the imagination and of man's right to his own madness', in which he says: 'The human condition is defined through the enigma and the simulacrum, which are corollaries of these vital facts: sexual instinct, consciousness of death, physical melancholy engendered by the time-space notion'. November: the first paranoiac ballet, *Bacchanal (Venusberg)*, is performed at the Metropolitan Opera House, with music by Wagner, choreography by Massine, and scenery by Dalí. In the autumn Gala and Dalí return to Europe and settle in Arcachon. As from this year Dalí's activities are to leave Surrealism completely. The Spanish Civil War ends with the victory of General Franco.

1940 Dalí begins to take an interest in Max Planck's quantum theory. In the face of the imminent Nazi invasion he leaves Europe again and settles, first, in Caresse Crosby's house in Virginia. Gala's organizing abilities come very much to the fore — according to Anaïs Nin, a fellow guest at the time — and very soon the whole house revolves around Dalí. He later settles in Pebble Beach, California. Among the works painted in this period are *Slave-market with Invisible Bust of Voltaire* and *The Face of War*. Dalí is to remain in the United States until 1948.

1941 He has very successful exhibitions at the Julien Levy Gallery in New York and the Dalzell Hatfield Gallery in Los Angeles. He now begins a prolific collaboration with the photographer Philippe Halsman, one which will end only with the latter's death in 1979. June: Dalí finishes editing his *Secret Life*, which is to be published in New York in 1942. October: first night of the ballet *Labyrinth* at the Metropolitan Opera House in New York. It has a libretto, scenery and costumes by Dalí and choreography by Massine, and is based on a plot taken from the myth of Theseus and Ariadne. In collaboration with the Duke of Verdura, Dalí creates his first jewels; the most notable are *Ruby Lips, Spider in its Web* and *Royal Heart,* as well as *The Persistence of Memory* in gold, enamel and diamonds. Breton in one of his works writes about Dalí: 'Despite an undeniable talent for putting himself across, the stamp of Dalí, ill-served by an ultra-retrograde technique (the return to Meissonier), is discredited by a cynical indifference to the media employed for communication, has for some time now been showing signs of panic and has not as yet saved itself, apparently, except by organizing its own vulgarization.'

1942 The retrospective show organized by the Museum of Modern Art of New York is transferred in succession to eight other cities in the United States. Dalí's relations with the world of photography are to have very fruitful results.

1943 Dalí becomes an accepted member of New York society and does a great many portraits of rich Americans for the Knoedler Gallery. He decorates Helena Rubinstein's flat with large murals *(Nude on the Plain of Roses)* and constructs Mae West's face 'for use as a drawing-room.' It is during this year that he paints *Geopolitical Child Observing the Birth of the New Year.*

1944 His theatrical activities are now greatly intensified and among works of his actually staged are *The Chinitas Café, Sentimental Colloquy* (based on a poem by Verlaine) and *Mad Tristan.* He starts work on illustrations for many books, among them Maurice Sandoz's *Mémoires Fantastiques* and his

own *Hidden Faces.* He paints *Dream Caused by the Flight of a Bee around a Pomegranate a Second before Awakening.*

1945 The explosion of the atom bomb at Hiroshima inspires Dalí to begin his 'nuclear' or 'atomic' period. He works with Alfred Hitchcock on the dream sequences in *Spellbound.* He writes the first number of the 'Dalí News.' In this year, too, he paints *Apotheosis of Homer, Three Apparitions of Gala's Face* and *Galarina.*

1946 Dalí and Walt Disney begin to work out an idea for a cartoon film to be called *Destiny,* which comes to nothing in the end. He illustrates Shakespeare's *Macbeth* and does covers for several magazines, such as 'Vogue' and 'Etcetera,' as well as for Billy Rose's book, *Wine, Women and Words.* He paints *The Temptations of St Anthony.*

1947 Dalí illustrates an edition of the *Essays* of Montaigne and has a one-man show at the Cleveland Museum of Art. Later he has one at the Bignou Gallery in New York. At the same time the tenth number of his review, 'Dalí News,' comes out.

1948 Before sailing for Europe, to settle down in Portlligat for good, he illustrates *50 Secrets of Magic Craftsmanship,* Shakespeare's *As You Like It* and Benvenuto Cellini's exuberant *Vita.* November: Dalí exhibits at the Galleria l'Obelisco in Rome on the occasion of Luchino Visconti's production of *As You Like It,* for which Dalí does the scenery and costumes. Dalí is now entering on a new phase, in which he will have no point of contact with the postwar avant-garde but will, on the contrary, seek inspiration in the great themes of western tradition.

1949 He designs the scenery for Strauss's *Salome* at Covent Garden. A religious character now makes its appearance in Dalí's work. His interest in harmonic and geometric theory grows, and he eagerly studies Luca Pacioli's *De divina proportione.* He is granted an audience by Pope Pius XII. November: he returns to New York. Breton continues to accentuate the breach between them through various writings, such as the second-edition note to the passage he devotes to Dalí in his *Anthologie de l'Humour noir.* This is the year in which Dalí paints *Atomic Leda,* for the execution of which he needs the intervention of a mathematician.

1950 January: in New York Dalí publishes a *Memorandum,* by way of reply to the book written by his sister, Anna Maria. November: first night of Zorrilla's *Don Juan Tenorio* at the Teatro María Guerrero in Madrid, with scenery and costumes by Dalí. His *Madonnas of Portlligat* are shown at the Carstairs Gallery in New York. He also illustrates Maurice Sandoz's *La limite.* Besides numerous drawings inspired by religion or mythology, he paints *Landscape of Portlligat* and *Dalí at the Age of Six, when he Thought he was a Girl, Lifting the Skin of the Water to see a Dog Sleeping in the Shade of the Sea.*

1951 April: Dalí finishes the editing of the *Mystical manifesto.* June: exhibition at the Galerie A. Weil in Paris. September: Gala and Dalí dress up as seven-metre-high giants to attend the ball given by Carlos de Beistegui at the Palazzo Labia in Venice. They are accompanied by Christian Dior, in identical costume. December: Dalí arrives in New York. In the course of this year he has painted his *Christ of St John of the Cross* and *Raphaelesque Head Bursting.*

1952 Dalí explains the elements of his nuclear mystique in the course of a tour that takes him to seven cities in the United States; at the same time he announces for the future, thanks to this new nuclear art, an Assumption of the Blessed Virgin. May: he writes *Authenticity and falsehood,* an article in which he violently declares his opposition to 'socialist realism.' He presents the work entitled *Assumpta Corpuscularia Lapislazulina* at the Carstairs Gallery. Throughout this period Dalí's attention is divided between his 'mystical nuclear art' and the 102 watercolours that constitute the series entitled *La Divina Commedia,* illustrating Dante's work. Also in this period he paints the *Nuclear Cross* and *Galatea of the Spheres.*

1954 A major retrospective of Dalí's work is presented in Rome (Palazzo Pallavicini), Venice and Milan successively. On the occasion of a press conference Dalí emerges from a 'metaphysical cube' to inform the public of his 're-naissance.' The fruit of his close collaboration with the photographer Philippe Halsman, the book entitled *Dalí Moustache,* is now finished and later published. Dalí and Robert Descharnes start shooting the film *Histoire prodigieuse de la dentellière et du rhinocéros,* the montage of which is soon under way. The *Discurso sobre la figura cúbica* of Juan de Herrera, architect of the Escorial, gives Dalí the guide-lines he needs for the painting of his *Crucifixion ('Hypercubic Body').* Throughout

this period he also spends much time on painting the *Rhinoceros Disintegration of Phidias' Illusus.* His obsession with the rhinoceros' horn (constructed in accordance with a perfect logarithmic spiral) is by now quite evident.

1955 May: Dalí uses his paranoiac-critical method to interpret Vermeer's *The Lacemaker* at the Vincennes Zoo. December: he arrives at the Sorbonne in his white Rolls Royce, previously filled with cauliflowers, to give a lecture on 'Phenomenological aspects of the paranoiac-critical method.' During this period he paints *The Last Supper* (which is to be bought for the Washington Gallery collection) and the *Paranoiac-critical study of Vermeer's Lacemaker.*

1956 Dalí has an interview with Franco in the Palace of El Pardo. Publication of his treatise on modern art, *Les cocus du vieil art moderne.* In an article entitled *Will Dalí murder modern art?* published in 'Arts' (12-9-1956), Alain Jouffroy writes: 'Everything Salvador Dalí says or does, and almost everything he paints, has at least the merit of annoying, disturbing and irritating all those who think that modern art has its laws and its limits, and who do not intend to have their convictions questioned (...). For twenty-five years now Dalí's work has been going against the stream of everything that is called "painting" and tending to the devaluation of what has formed contemporary taste: Cubism, Abstract Art, Expressionism (...). He does not conceal but, on the contrary, proclaims his deep-felt desire *to murder Modern Art.* We should not be deceived, however, by the humorous, delirious tone of his proposals. Dalí is serious, profoundly serious, and that *absolutely* First-rate intelligence that he was recognized as having by A. Breton in 1936 has been pressed into the service of a destructive activity at the expense of the prestige of "modern art."' July: retrospective of Dalí's work at the Casino of Knokke-le-Zoote, Belgium. December: using rhinoceros horns, he does one of the lithographs for his *Don Quixote* series in a street in Montmartre, under the eyes of the lithographer Charles Sorlier and an astonished public. Another of the lithographs for this series is done by means of ink-filled eggs. In this period he paints the following works: *Rhinoceros Gooseflesh, Living Still Life* and *Zurbarán's Skull.*

1957 The fifteen lithographs of the *Don Quixote* series are presented to the public at the Musée Jacquemart-André in Paris.

1958 Throughout this and the following year Dalí continues to explore the painting of the past (especially the work of Velázquez) and the religious and historical themes of western civilization. He also initiates his 'optical' art, incessantly seeking all sorts of optical effects and illusions, and at the same time begins to talk about Heisenberg's 'Cosmic Glue.' 8th August: Dalí and Gala are married religiously at the 'Chapel of the Angels' in Montrejic, Spain. November: Dalí is presented — by the Cuban ambassador in Paris — with the *Médaille à la Qualité Française* for his illustrations of *Don Quixote.* December: exhibition at the Carstairs Gallery. In this period he paints *Saint James the Great, The Dream of Columbus* (also called *The Discovery of America by Christopher Columbus), Ear with Madonna, Velázquez Painting the Infanta Margarita, Surrounded by the Lights and Shadows of Her Own Glory* and *Virgin of Guadalupe.*

1959 Dalí visits Pope John XXIII. Olivier Merlin, in 'Paris Match' (16-5-1959), says of this visit: 'At the beginning of the month Dalí was granted an audience by the Pope in the Vatican and informed him of his latest great project: a cathedral containing all the symbols of a united Christianity: Orthodox, Catholic, Protestant (...). It will be built, they say, 30 centimetres from the ground on a pear-shaped ball representing the true shape of the earth, as it has been revealed to us by the American satellite "Vanguard (...)"' For Salvador Dalí this pear shape represents various symbols: the Resurrection in the Middle Ages, the power of development, the prefiguration of the ecumenical council and the moral unity of the world.' After some lectures given in London and Paris, plans for a review ('Rhinocéros') with Skira and the magnificent execution of some of the plates intended to illustrate the *Apocalypse of Saint John,* at the Crystal Palace in December Dalí presents the *Ovocipede,* a revolutionary means of transport consisting of a hollow plastic sphere with room for one passenger. He later does illustrations for Pedro Antonio de Alarcón's *Three-cornered Hat.*

1960 February: private presentation in New York of his work *The Discovery of America by Christopher Columbus.* May: the Surrealists write the article *We don't ear it that way,* against Dalí's participation in an international exhibition of

Surrealism in New York. December: presentation, at the Carstairs Gallery in New York, of Dalí's *Ecumenical Council* (done in the *quantified realism* technique, according to which the quantum of action is 'no more than the non-figurative experiences that the abstracts may have contributed to the great tradition'). He starts work on *The World of Salvador Dalí* with Robert Descharnes. Meanwhile his interest in Mariano Fortuny is renewed, finding concrete expression in *The Battle of Tetuán.* Also in this period he paints *Gala Nude from Behind Looking in an Invisible Mirror* and *Hyperxiological Sky.*

1961 First performance, in Venice, of the *Ballet de Gala,* with Ludmilla Tcherina (scenography, settings and costumes by Dalí; choreography by Maurice Béjart) and Scarlatti's *The Spanish Lady and the Roman Gentleman.* The 'Drawing-room of the Egg' is the latest of the rooms added to Gala and Dalí's house in Portlligat; it is entirely Gala's creation and is dedicated to the myth of Leda.

1962 From now on Dalí tends increasingly to concentrate on, and summarize, different themes and techniques of his past career, which he examines and works out again, echoing both the results of American Pop Art and the most recent technical and scientific discoveries (Crick, Watson and Wilkins are awarded the Nobel prize for their research on deoxyribonucleic acid, the 'molecule of life'). October: he finishes *The Battle of Tetuán* and shows it in Barcelona, alongside Fortuny's famous picture of the same name. Robert Descharnes publishes his monograph *Dalí de Gala,* which is presented in December; on this occasion Dalí uses 'oscillograms' in signing copies, so that the recipient of each dedication may measure the exact degree of the bond between the painter and himself. In this year he paints the *Christ of the Vallès.*

1963 Exhibition of Dalí's most recent works at the Knoedler Gallery in New York. Publication of his book *The Tragic Myth of Millet's Angelus,* written in 1933, the original of which had been mislaid. It is very favourably received by the press. He paints *Portrait of his Dead Brother* and *Galassdellaidesossiribonucleica,* and Crick and Watson's double spirals, models of molecular structure, begin to appear in his work.

1964 Dalí is decorated with the Grand Cross of Isabel la Católica. May: publication of *Diary of a Genius.* July: 'Playboy' publishes a long interview with Dalí in which he explains the meaning of his soft watches: 'The soft watches constitute, moreover, a prefiguration of Christ, for they resemble the cheese with which I was obsessed: Dalí has realized that the body of Christ is like a cheese. But Dalí is not the only one who is of this opinion. The first to realize it was St Augustine, who compared the body of Christ to piles of cheese. All I have done is to re-introduce the concept of cheese in the body of Christ. In the Holy Communion the body and the blood are symbolized by the bread and wine. In the same way in my work the soft watches, like soft cheese, are the presence of the body of Christ.' He also explains the meaning of the rhinoceros and the crutches. September: a major retrospective show of Dalí's work in Tokyo, organized by the 'Mainichi Newspaper.'

1965 The Gallery of Modern Art in New York offers the public the most important of all Dalí retrospectives held to date, including for the first time pictures from Reynold Morse's private collection. December: the Knoedler Gallery presents Dalí's latest work, his 'best work to date,' according to his own statement. This is *Pop-op-yes-yes-pompier,* also known by the name of *The Station at Perpignan.* The Albin Michel publishing house is to sign a contract with Dalí by the terms of which the painter undertakes to write, for the *Lettre ouverte* collection, an *Open letter to Salvador Dalí.* He also does a series of 100 watercolours intended to illustrate the Bible and a series of pen-and-ink drawings for *Las Metamorfosis Eróticas.* He begins to develop an interest in holography and three-dimensional art. Among the works painted during this period are *The Apotheosis of the Dollar* and *Gala contemplating Dalí in a State of Weightlessness over his Work of Art Pop-op-yes-yes-pompier.*

1966 He designs an envelope for the United Nations on the occasion of the twentieth anniversary of the World Federation of United Nations Associations, and a sundial which is later placed on No. 27 in the rue Saint Jacques, Paris. During this summer Jean Cristoph Avery begins making *Portrait mou avec du lard grillé,* shown on French television in 1972. 'Le Monde' publishes an interview with Dalí, in which he gives the reason behind this *Portrait:* 'Soft on account of the attraction Salvador Dalí feels towards soft things (life is soft, and

everything living; everything that is hard is inert, dead). With bacon because there are a lot of pigs in the film, for the pig is the softest of animals, the most eatable. Salvador Dalí believes himself to be a pig; he says that it is the only animal that charges straight at ghosts and deliria.' During this year and the following one Dalí paints *The Tunny Catch,* one of his most important pictures.

1967 November: Dalí presents *The Tunny Catch* at the Hôtel Meurice, on the occasion of an exhibition in homage to Meissonier, which includes works by Meissonier himself, Neville, Moreau, etc. In the same hotel Dalí gives a lecture on Karl Marx to the pupils of the E.S.S.E.C. He also carries out two design commissions: for *Puiforcat* he designs a pack of cards and for *Air India* an ashtray, the main motif of which is a swan being transformed into an elephant. In the same month he receives an honorary doctorate from the Académie de la Fourrure.

1968 May: publication of *Les Passions selon Dalí,* a book written by Dalí and Louis Powell. Later this year the book *Dalí de Draeger* is published and is launched at a big party in the Draeger atelier. The 'events of May' in France give Dalí occasion to write a pamphlet entitled *My cultural revolution,* in which he highlights opposition to bourgeois culture as a virtue and speaks of the need to add a modicum of libido to anti-pleasure organizations like UNESCO and of the possibility of turning that 'home of super-tedium' into a true erogenous zone under the auspices of St Louis, the first man to legislate on matters of venal love. He ends with the famous words: 'Wherever the cultural revolution passes, the fantastic is sure to spring up.' During this and the following years he is to do several sculptures in glass, such as *Cyclops, Fleur du Mal* and *What Matters is the Rose,* while gathering notes for his book *The Art of History.*

1969 Publication of *Las Metamorfosis Eróticas,* one of the high points of his paranoiac-critical method. July: Dalí writes a special report for 'Paris Match' on Paris and Barcelona, an interesting passage in which says: 'S. Dalí sees in Gaudí an antidote to the most baneful poison of our age: Le Corbusier. According to him, the architecture of the future will not be either clinical or functional in the style of the Protestant Le Corbusier. It will be "soft, hairy," like that of Gaudí, Catholic, Apostolic and Roman.' He works on commercial posters for the firms of *Perrier* (on the theme of thirst) and *Lanvin* chocolates. December: he is invited to be the guest of honour at an 'Articled Lawyers' Conference' in France, the theme proposed being: 'If an artist attributes the merit and originality of his work to the paranoiac state in which he considers himself to exist, has he grounds for bringing an action for libel against a journalist who has maintained in an article that the said artist's career is the soundest possible proof of moral health?' On being asked how Dalí conducted himself after his introductory contribution (he arrived very late, accompanied by a bizarre and ambiguous retinue), the secretary of the conference, Philippe Bern, replies: 'Well, he listened attentively to the speeches. But to return to his introductory contribution, I may tell you that it was longer than anyone expected. He proclaimed himself "an anarchist, a monarchist and an enemy of the consumer society," ending rather unexpectedly by declaring that, "since eloquence is quite impossible in any language but Catalan, the language of Ramon Llull," he felt he should recite a "genetic" poem in that language. So he recited a poem in Catalan which nobody understood — but, it must be admitted, in tones worthy of Sarah Bernhardt.' It is at this time that he paints the *Portrait of Gala.*

1970 The exhibition held at the Knoedler Gallery at the end of 1969 arouses great interest in the American press. Dalí announces the forthcoming creation of the Dalí Museum in Figueres and at the same time proposes the establishment of a Museum of Surrealist Objects, to which he would donate fifty exhibits of his own. He does six posters for the French Railways and signs copies of the book *Dalí por Dalí de Draeger* at the newly-opened shop *Brummel du Printemps.* November: the Boymans-van Beuningen Museum in Rotterdam organizes the first of the major Dalí retrospectives to be held in Europe, including the E.F.W. James Collection. Dalí continues to explore three-dimensional art and studies the work of the Dutch painter Gerard Dou, a contemporary of Vermeer, in whose canvases he discovers double (i.e. 'stereoscopic') images. It is at this time that he begins to work with a Fresnel lens to create such images. He finally completes his painting *Hallucinogenous Bullfighter* and the *Death Mask of Napoleon* in ormolu. He works on the preliminary project for the Dalí Museum in Figueres with the Spanish architect Emilio Pérez Piñero.

1971 Formal opening of the Dalí Museum in Cleveland (Ohio), consisting largely of the Reynold Morse Collection. He dedicates a set of chessmen, made from casts of teeth and fingers, to Marcel Duchamp; at the same time he does work for various magazines, such as 'Vogue' and 'Scarab.' He also does the preliminary studies for the ceiling of the Museum in Figueres. Meanwhile he is becoming more and more interested in holography, and this interest increases still further when Dennis Gabor is awarded the Nobel prize for his work on lasers. Gabor is to advise Dalí on the preparation of three holographical compositions in the course of the following year. November: important exhibition of engravings, entitled 'Homage to Dürer,' at the Galería Visión. Publication of *Oui!,* the first anthology of texts written by Dalí.

1972 Exhibition of holograms at the Knoedler Gallery in New York. Robert Hughes, writing in 'Time,' describes this initiative as *pseudoscientific* and says: '... Dalí has simply used a new medium to transmit his old mannerisms.' August: Salvador Dalí announces the donation of all his works to the Spanish State (meaning all the works that belong to him, whether painted by him or not). He does illustrations for Boccaccio's *Decameron.*

1973 At the Hôtel Meurice Dalí presents his first *Chronohologram.* April: the Knoedler Gallery opens a 'Dalinian Holographic Room'. Publication of *Dix recettes d'immortalité* and, for the first time in French, of *Visages occultes* and *Comment on devient Dalí.* Draeger publishes *Les dîners de Gala.* 22nd June: presentation at the Musée d'Art Moderne de la Ville de Paris of André Malraux's *Roi, je t'attends à Babylone,* with 14 illustrations by Dalí, published by Albert Skira.

1974 Publication of *50 Secrets of Magic Craftsmanship.* March: retrospective at the Städel Museum in Frankfurt-am-Main. Publication of *Comment on devient Dalí.* Of this book Didier Lecoin writes, in 'Les Nouvelles Littéraires' (18-3-1974): 'A beautiful book. False and sincere at the same time. A book on two levels, a concerto for two voices.' 28 September: opening of the Dalí Museum-Theatre in Figueres; besides a varied exhibition of Dalí's genius, it possesses works by Ernst Fuchs, Arno Breker and Antoni Pitxot. At this time, too, he paints *Ruggiero Freeing Angelica, Transformation, Anchorite, Figure from Behind, Explosion of Faith in a Cathedral, Angels Contemplating the Ordination of a Saint* and *Battle of Clouds.*

1975 January: presentation in Avoriaz of the first part of the film *Voyage en Haute Mongolie,* made by Dalí. Exhibition, sponsored by Nikkon, of photographs by Robert Descharnes and Marc Lacroix on the theme of 'Dalí, paranoiac-critical method, objective randomness and third dimension,' the photographs having been taken following initiatives of Dalí himself.

1976 October: Dalí deposits a copy of his book *L'Alchimie des Philosophes* at the National Library in Paris. In the same month the review 'Sauvage' publishes, under the title *Les Mandalas de Dalí,* a conversation with the painter which may be considered one of the most incisive talks with Dalí ever published.

1977 May: a retrospective show of Dalí's work at the 22nd Salon de Montrouge. November: François Petit presents *The Station at Perpignan* in Paris, together with a selection of the artist's earlier and more recent works.

1978 April: at the Guggenheim Museum in New York Dalí presents his first hyper-stereoscopic work: *Dalí Lifting the Skin of the Mediterranean to show Gala the Birth of Venus.* May: Dalí is elected a foreign associate member of the Académie Française des Beaux-Arts. July: Dalí initiates conversations with the writer Ignacio Gómez de Liaño on the Museum-Theatre of Figueres, interpreted in the light of what is known of Giulio Camillo's *Theatre of Memory* and Ramon Llull's *Combinatorial Wheels.* In the course of these conversations, which are prolonged in succeeding years, Dalí's famous picture *The Persistence of Memory* is interpreted as the paradigm of the Golden Fleece. August: King Juan Carlos and Queen Sofia of Spain, with their son, the Prince of Asturias, visit the Museum-Theatre of Figueres accompanied by Dalí and his wife. September: Dalí is presented with the Gold Medal of Figueres. December: on the occasion of an exhibition in homage to Claude Lorrain at the Hôtel Meurice, François Petit presents *Dalí's Hand Drawing Back a Golden Fleece in the Shape of a Cloud to show Gala the Naked Dawn very, very far behind the Sun.* At this period Dalí also paints *The Harmony of the Spheres, Cybernetic Odalisque, Lunar Pierrot, The Christ of Gala* and *In Search of the Fourth Dimension,* which he concludes in the following year.

1979 May: at the Hôtel Meurice Dalí receives from Louis Weiler the academician's sword, designed by the artist himself. On the following day, under the dome of the Institut de France, he reads his Academy admission speech, entitled *Gala, Velázquez and the Golden Fleece*. Among other subjects, he speaks of the ADN, Heisenberg, Leibnitz, Descartes, R. Thom, Eugenio Montes and the Theatre of Memory. December: opening of a retrospective show of Dalí's work and of its setting, *La kermesse héroique*, specially designed for the Centre Georges Pompidou in Paris. The pictures *Raphaelesque Hallucination* and *The Pentagonal Sardana* are painted at this time.

1980 Spring: another major retrospective of the work of Salvador Dalí is held at the Tate Gallery in London. October: Dalí delivers at the Zarzuela Palace in Madrid his portrait of the King of Spain, to which he has given the title *The Dream Prince*, a singular work done in a blend of various techniques: surrealism, hyper-realism, cybernetics, anamorphism, etc. In this year, too, he paints *The Gay Horse*, now in the Museum of Figueres, a picture full of expressiveness and dramatic force, in which one sees some offal with flies and the Empordà countryside.

1981 Dalí recovers slowly from an illness contracted in New York during the winter, which is aggravated by the weariness that is the result of the intensely active life led by the artist over the last few years. August: he is visited at his house in Portlligat by King Juan Carlos and Queen Sofía of Spain, who express their concern about his health and their hope that he will live many years longer to work for Spain. September: Dalí, ever more retired from social life in his Portlligat house, pays a visit to the Museum-Theatre in Figueres and resumes his artistic activities with the themes of the Llullian Wheels and the Golden Fleece.

1982 In his retreat in the Empordà he paints several pictures which represent a fresh working-out of some themes of his own and of others taken from Velázquez and Michelangelo. February: opening of an exhibition entitled 'The literary cycles of Salvador Dalí' in the Tiepolo Room of the Caja de Ahorros (Savings Bank) of Madrid. March: formal opening of the Dalí Museum of St Petersburg (Florida), founded by Reynold and Eleanor Morse. The Honourable Jordi Pujol, President of the Autonomous Government of Catalonia, personally presents Dalí with the gold medal of that Government.

Gala is twice sent to hospital in Barcelona. 10 June: death of Gala, the artist's companion, muse and model for over fifty years. In a private ceremony on the following day her mortal remains are buried in the grounds of the castle of Púbol, near the village of La Pera in the province of Girona. 16 June: at Púbol Dalí receives a special visit from the delegate of the Spanish Government in Catalonia, Señor Rovira Tarazona, who in the King's name gives him the credential of the awarding of the Grand Cross of the Order of Carlos III, the highest decoration of the Spanish State. On the same afternoon he is visited by the Director General of Fine Arts, Señor Pérez de Armiñán, and the Assistant Director General of Plastic Arts, Señora Beristain, for the signing of the protocol for the great anthological exhibition of Dalí's work which is to be held in Barcelona and Madrid in the coming months. The signatories to this protocol on Dalí's side are Antoni Pitxot, Robert Descharnes, Miquel Domènech and Ignacio Gómez de Liaño.

The last pictures painted by Dalí in the months of May and June are *The Three Glorious Enigmas of Gala* and *Rome*. In the first we see, in a flat, grey landscape with tinges of iridescent colours and reflections, three objects repeated in the form of a Gaudí balustrade or like prehistoric megaliths, which in fact correspond, as double-images, to three outlines of Roman heads at an angle of ninety degrees. In the second picture this motif is accompanied by another of a sacrificial type which is related to the theme of *Martyr*, the unfinished tragedy on which Dalí has been working for several years. On July 10 Dalí voluntarily decides to retire to the castle of Púbol, on account of his illness and his state of dejection. Here he continues his painting activities until he finally gives them up early in 1983.

1983 On April 15 the King and Queen of Spain open the anthological exhibition '400 works by Salvador Dalí, from 1914 to 1983' at the Spanish Museum of Contemporary Art, Madrid. The same exhibition, now including *Corpus hypercubus* and four oil paintings from the Reynolds Morse collection, is presented in Barcelona on July 10 at the Royal Palace of Pedralbes, and opened by Jordi Pujol, President of the Generalitat, and Javier Solana, Minister of Culture.

1984 On March 27 the official opening of the Gala-Salvador Dalí Foundation takes place in Figueres. The act is presided over by Jordi Pujol, President of the Generalitat. Early in the morning of August 30 Dalí suffers burns from a fire that beaks out in his bedroom in the castle of Púbol. He is taken to a hospital in Barcelona the Pilar Clinic, where surgeons operate on him. During his period of convalescence he is visited by a number of personalities, among them the President of the Generalitat. Doctor García Sanmiguel, in charge of the medical team treating the artist, decides to install a naso-gastrical probe so that Dalí might be properly fed. On October 17 Dalí is transferred to the Torre Galatea in Figueres, where major alterations have been carried out in order to house him.

1985 On March 28 the members of the Honorary Committee of the Gala-Salvador Dalí Foundation are received by the King and Queen of Spain. Dalí's collaborators deliver the following message from the painter: 'Your Majesties, Spain is a bloody thorn; the King, a sublime crown of Spain. Saint Teresa and Nietzsche believed that if a work is to become eternal, it must be written in blood. Our blood and Gala's.'

1986-1987. He remains practically isolated, the only people with access to him being his medical team and his closest collaborators, who are entrusted with the task of informing the public about everything concerning the artist. Despite his pacemaker, Dalí suffers two more heart attacks during this period.

1988 In November his condition worsens and on the 28th of the month he is rushed to the Quirón Clinic, Barcelona. In hospital, Dalí is visited by the King, to whom he gives a book of poems written by himself. He recovers sufficiently to be back in the Torre Galatea for Christmas.

1989 He suffers another heart attack, as a result of which he dies on January 23 in a Figueres clinic. He is embalmed and buried beneath the dome of the Dalí Museum-Theatre.

1. *Crepuscular Old Man.* 1917-1918.
 Oil on canvas with sand, 50×30 cm.
 Ramon Pitxot Soler Collection, Barcelona.

1

2

2. *Grandmother Anna Sewing*. C. 1917.
 Oil on sackcloth, 46 × 62 cm.
 Dr Joaquín Vila Moner Collection, Figueres (Girona).

3. *Self-portrait of the Artist at his Easel in Cadaqués*. C. 1919.
 Oil on canvas, 27 × 21 cm.
 Collection: Mr. and Mrs. A. Reynolds Morse. Loaned to
 The Salvador Dalí Museum. St. Petersburg, Florida.

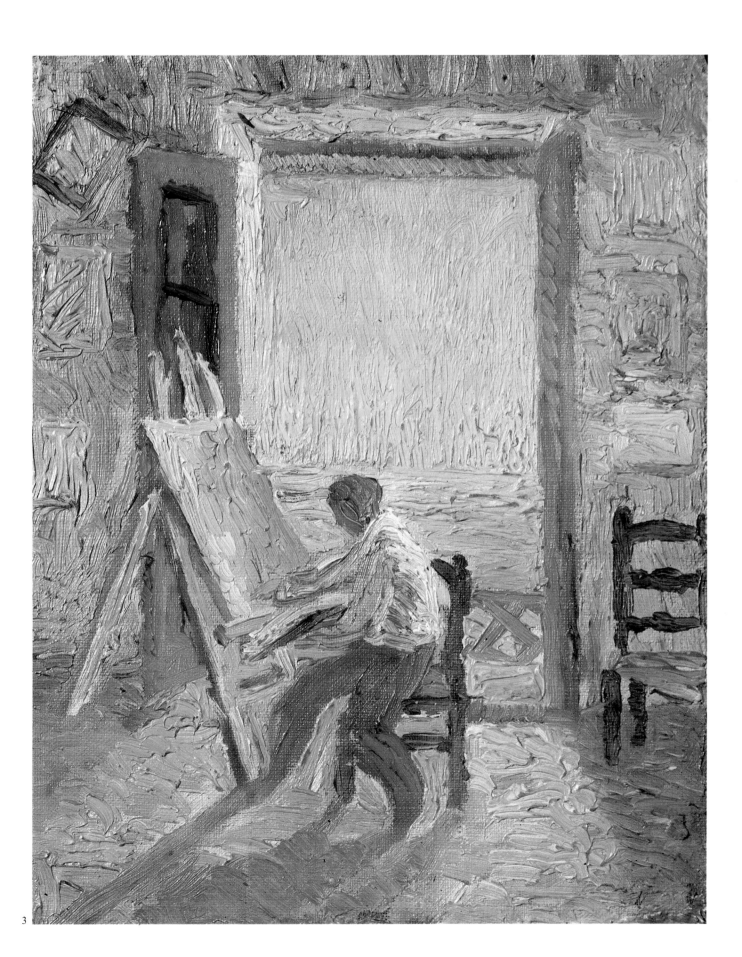

3

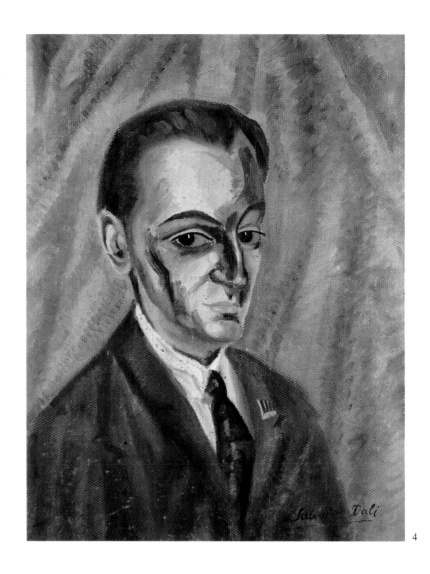

4

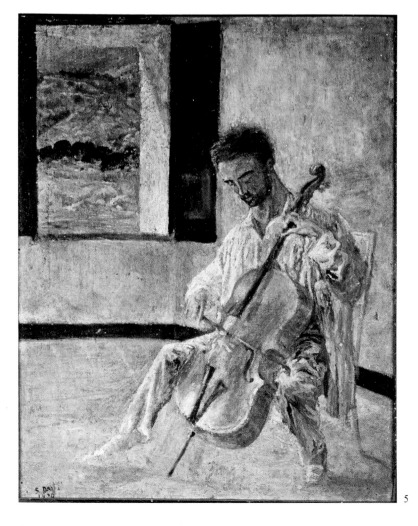

4. *Portrait of José M. Torres.* C. 1920.
Oil on canvas, 49.5 × 39.5 cm.
Museum of Modern Art, Barcelona.

5. *Portrait of the Cellist Ricard Pitxot.* 1920.
Oil on canvas, 61.5 × 49 cm.
Antoni Pitxot Soler Collection, Cadaqués.

6. *Self-portrait with Raphael's Neck.* 1920-1921.
Oil on canvas, 47 × 30 cm.
Private collection, Spain.

5

6

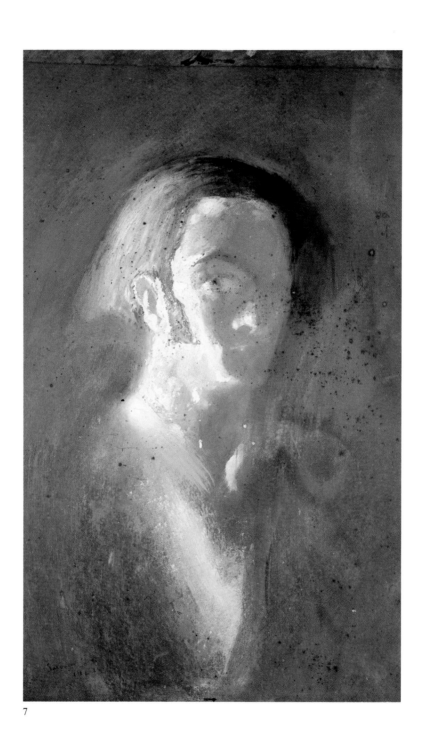

7

7. *Self-portrait.* 1921.
Oil on cardboard, 47 × 30 cm.
Dalí Museum-Theatre, Figueres (Girona).

8. *The Llané Beach at Cadaqués.* 1921.
Oil on cardboard, 63 × 89 cm.
Peter Moore Collection, Paris.

9. *Cadaqués.* 1922.
Oil on canvas, 60.5 × 82 cm.
Montserrat Dalí de Bas Collection, Barcelona.

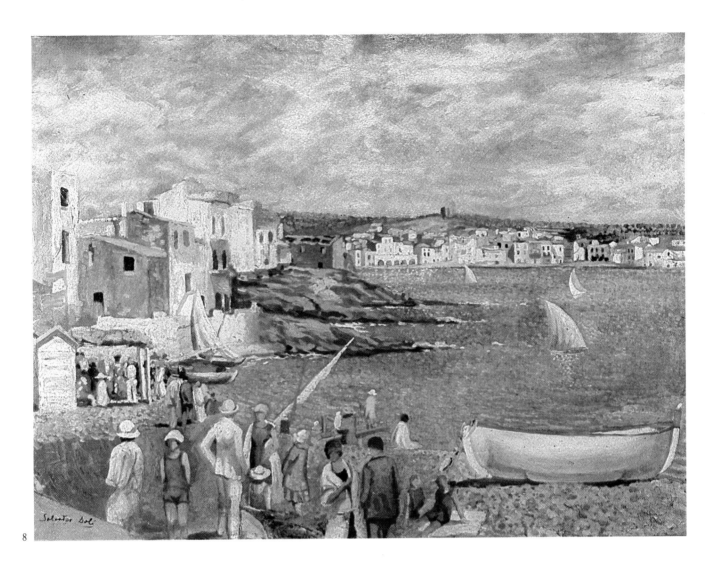

8

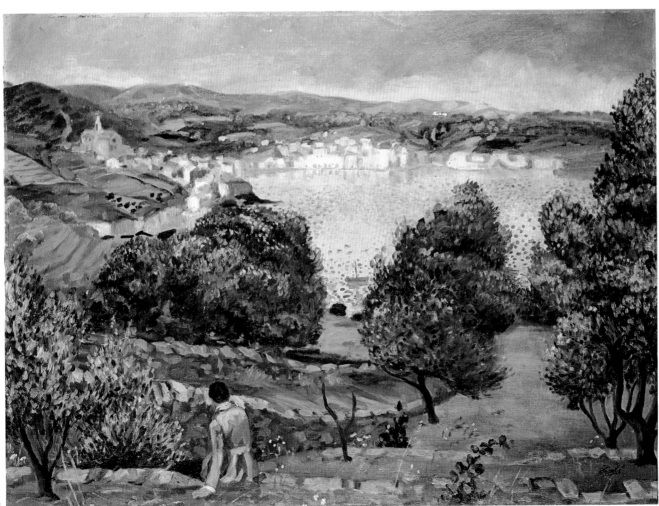

9

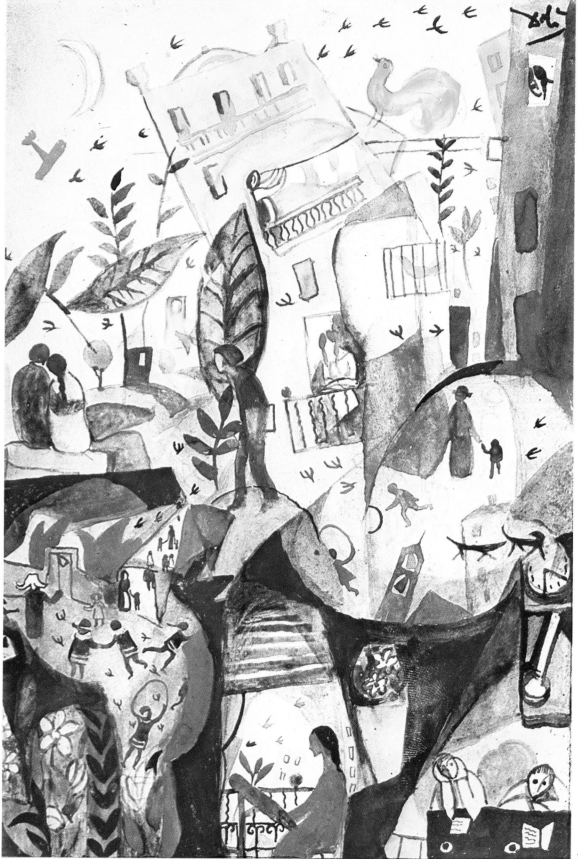

10

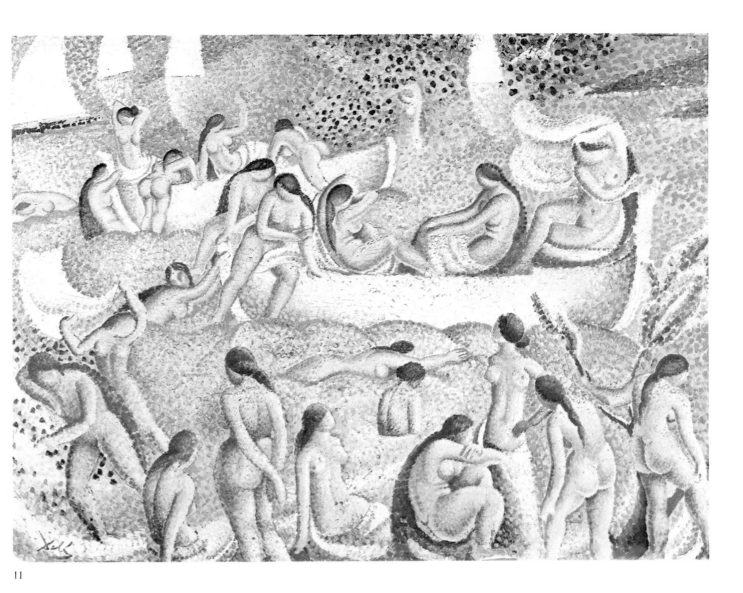

11

12

10. *The First Days of Spring*. 1922-1923.
India ink and watercolour on paper, 21.5 × 14.5 cm.
Private collection.

11. *Bathers at El Llané*. 1923.
Oil on cardboard, 72 × 103 cm.
José Encesa Collection, Barcelona.

12. *Port Alguer*. 1924.
Oil on canvas, 100 × 100 cm.
Dalí Museum-Theatre, Figueres (Girona).

13

14

13. *Anna Maria* (the artist's sister). 1924.
 Oil on canvas.
 Señora de Carles Collection, Barcelona.

14. *Crystalline Still Life.* 1924.
 Oil on canvas, 100 × 100 cm.
 Private collection.

15. *Venus with Amorini.* 1925.
 Oil on wooden panel, 26 × 23 cm.
 Private collection.

16. *Port Alguer.* 1925.
 Oil on canvas, 36 × 38 cm.
 Private collection.

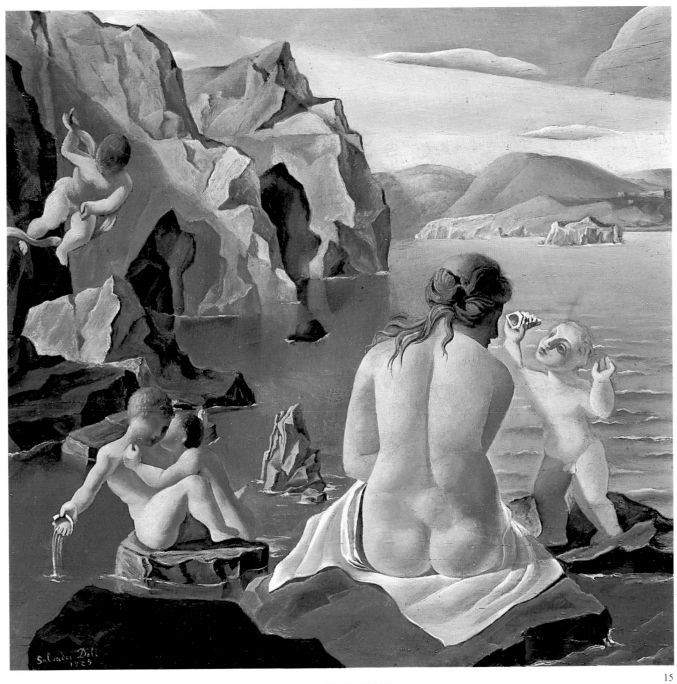

15

16

17. *Seated Girl from Behind* (Anna Maria). 1925.
 Oil on canvas, 108 × 77 cm.
 Spanish Museum of Contemporary Art, Madrid.

18. *Girl Standing at the Window* (his sister, Anna Maria). 1925.
 Oil on canvas, 103 × 74 cm.
 Spanish Museum of Contemporary Art, Madrid.

19. *Bay of Cadaqués.* 1925.
 Oil on canvas, 40 × 52 cm.
 Private collection.

18

19

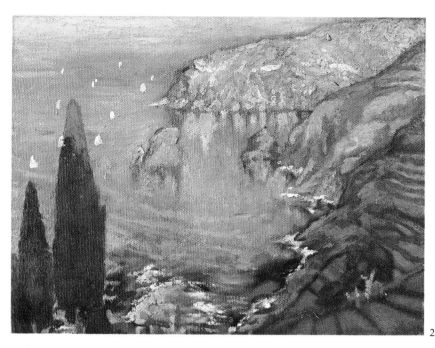

20. *Cala Nans, Cadaqués, Embellished with Cypresses.* 1925.
Oil on canvas, 40 × 50 cm.
Enric Sabater Collection, Palafrugell (Girona).

21. *Portrait of the Artist's Father.* 1925.
Oil on canvas, 104.5 × 104.5 cm.
Museum of Modern Art, Barcelona.

22. *Cliff* (also known as *Woman Sitting on the Rocks.* The landscape is that of Cap Norfeu, in the vicinity of Cadaqués). 1926.
Oil on wooden panel, 26 × 40 cm.
Marianna Minota de Gallotti Collection, Milan.

23. *The Bread-basket.* 1926.
Oil on wooden panel, 31.7 × 31.7 cm.
Collection: Mr. and Mrs. A. Reynolds Morse.
Loaned to The Salvador Dalí Museum.
St. Petersburg, Florida.

20

21

22

23

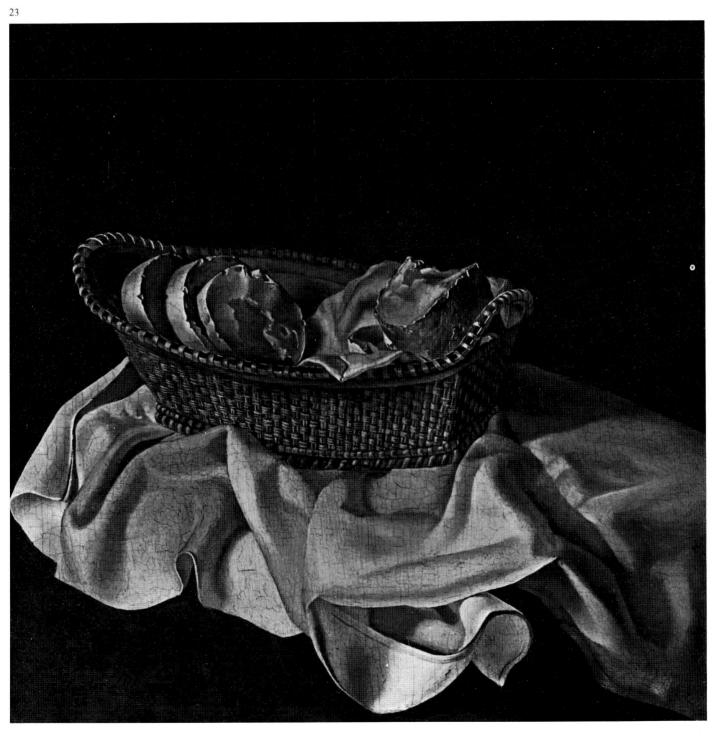

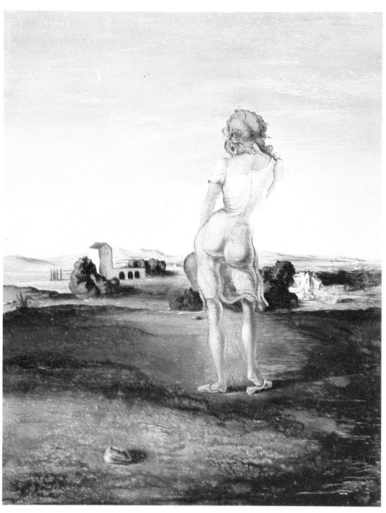

24

24. *The Girl with the Curls (The Girl from the Empordà)*. 1926.
 Oil on plywood, 51 × 40 cm.
 Collection: Mr. and Mrs. A. Reynolds Morse.
 Loaned to The Salvador Dalí Museum.
 St. Petersburg, Florida.

25. *Painting with Sailor*. C. 1926.
 Belitz Collection, New York.

26. *Cubist Self-portrait*. 1926.
 Gouache and collage, 105 × 75 cm.
 Private collection.

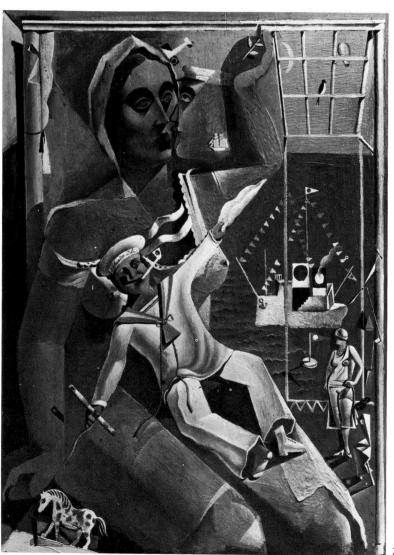

25

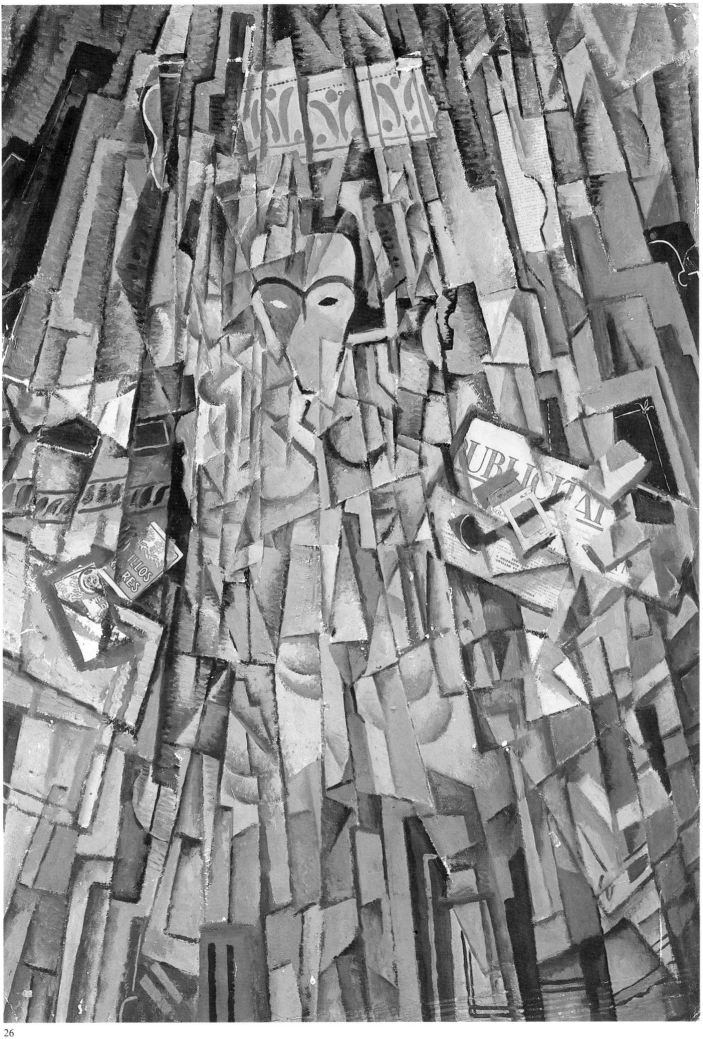

26

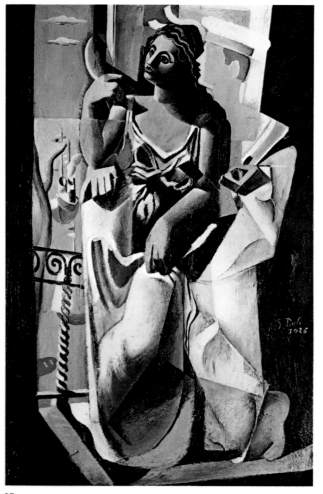

27

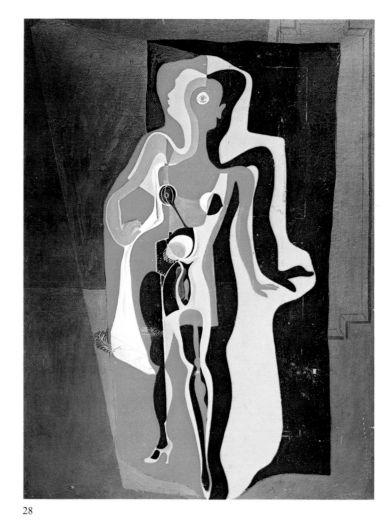

28

27. *Venus and Sailor* (homage to Salvat-Papasseit). 1926.
 Oil on canvas, 216 × 147 cm.
 Gulf American Gallery, Inc, Miami.

28. *The Barcelona Mannequin*. 1927.
 Oil on wooden panel, 198 × 149 cm.
 Private collection, New York.

29. *Senicitas*. 1926-1927.
 Oil on wooden panel, 63 × 47 cm.
 Spanish Museum of Contemporary Art, Madrid.

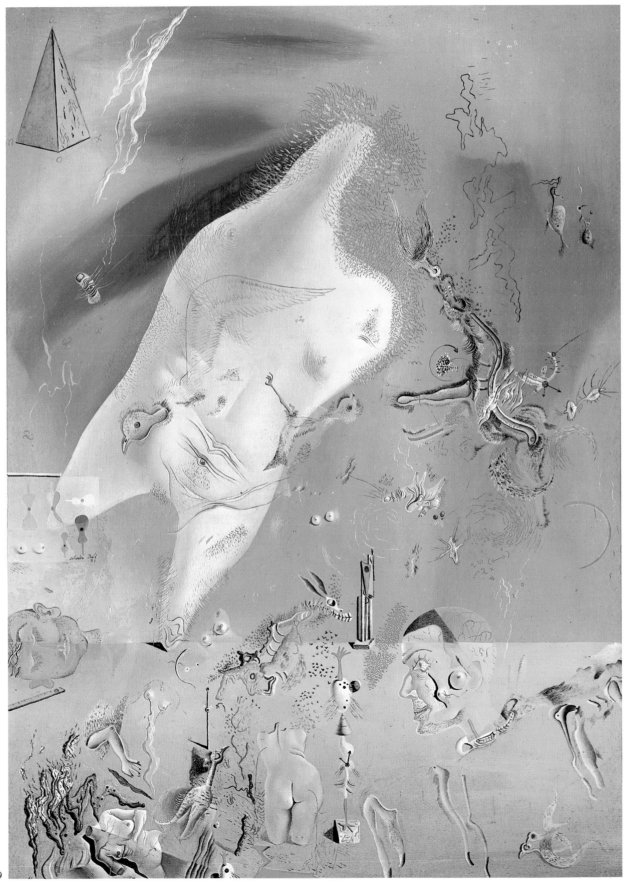

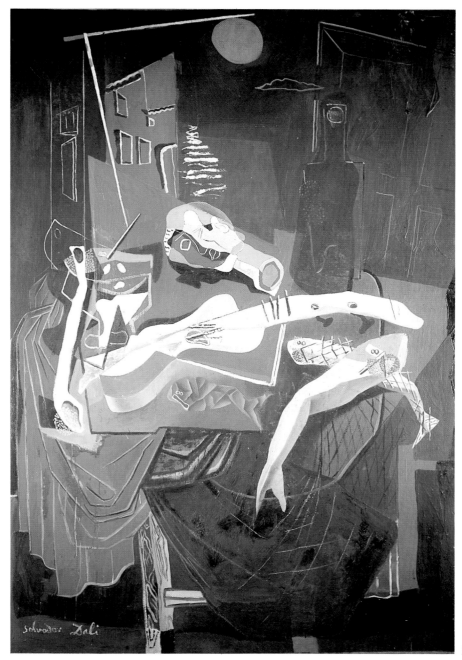

30

30. *Still Life.* 1927.
Oil on canvas, 199 × 150 cm.
Private collection.

31. *Amoeba Face.* 1927.
Oil on canvas, 100 × 100 cm.
Private collection.

32. *Honey is Sweeter than Blood.* 1927.
Formerly in the collection of Mlle Coco
Chanel. García Lorca called this picture
The Forest of the Objects. The work's
original title is taken from a phrase spoken
by Lidia Nogués.

33. *The Putrefied Donkey.* 1928.
Oil on wooden panel, 61 × 50 cm.
F. Petit Collection, Paris.

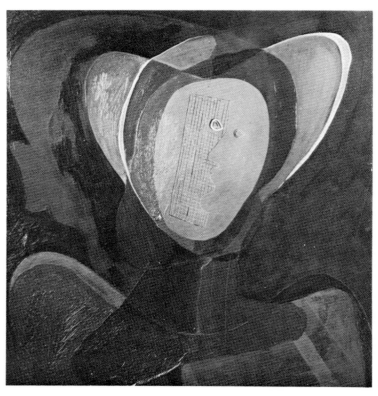

31

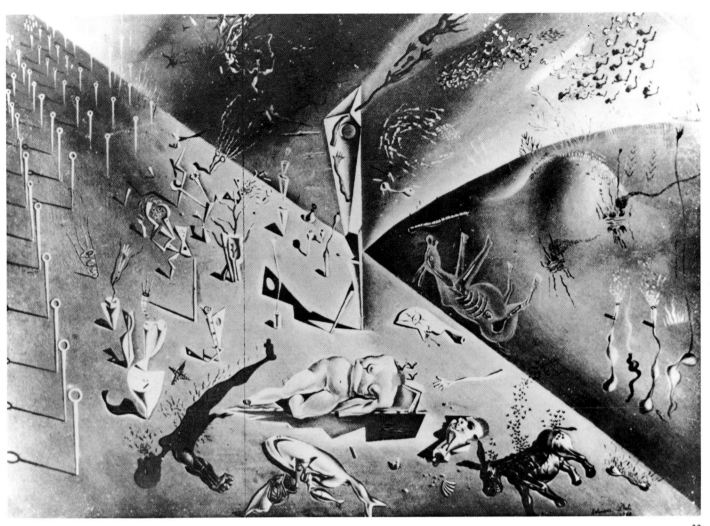

32

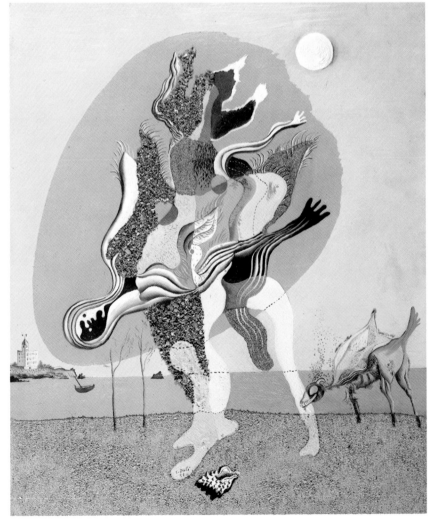

33

34. *Inaugural Gooseflesh*. 1928.
 Oil on canvas, 75.5 × 62.5 cm.
 Ramon Pitxot Soler Collection, Barcelona.

35. *Portrait of Paul Éluard*. 1929.
 Oil on cardboard, 33 × 25 cm.
 Private collection.

34

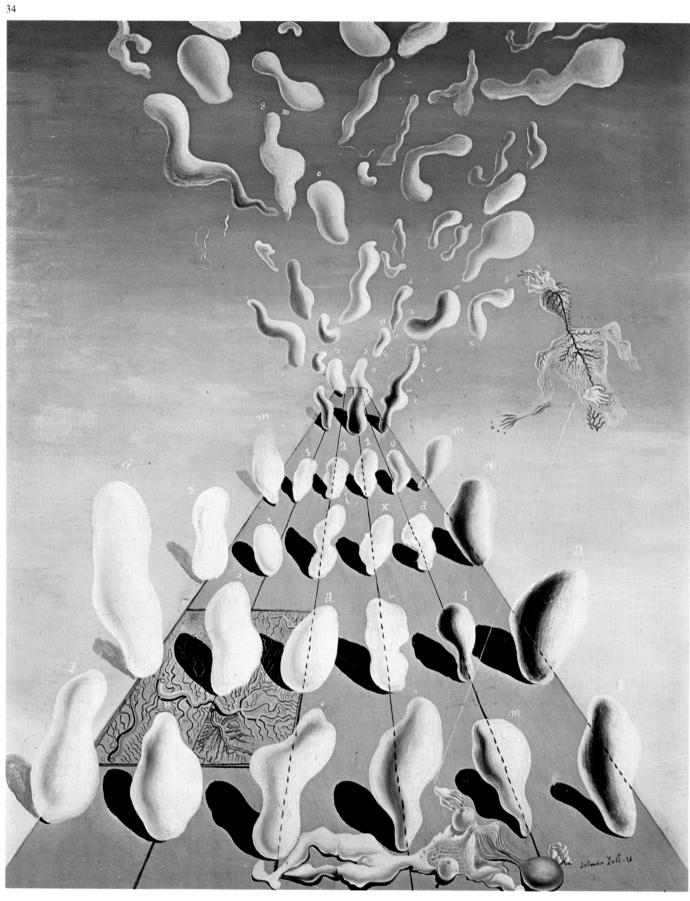

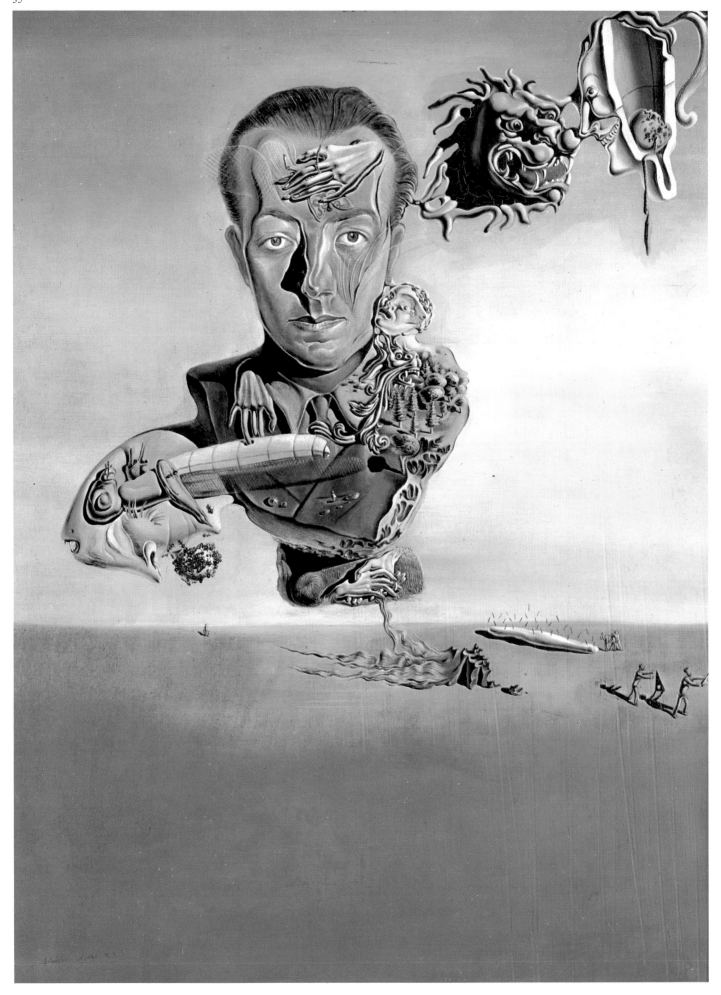

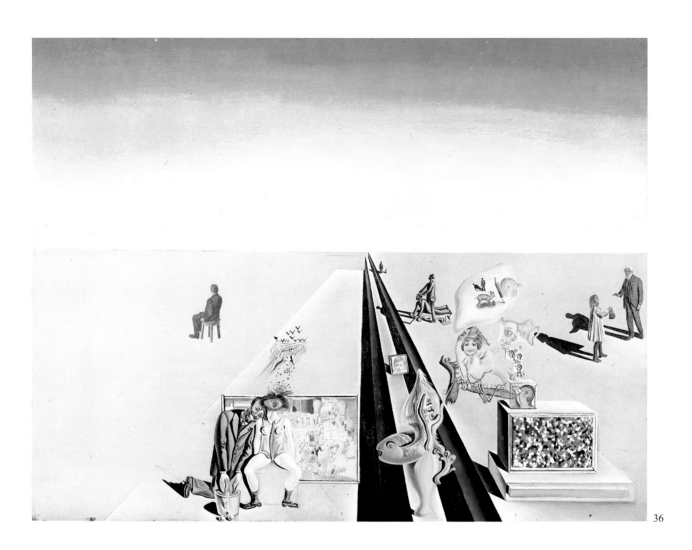

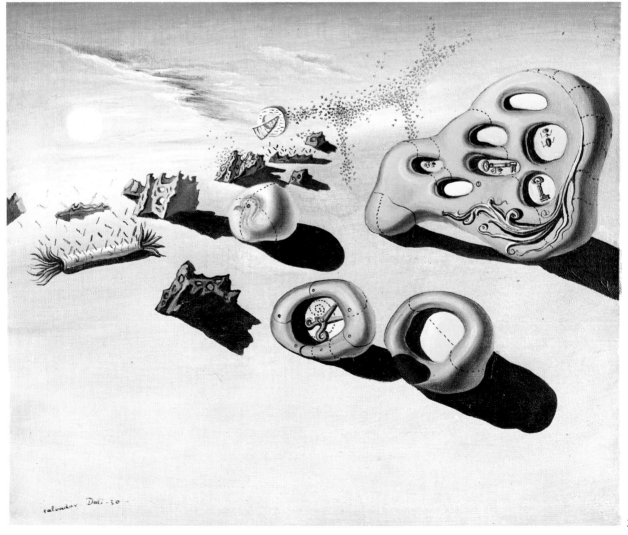

36. *The First Days of Spring*. 1929.
 Oil and collage on wooden panel, 49.5 × 64 cm.

37. *Spectre of the Afternoon*. 1930.
 Oil on canvas, 46 × 54 cm.
 San Diego Museum of Art, San Diego, California.

38. *Vertigo* or *Tower of Pleasure* (detail). 1930.
 Oil on canvas, 60 × 50 cm.

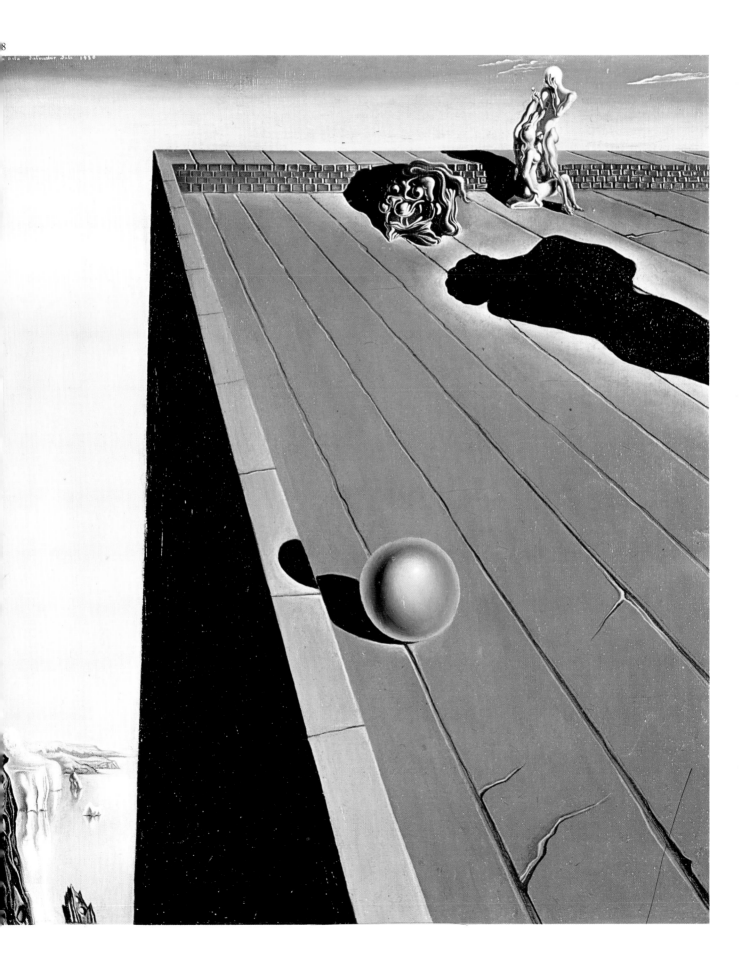

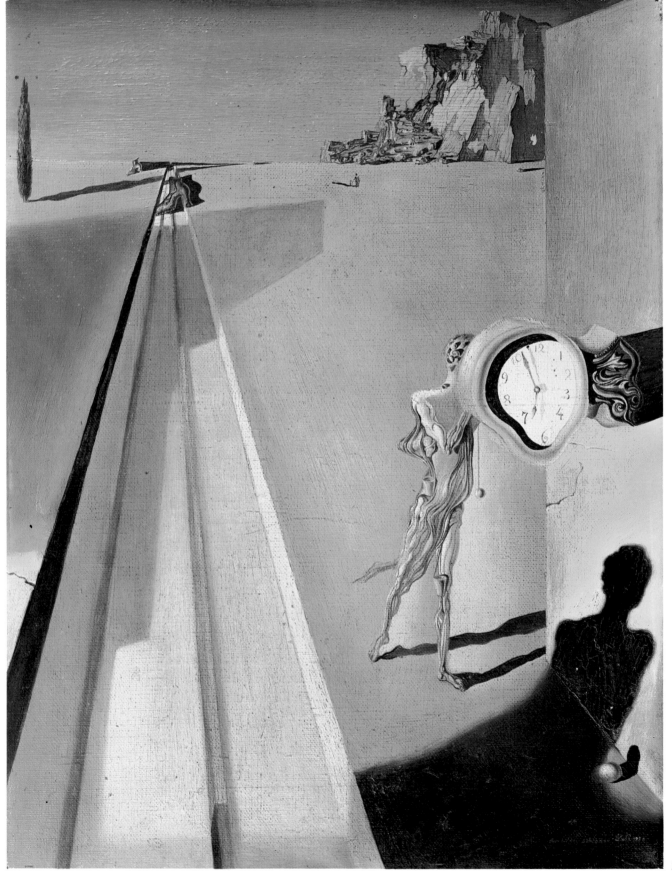

40

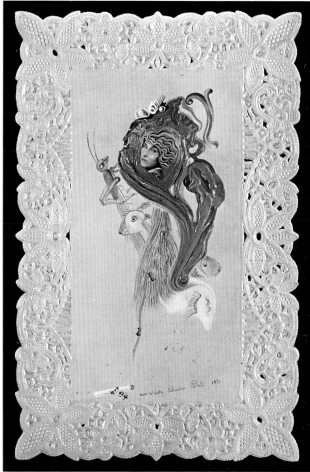

41

42

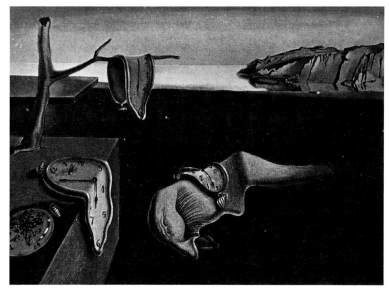

39. *Premature Ossification of a Station.* 1930.
 Oil on canvas, 31.5 × 27 cm.
 Private collection.

40. *Bleeding Roses* (detail). 1930.
 Oil on canvas, 75 × 64 cm.
 J. Bounjon Collection, Brussels.

41. *First Portrait of Gala.* 1931.
 Oil on cardboard, 14 × 9 cm.
 Albert Field Collection, New York.

42. *The Persistence of Memory (The Soft Watches).* 1931.
 Oil on canvas, 26.3 × 36.5 cm.
 The Museum of Modern Art, New York.

43. *Gradiva Finds the Anthropomorphous Ruins.* 1931.
 Oil on canvas, 65 × 54 cm.
 Thyssen-Bornemisza Collection, Lugano-Castagnola, Switzerland.

44. *Shades of Night Coming Down.* 1931.
 Oil on canvas, 61 × 50 cm.
 Collection: Mr. and Mrs. A. Reynolds Morse.
 Loaned to The Salvador Dali
 Museum. St. Petersburg, Florida.

45. *Agnostic Symbol.* 1932.
 Oil on canvas, 54.3 × 65.1 cm.
 The Philadelphia Museum of Art, Philadelphia.

43

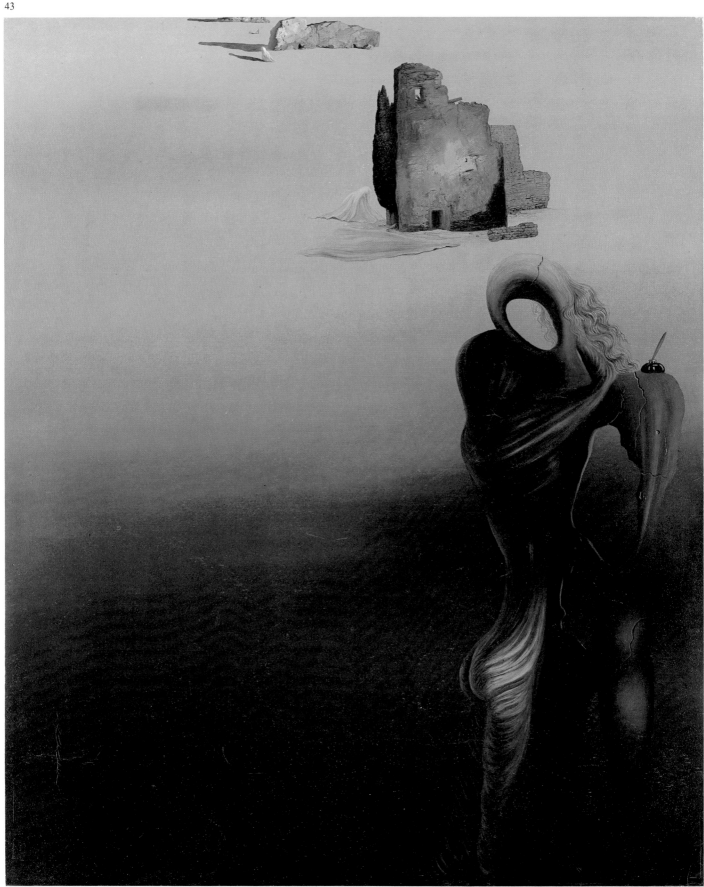

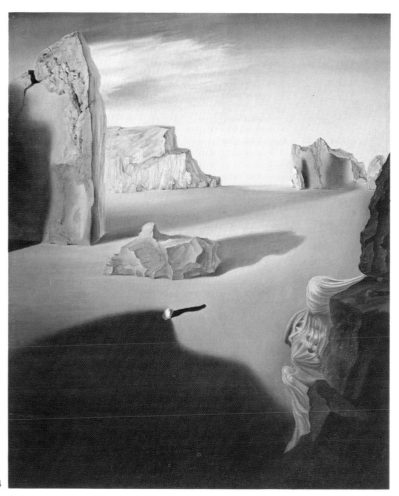

44

45

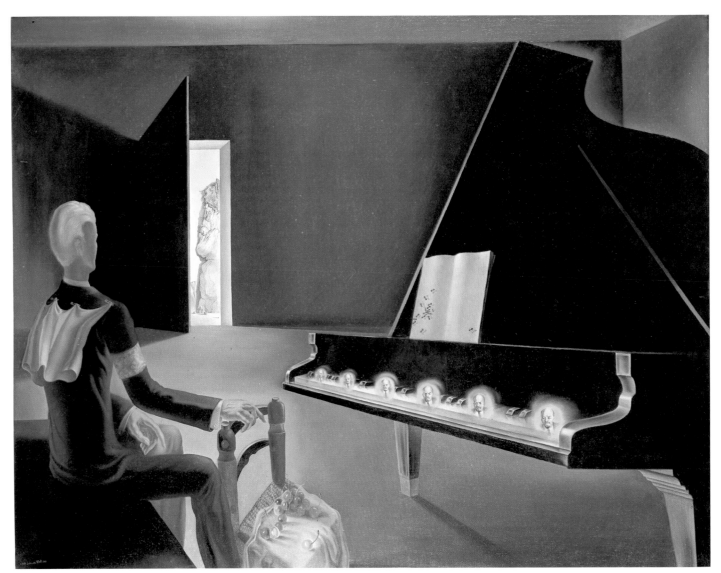

46

46. *Partial Hallucination. Six Apparitions of Lenin on a Piano.* 1931.
Oil on canvas, 114 × 146 cm.
Musée National d'Art Moderne, Paris.

47. *Meditation on the Harp.* 1932-1934.
Oil on canvas, 67 × 47 cm.
Collection: Mr. and Mrs. A. Reynolds Morse.
Loaned to The Salvador Dalí
Museum. St. Petersburg, Florida.

48. *The Invisible Man.* 1929-1933.
 Oil on canvas, 143 × 81 cm.
 Private collection.

49. *Babaouo.* 1932.
 Wooden box with painted glass panes,
 25.8 × 26.4 × 30.5 cm.
 Perls Galleries, New York.

50. *The Phantom Wagon.* 1933.
 Oil on wooden panel, 19 × 24.1 cm.
 Edward F. W. James Collection, Sussex.

49

50

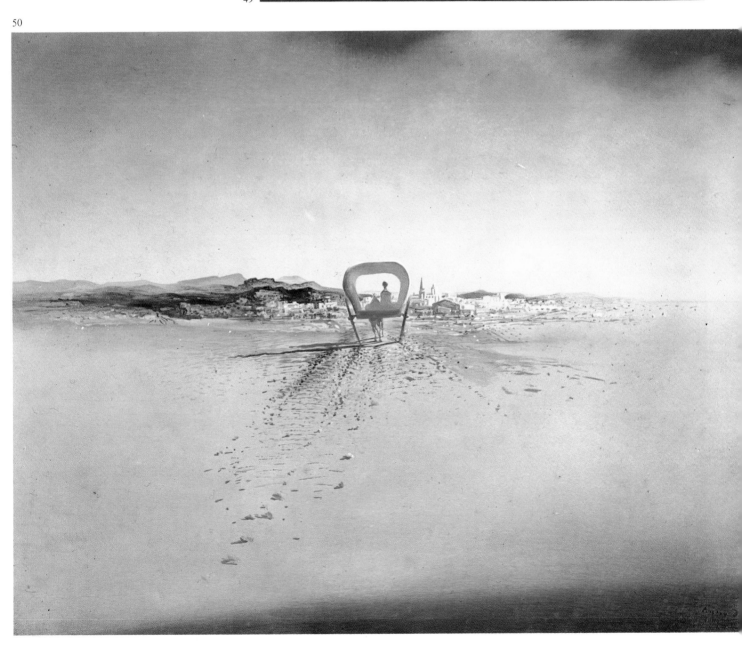

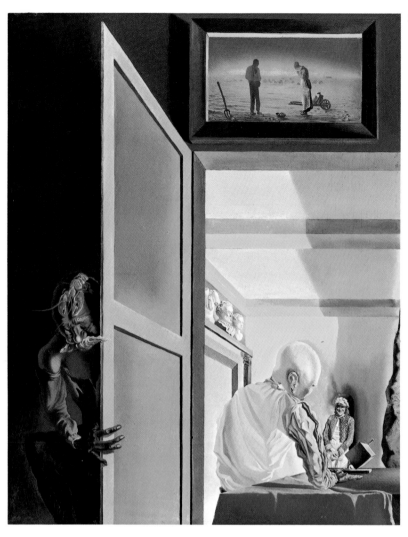

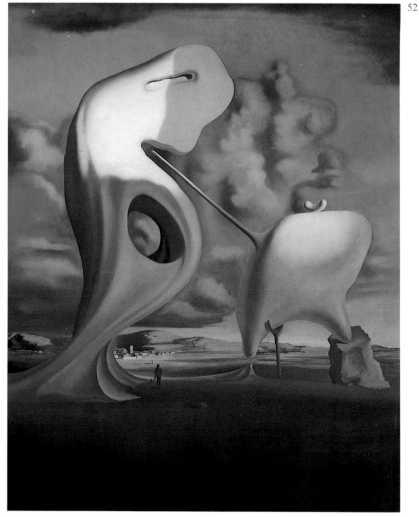

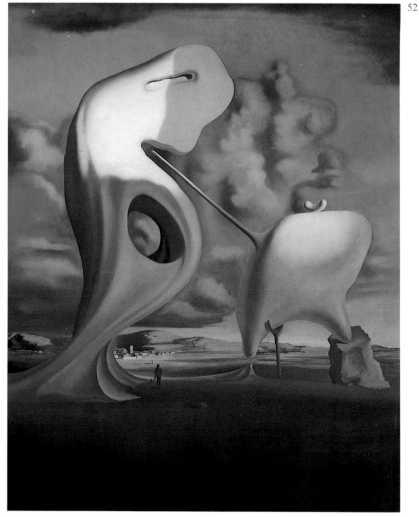

51. *Gala and Millet's Angelus Preceding the Imminent Arrival of the Conical Anamorphoses.* 1933.
Oil on plywood, 24 × 18.8 cm.
National Gallery of Canada, Ottawa.

52. *Millet's Architectural Angelus.* 1933.
Oil on canvas, 73 × 60 cm.
Perls Galleries, New York.

53. *Masochistic Instrument.* 1933-1934.
Oil on canvas, 62 × 47 cm.
Private collection.

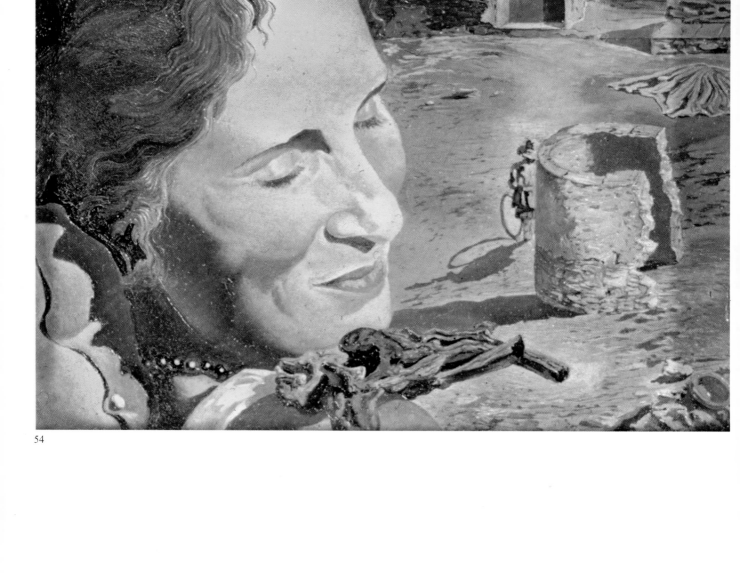

54

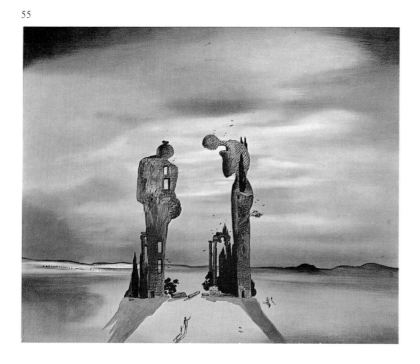

55

54. *Gala with Two Lamb Chops Balanced on her Shoulder*. 1933.
Oil on plywood, 31 × 39 cm.
Private collection.

55. *Archaeological Reminiscences of Millet's Angelus*.
1933-1935.
Oil on wooden panel, 31.7 × 39.3 cm.
Collection: Mr. and Mrs. A. Reynolds Morse.
Loaned to The Salvador Dalí Museum.
St. Petersburg, Florida.

56. *The Spectre of Sex-appeal*. 1934.
Oil on wooden panel, 18 × 14 cm.
Dalí Museum-Theatre, Figueres (Girona).

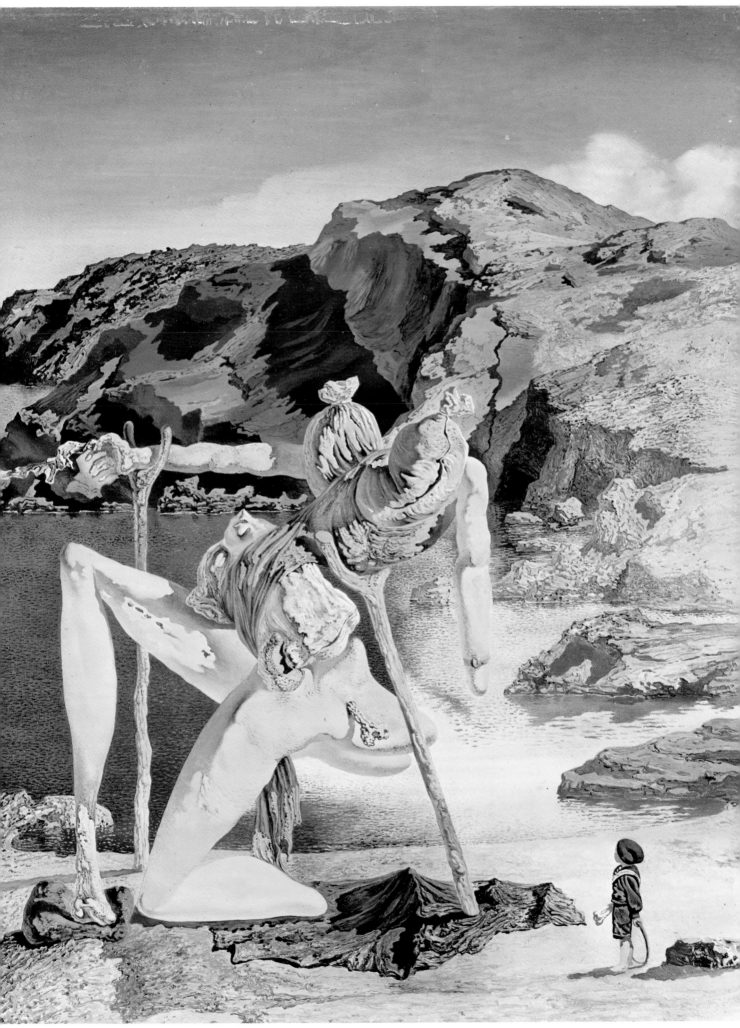

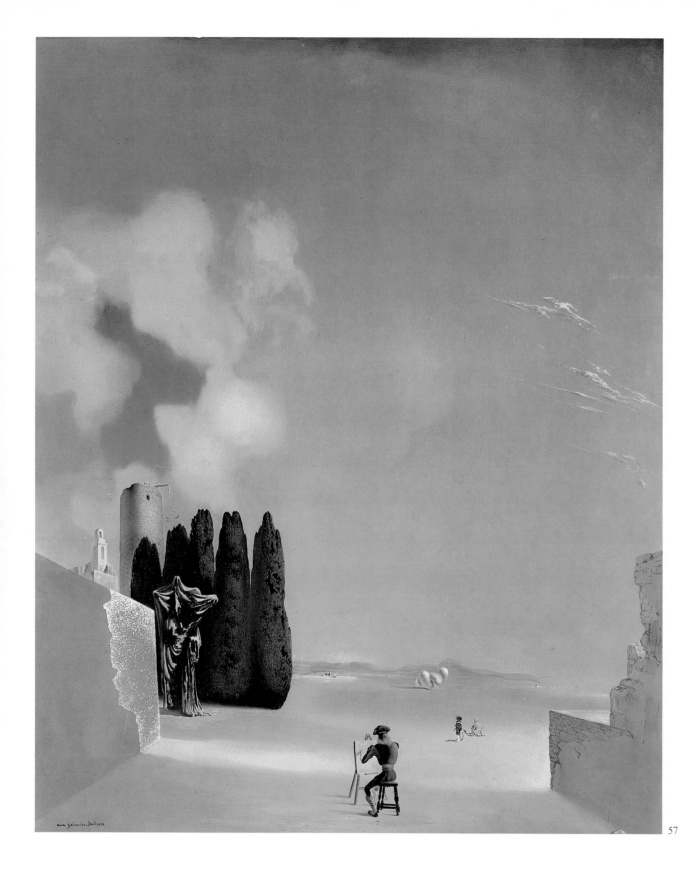

57. *Enigmatic Elements in a Landscape* (detail). 1934.
 Oil on wooden panel, 61.5 × 58.5 cm.
 Sulzberger Collection, Paris.

58. *Weaning from the Food Chair.* 1934.
 (Notice that the landscape of Portlligat is inverted in this work).
 Oil on wooden panel.
 Collection: Mr. and Mrs. A. Reynolds Morse. Loaned to
 The Salvador Dalí Museum. St. Petersburg, Florida.

59. *Apparition of My Cousin Carolineta on the Beach at Roses* (detail). 1934.
 Oil on canvas, 73 × 100 cm.
 Martin Thèves Collection, Brussels.

60. *The Ship.* 1934-1935.
 Oil on canvas, 29.5 × 22.5 cm.
 Private collection.

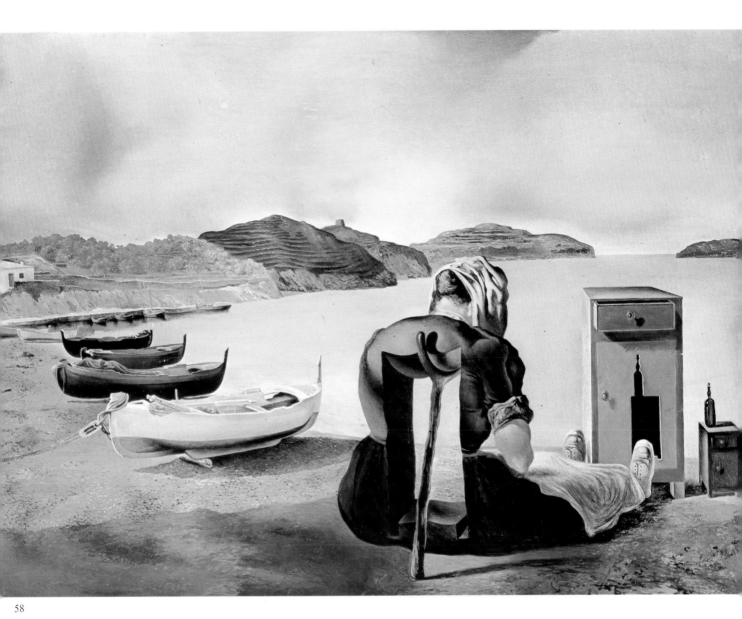

58

59

60

61. *Atavistic Traces after the Rain.* 1934.
 Oil on canvas, 65 × 54 cm.
 Perls Galleries, New York.

62. *Portrait of Gala* or *Gala's Angelus.* 1935.
 Oil on canvas, 32.4 × 26.7 cm.
 The Museum of Modern Art, New York.

61

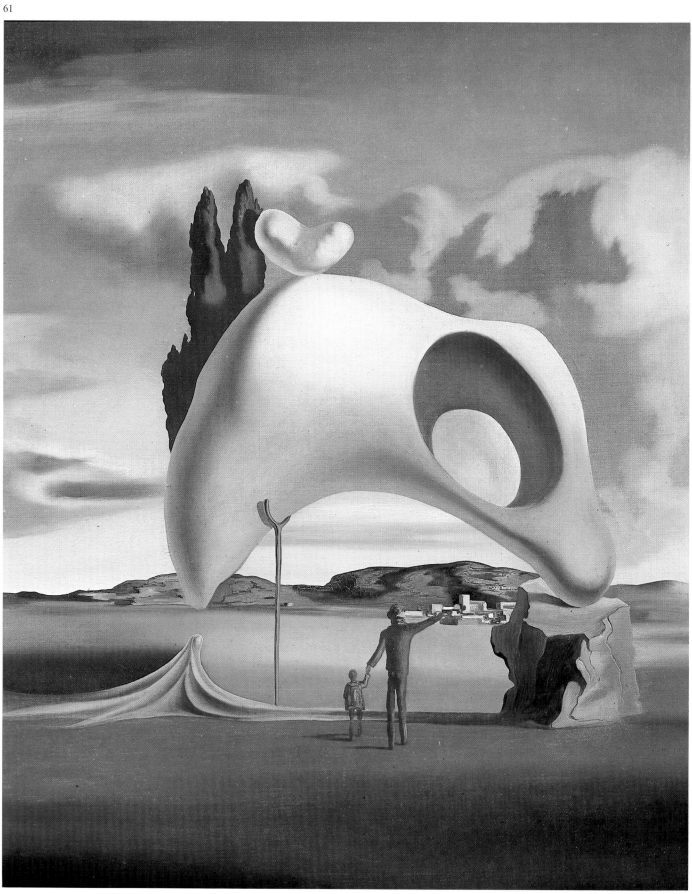

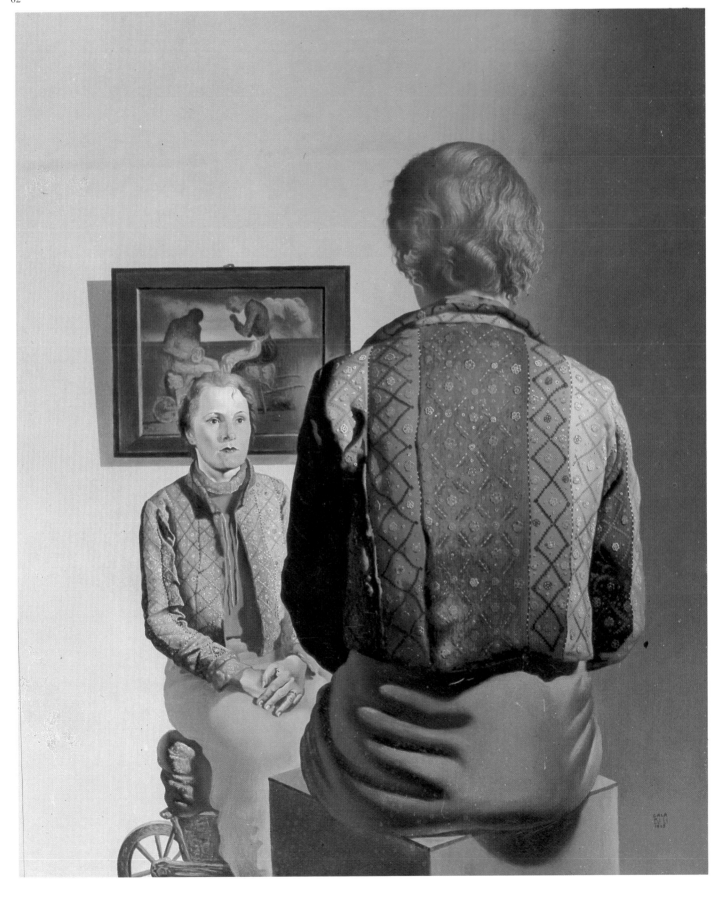

63. *The Rider of Death*. 1935.
 Oil on canvas, 65 × 53 cm.
 F. Petit Collection, Paris.

64. *Perspectives*. 1936.
 Oil on canvas, 65 × 65.5 cm.
 Kunstmuseum, Basel.
 Fmmanuel Hoffman Foundation.

65. *The Anthropomorphic Chest of Drawers*. 1936.
 Oil on wooden panel, 25.4 × 43.1 cm.
 Kunstsammlung Nordheim-Westfalen, Düsseldorf.

63

64

65

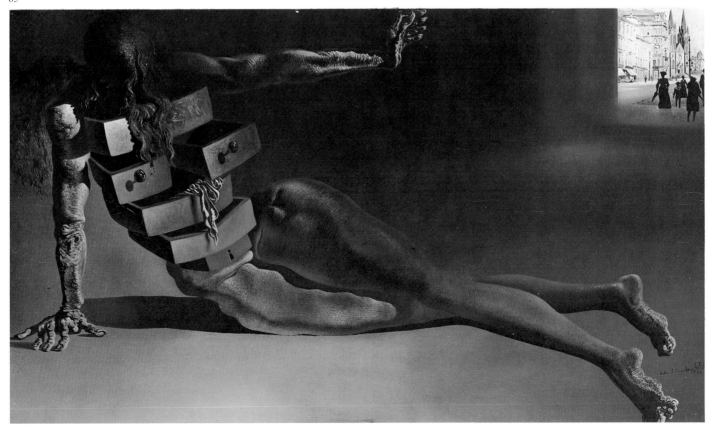

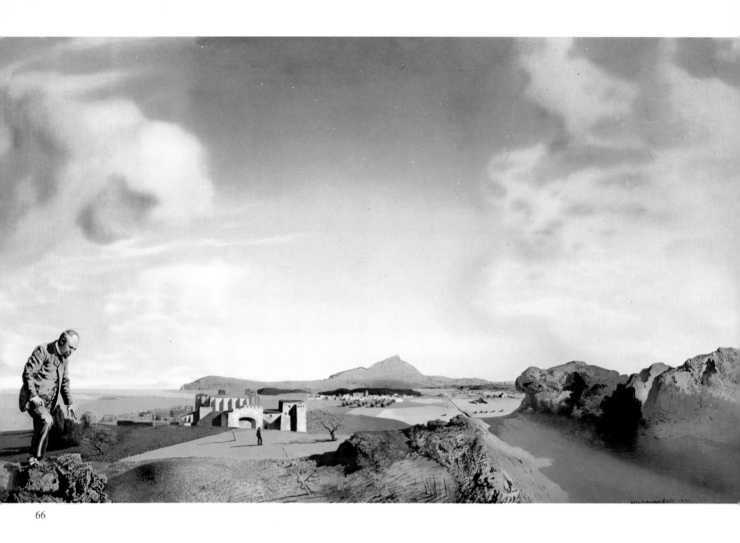

66

67

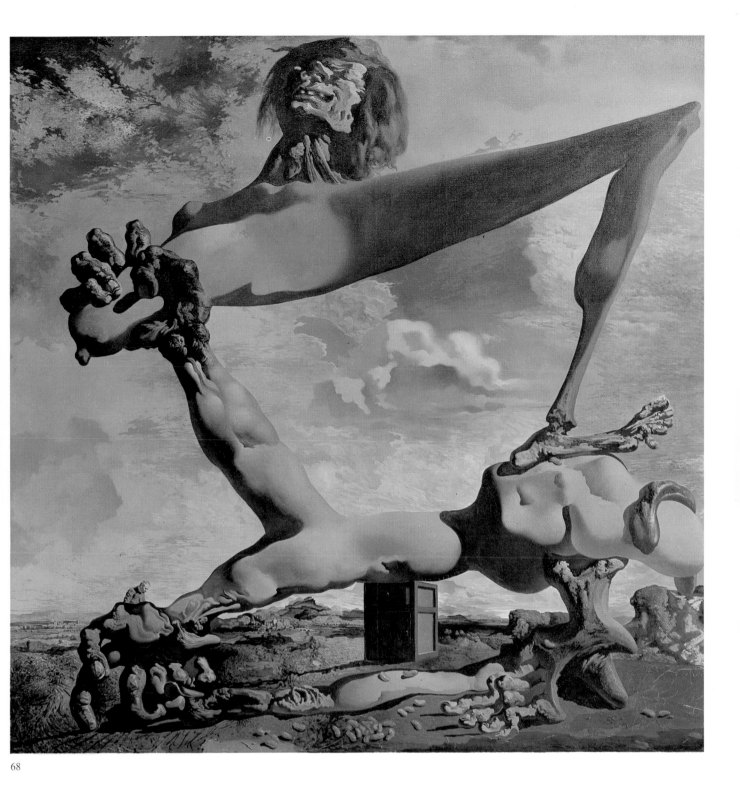

68

66. *The Chemist from Figueres who is not Looking for Anything at All.* 1936.
Oil on wooden panel, 30×56 cm.
Edward F. W. James Collection, Sussex.

67. *White Calm.* 1936.
Oil on wooden panel, 41×33 cm.
Edward F. W. James Collection, Sussex.

68. *Soft Construction with Cooked Beans (Premonition of the Spanish Civil War).* 1936.
Oil on canvas, 100×99 cm.
The Philadelphia Museum of Art, Philadelphia.

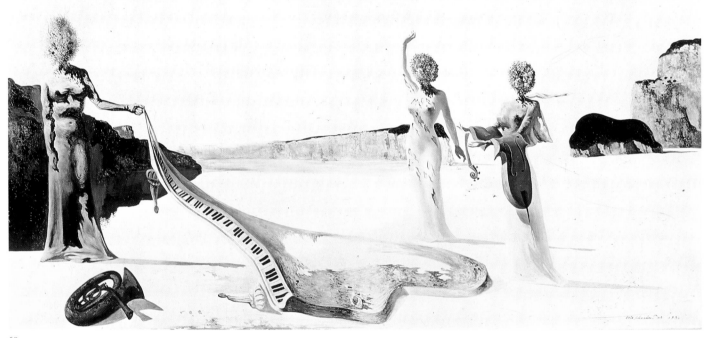

69

70

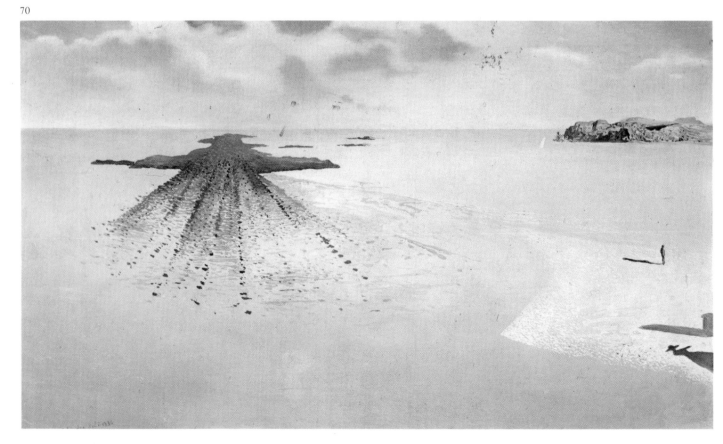

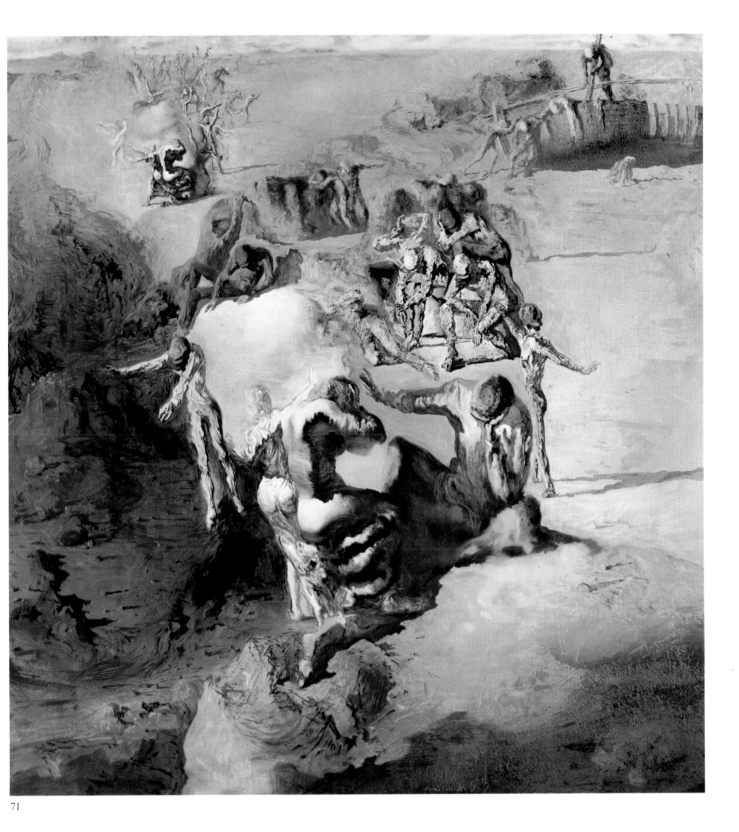

71

69. *Women with Flowers for Heads Finding the Skin of a Grand Piano on the Beach.* 1936.
Oil on canvas, 54×65 cm.
Collection: Mr. and Mrs. A. Reynolds Morse. Loaned to The Salvador Dalí Museum.
St. Petersburg, Florida.

70. *Geological Justice.* 1936.
Oil on wooden panel, 11×19 cm.
Boymans-van Beuningen Museum, Rotterdam.

71. *The Great Paranoiac.* 1936.
Oil on canvas, 62×62 cm.
Boymans-van Beuningen Museum, Rotterdam.

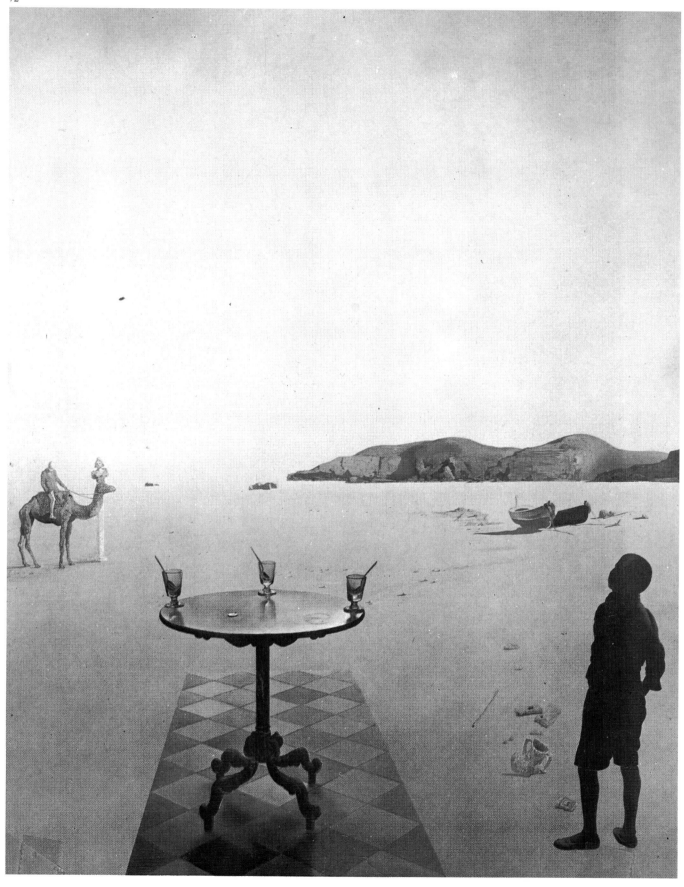

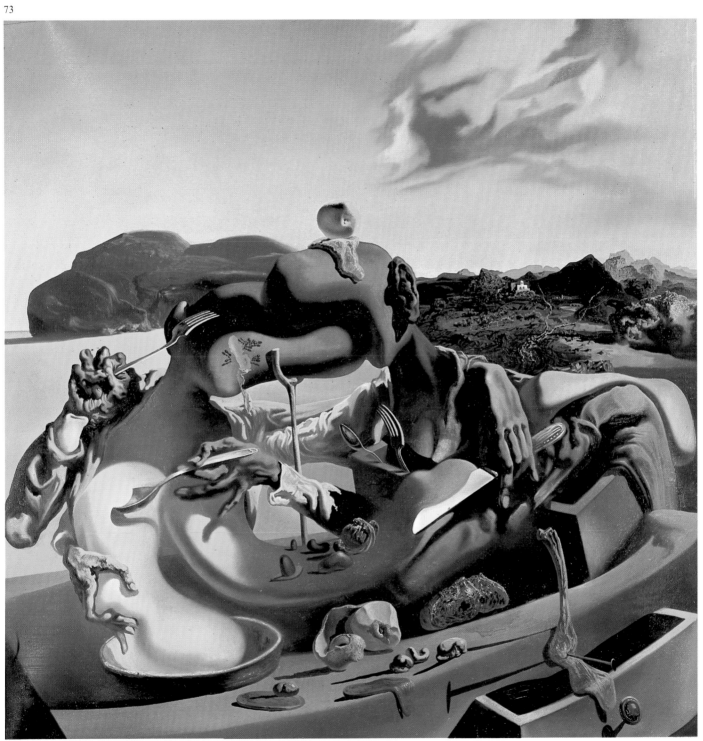

72. *Solar Table*. 1936.
 Oil on wooden panel, 60×46 cm.
 Boymans-van Beuningen Museum, Rotterdam.

73. *Cannibalism in Autumn*. 1936-1937.
 Oil on canvas, 65×65.2 cm.
 Tate Gallery, London.

74. *Lighted Giraffes.* 1936-1937.
 Oil on wooden panel, 35×27 cm.
 Kunstmuseum, Basel.
 Emmanuel Hoffman Foundation.

75. *The Dream.* 1937.
 Oil on canvas, 50×77 cm.
 Edward F. W. James Collection, Sussex.

76. *The Enigma of Hitler.* 1937.
 Oil on canvas.
 Private collection.

77. *The Invention of Monsters.* 1937.
 Oil on wooden panel, 51.2×78.5 cm.
 The Art Institute of Chicago, Chicago.

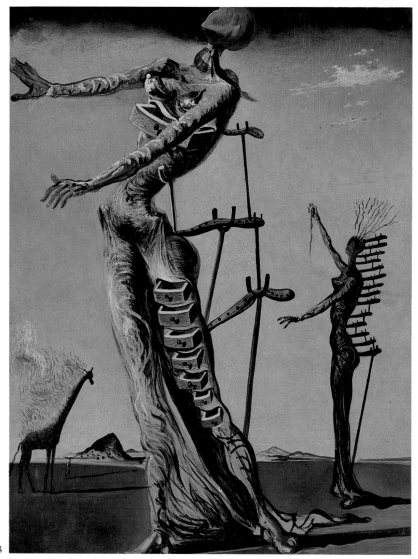

74

75

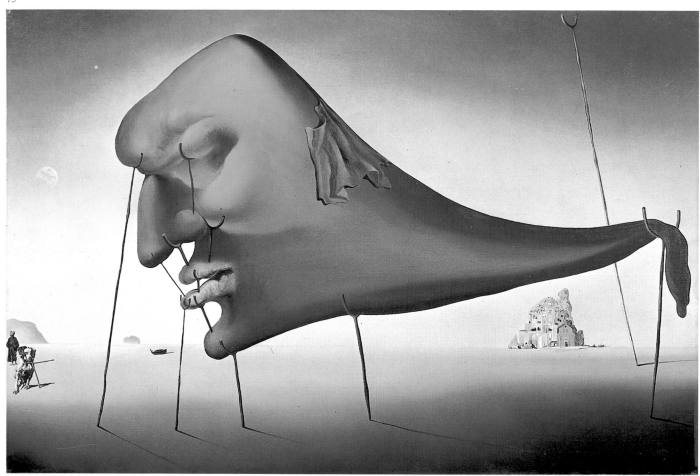

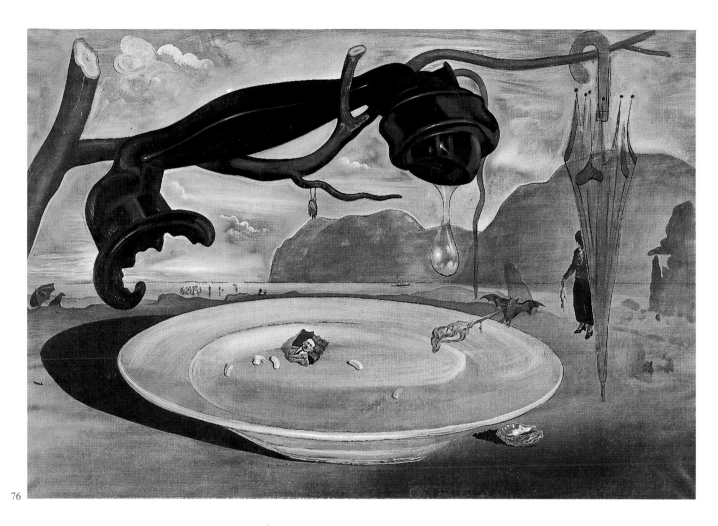

76

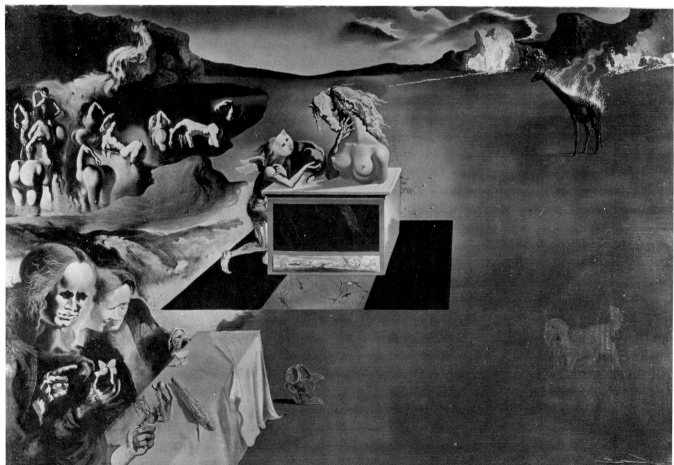

77

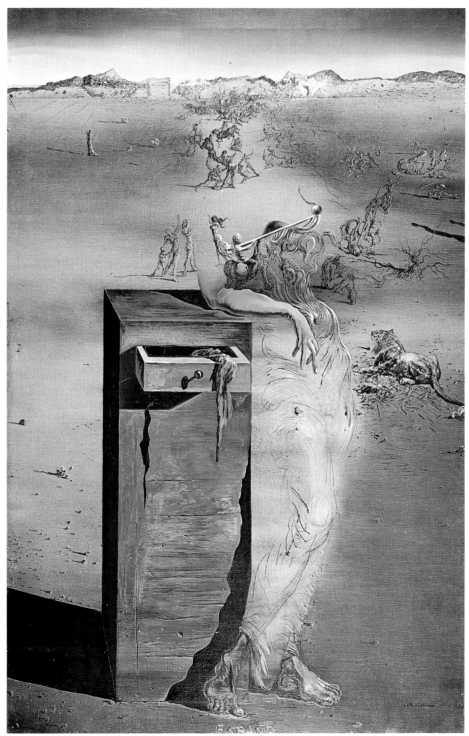

78

78. *Spain*. 1936-1938.
 Oil on canvas, 91.8×60.2 cm.
 Boymans-van Beuningen Museum, Rotterdam.

79. *Metamorphosis of Narcissus*. 1937.
 Oil on canvas, 50.8×78.2 cm.
 Tate Gallery, London.

80. *Transparent Simulacrum of a False Image*. C. 1938.
 Oil on canvas, 73.5×92 cm.
 Albright-Knox Art Gallery, Buffalo, N. Y.

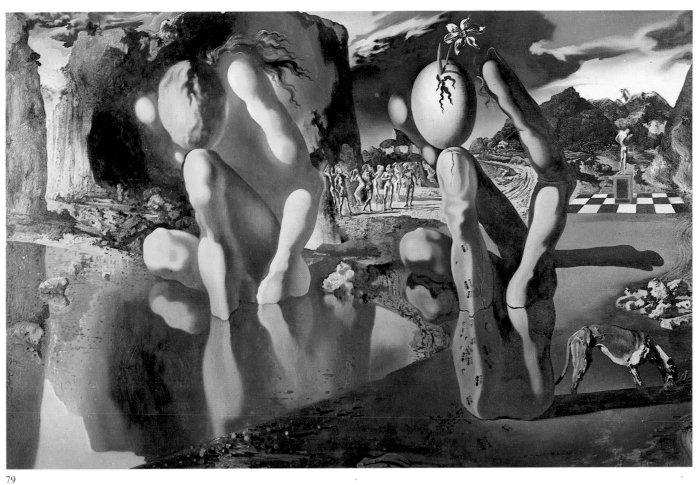

79

80

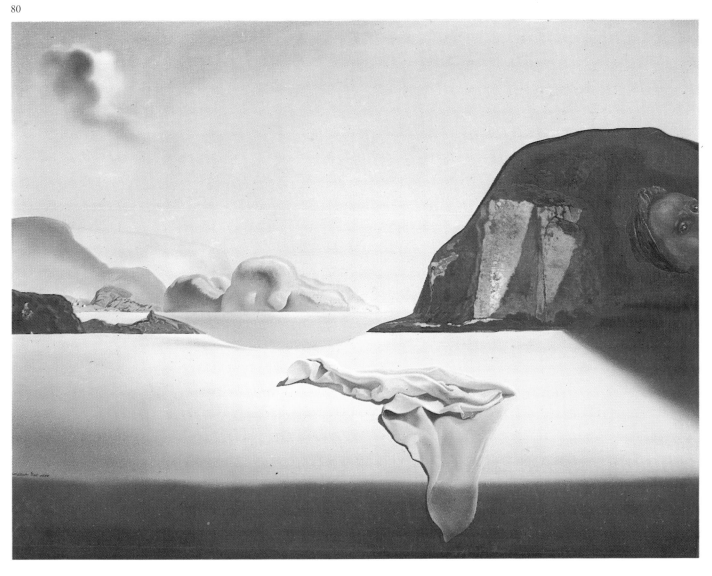

81

81. *Impressions of Africa* (detail). 1938.
Oil on canvas, 91.5 × 117.5 cm.
Boymans-van Beuningen Museum, Rotterdam.

82. *Palladian Corridor with a Dramatic Surprise.*
1938.
Oil on canvas, 75 × 104 cm.
Segialant Anstalt.

83. *Beach with Telephone.* 1938.
Oil on canvas, 73 × 92 cm.
Tate Gallery, London.

84. *The Image Vanishes.* 1938.
Oil on canvas, 55.9 × 50.8 cm.
Private collection.

85. *The Infinite Enigma.* 1938.
Oil on canvas, 114.5 × 146.5 cm.
Private collection.

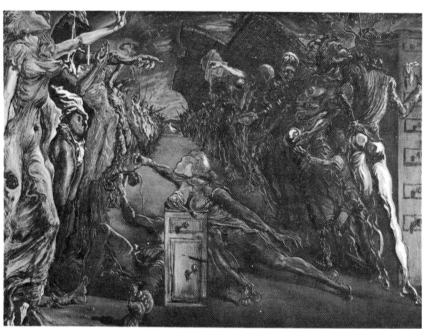

82

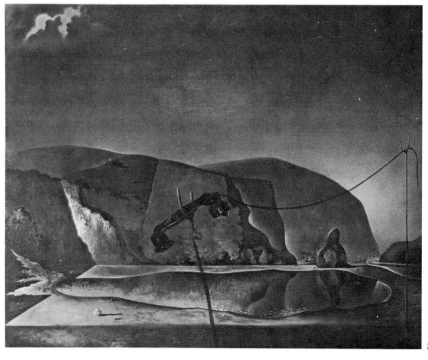

83

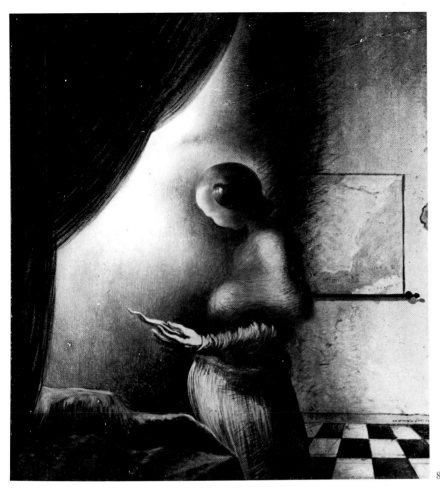

84

85

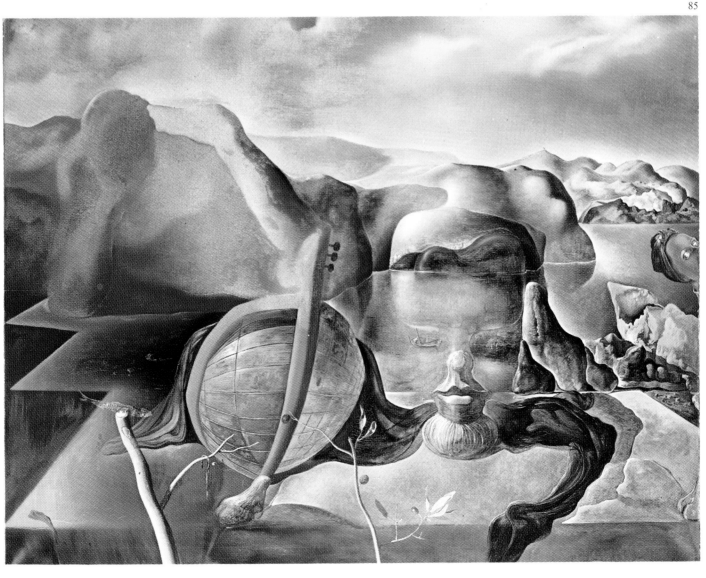

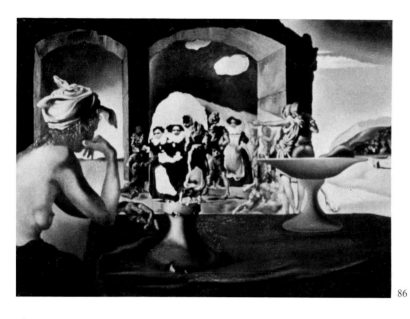

86

86. *Slave-market with the Apparition of the Invisible Bust of Voltaire.* 1940.
Oil on canvas, 46.5 × 65.5 cm.
Collection: Mr. and Mrs. A. Reynolds Morse.
Loaned to The Salvador Dalí Museum.
St. Petersburg, Florida.

87. *Spider of the Afternoon, Hope!* 1940.
Oil on canvas, 41 × 51 cm.
Collection: Mr. and Mrs. A. Reynolds Morse.
Loaned to The Salvador Dalí Museum.
St. Petersburg, Florida.

88. *Soft Self-portrait with Grilled Rasher of Bacon.*
1941.
Oil on canvas, 61 × 50.8 cm.
Private collection.

87

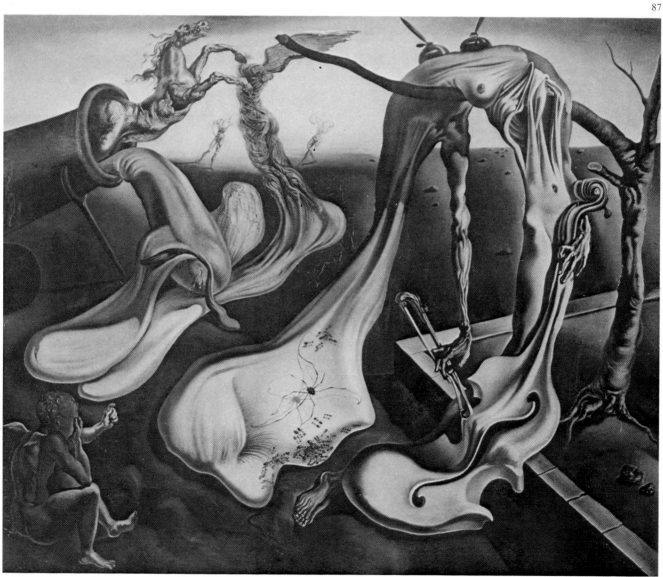

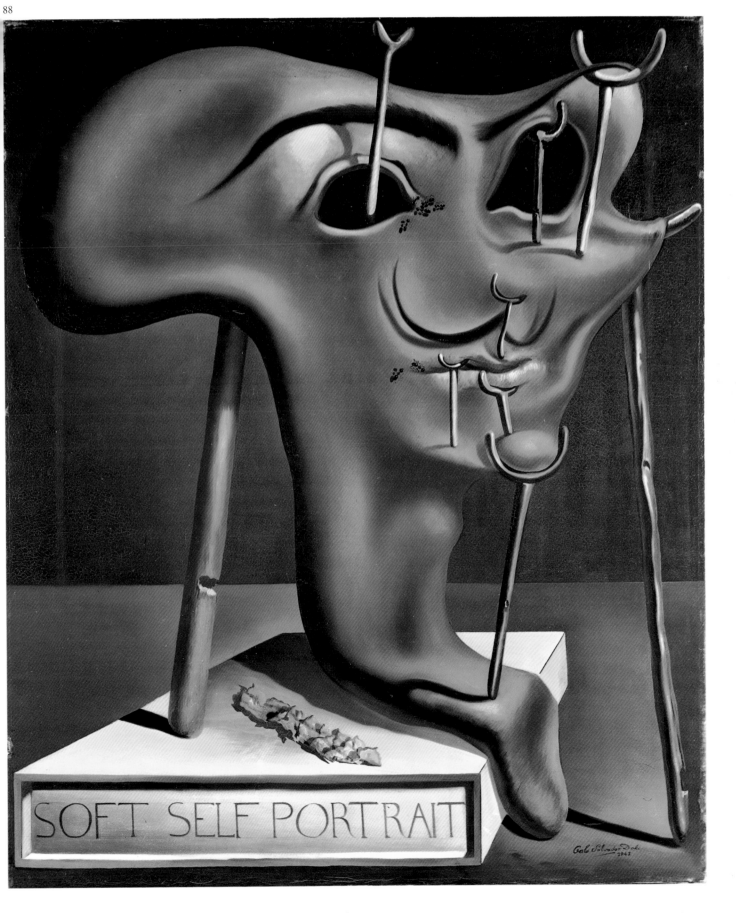

89

90

91

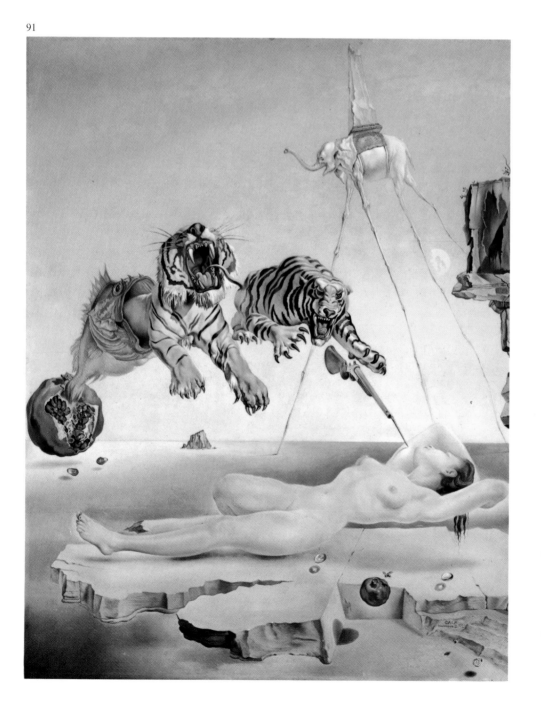

89. *The Eye of Time.* 1941.
 Jewel-watch.
 The Owen Cheatham Foundation.

90. Jewel (gold, rubies and pearls).
 1941.
 The Owen Cheatham Foundation.

91. *Dream Caused by the Flight of a
 Bee around a Pomegranate a
 Second before Awakening.* 1944.
 Oil on wooden panel, 51×41 cm.
 Thyssen-Bornemisza Collection,
 Lugano-Castagnola, Switzerland.

92. *Half a Giant Cup Suspended with
 an Inexplicable Appendage Five
 Metres Long.* 1944-1945.
 Oil on canvas, 50×31 cm.
 Private collection, Basel.

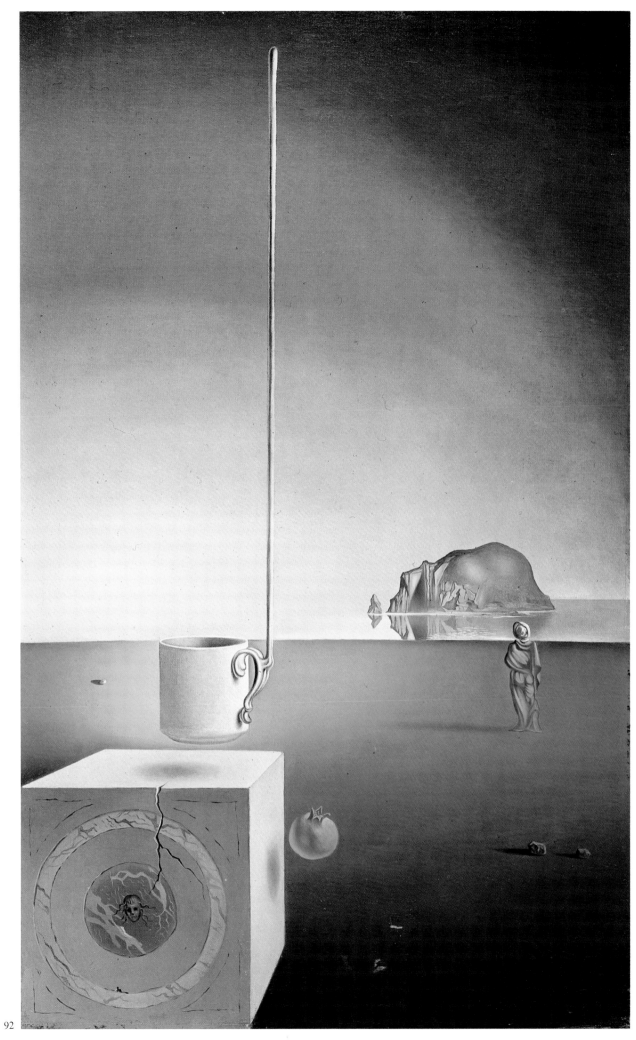

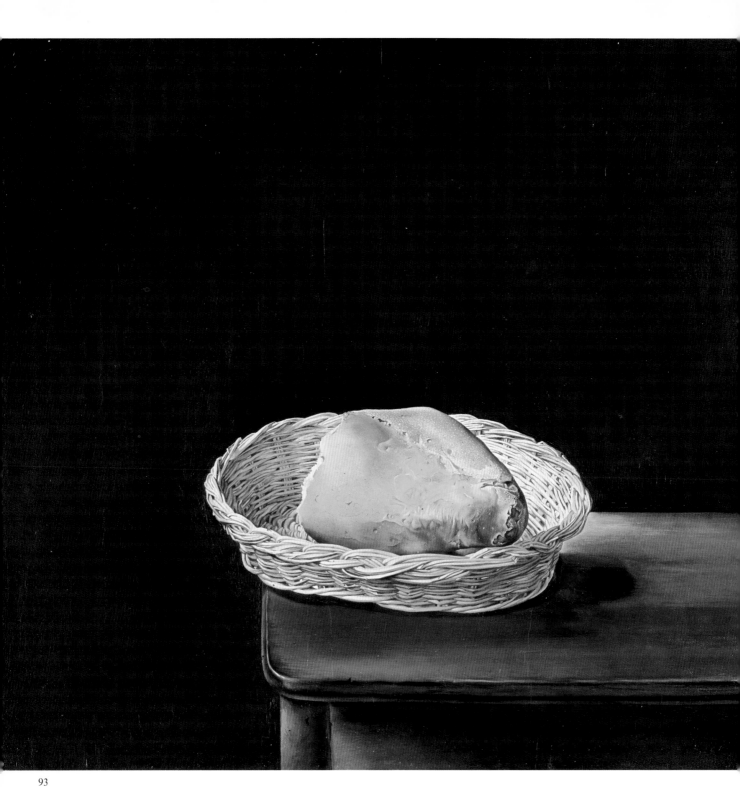

93. *The Bread-basket.* 1945.
Oil on wooden panel, 37×32 cm.
Dalí Museum-Theatre, Figueres (Girona).

94. Design for the film *Spellbound,*
starring Ingrid Bergman and
directed by Alfred Hitchcock. 1945.

95. *Portrait of Picasso in the Glory of the Sun.* 1947.
Oil on canvas, 64.1×54.7 cm.
Private collection, New York.

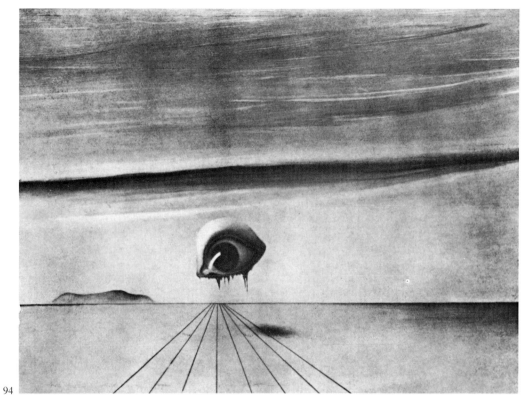

94

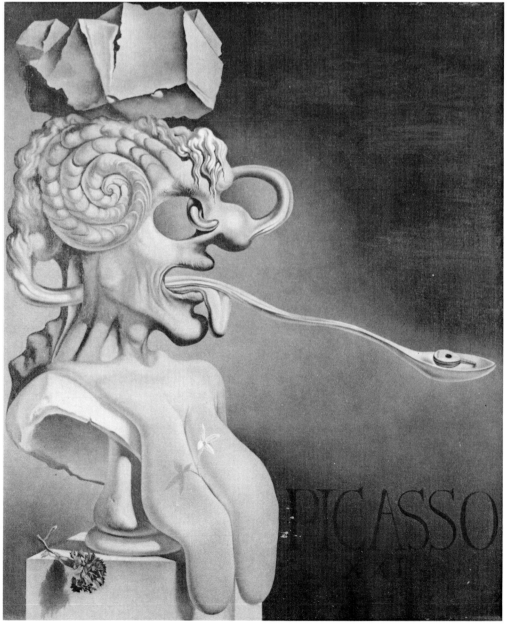

95

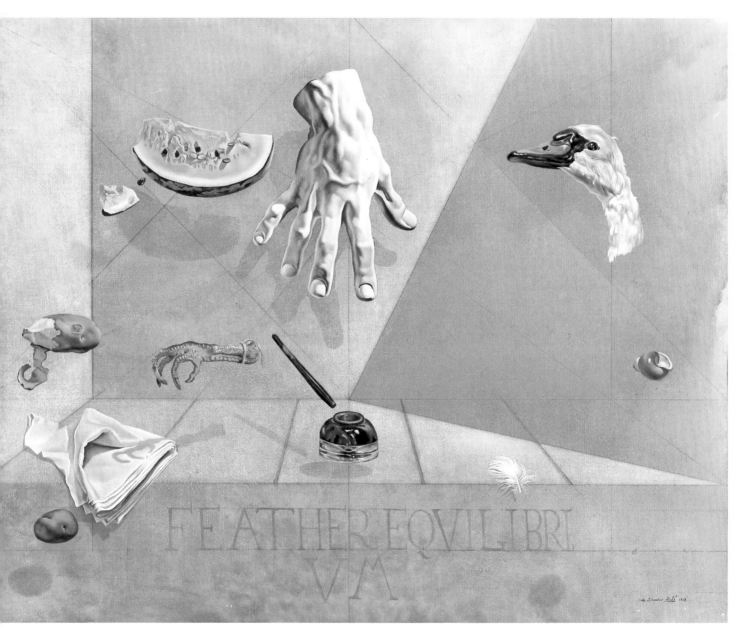

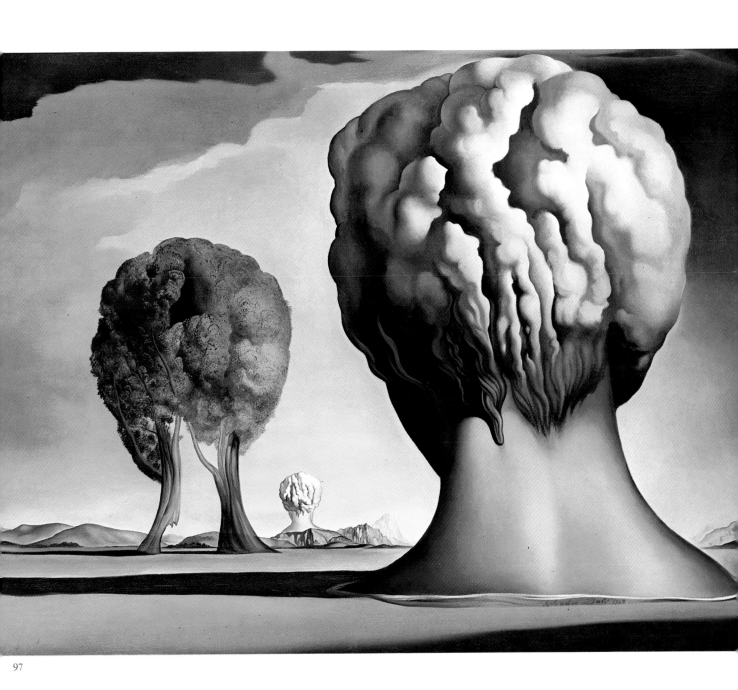

97

96. *Interatomic Balance of a Swan's Feather.* 1947.
 Oil on canvas, 77.5 × 96.5 cm.
 Private collection.

97. *The Three Sphinxes of Bikini.* 1947.
 Oil on canvas, 30 × 50 cm.
 Galerie Petit, Paris.

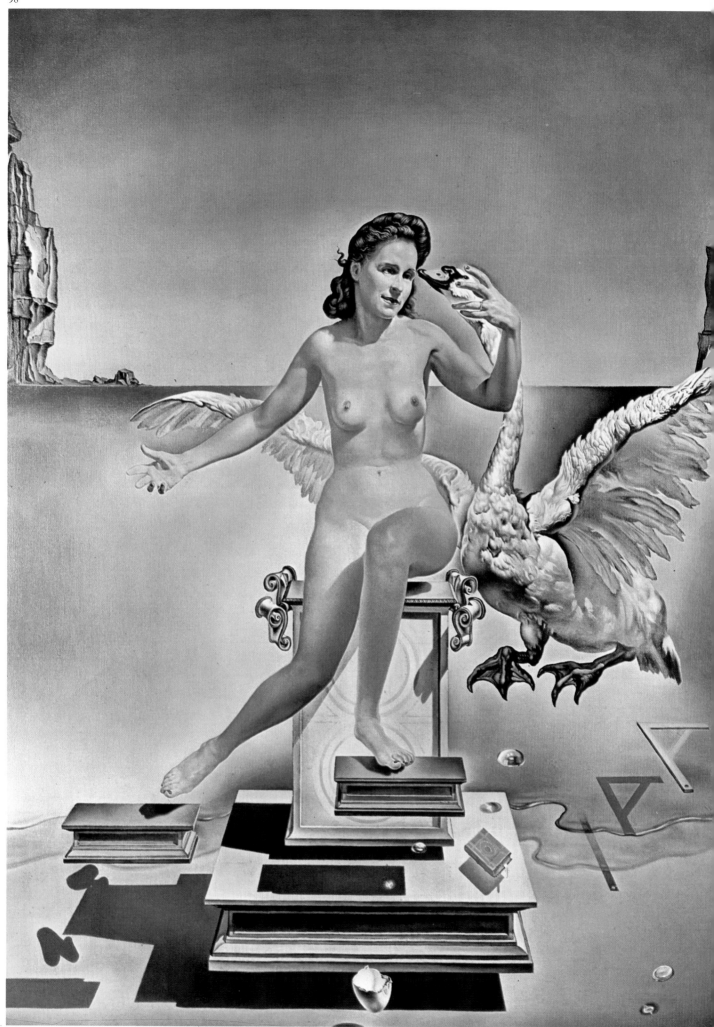

98. *Atomic Leda.* 1949.
 Oil on canvas, 60×44 cm.
 Dalí Museum-Theatre, Figueres (Girona).

99. *First study for the Madonna of Portlligat.* 1949.
 Oil on canvas, 48.9×37.5 cm.
 Marquette University Committee on the Fine Arts, Milwaukee, Wisconsin.

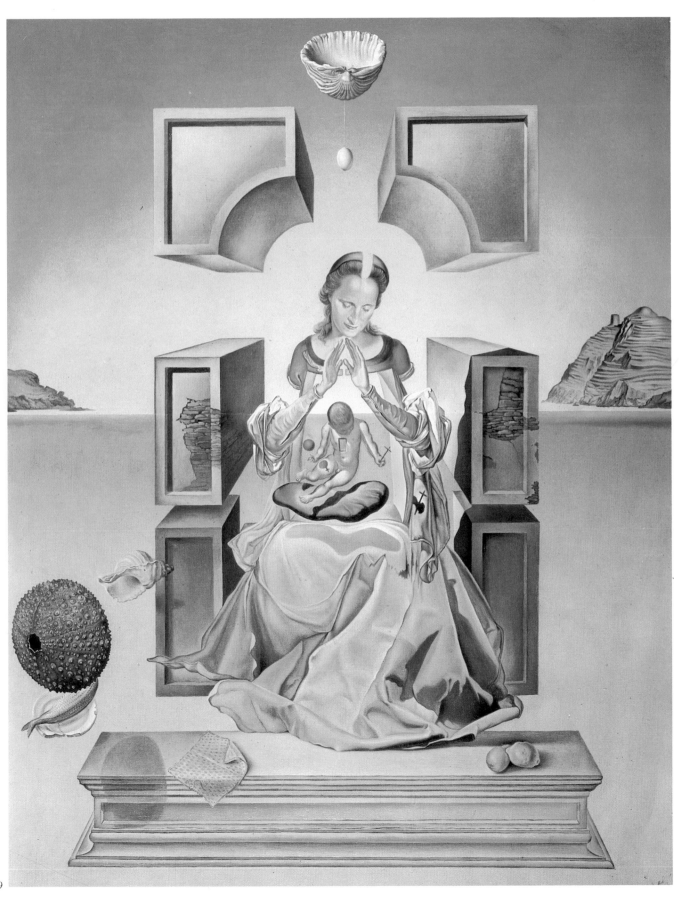

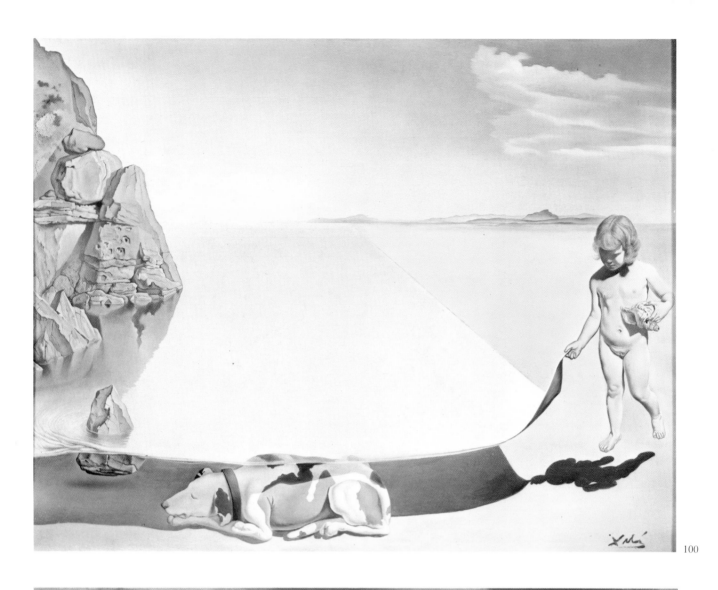

100

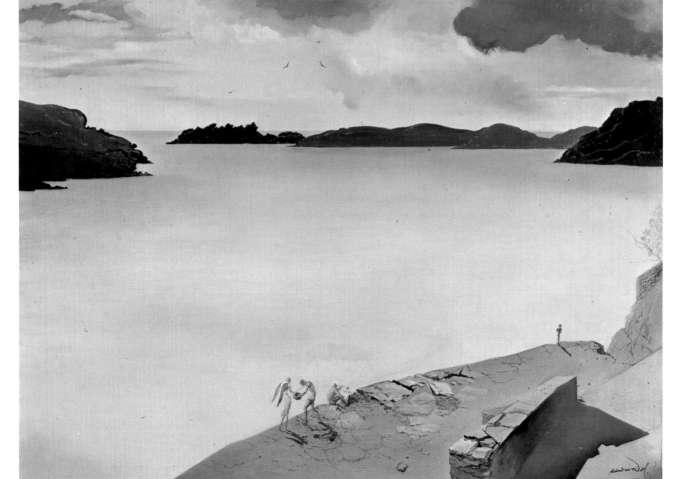

101

100. *Dalí at the Age of Six, when he Thought he was a Girl, Lifting the Skin of the Water to see a Dog Sleeping in the Shade of the Sea.* 1950.
Oil on canvas, 80×99 cm.
Comte François de Vallombreuse Collection, Paris.

101. *Landscape of Portlligat.* 1950.
Oil on canvas, 58×78 cm.
Collection: Mr. and Mrs. A. Reynolds Morse.
Loaned to The Salvador Dalí Museum.
St. Petersburg, Florida.

102. *Raphaelesque Head Bursting.* 1951.
Oil on canvas, 44.5×35 cm.
Stead H. Stead Ellis Collection, Somerset.

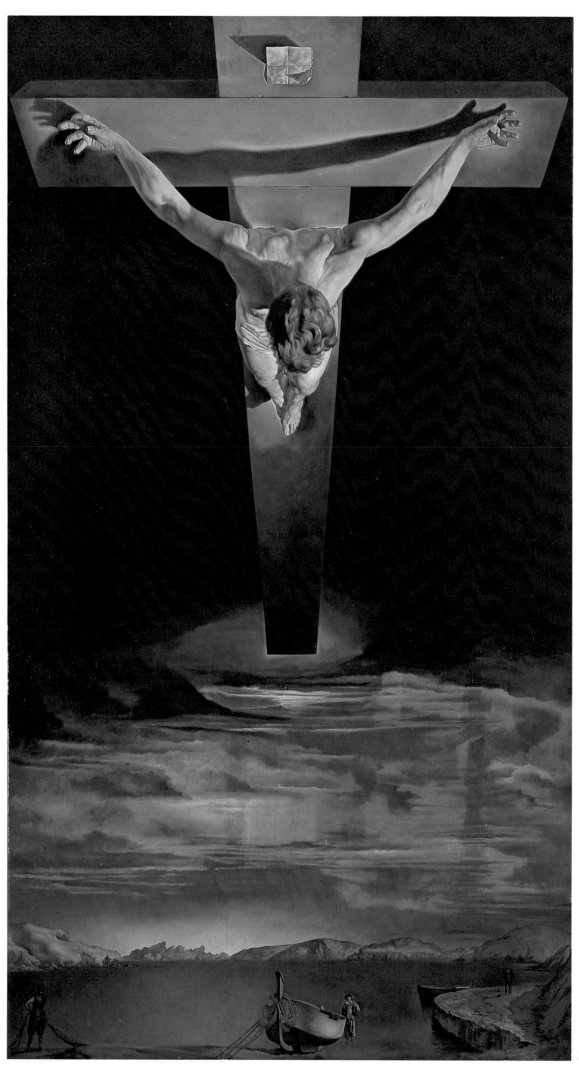

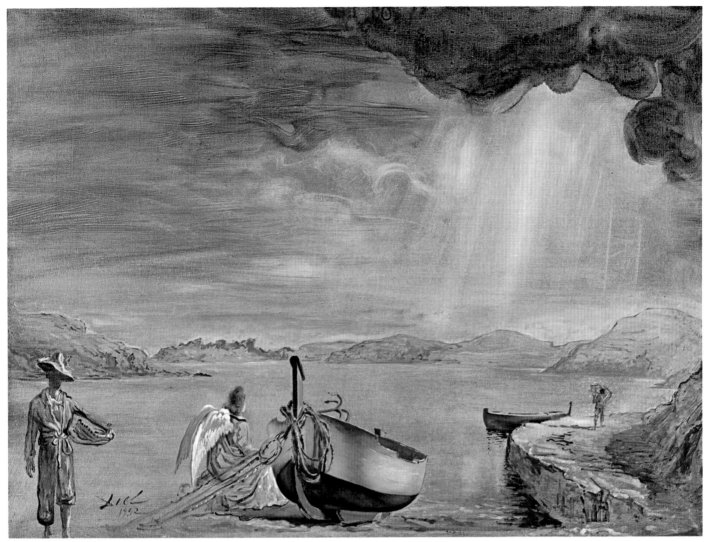

104

103. *Christ of St. John of The Cross.* 1951.
 Oil on canvas, 205×116 cm.
 Art Gallery, Glasgow.

104. *The Angel of Portlligat.* 1952.
 Oil on canvas, 58.4×78.3 cm.
 Collection: Mr. and Mrs. A. Reynolds Morse.
 Loaned to The Salvador Dalí Museum.
 St. Petersburg, Florida.

105. *Galatea of the Spheres.* 1952.
 Oil on canvas, 64×54 cm.
 Private collection.

105

106

106. *Portrait of Gala with Rhinocerotic Symptoms.* 1954.
Oil on canvas, 39 × 31.5 cm.
Private collection.

107. *Disintegration of the Persistence of Memory.* 1952-1954.
Oil on canvas, 25 × 33 cm.
Collection: Mr. and Mrs.
A. Reynolds Morse. Loaned to
The Salvador Dalí Museum.
St. Petersburg, Florida.

108. *Crucifixion ('Hypercubic Body').*
1954.
Oil on canvas, 194.5 × 124 cm.
Metropolitan Museum of Art,
New York.
Chester Dale Bequest.

107

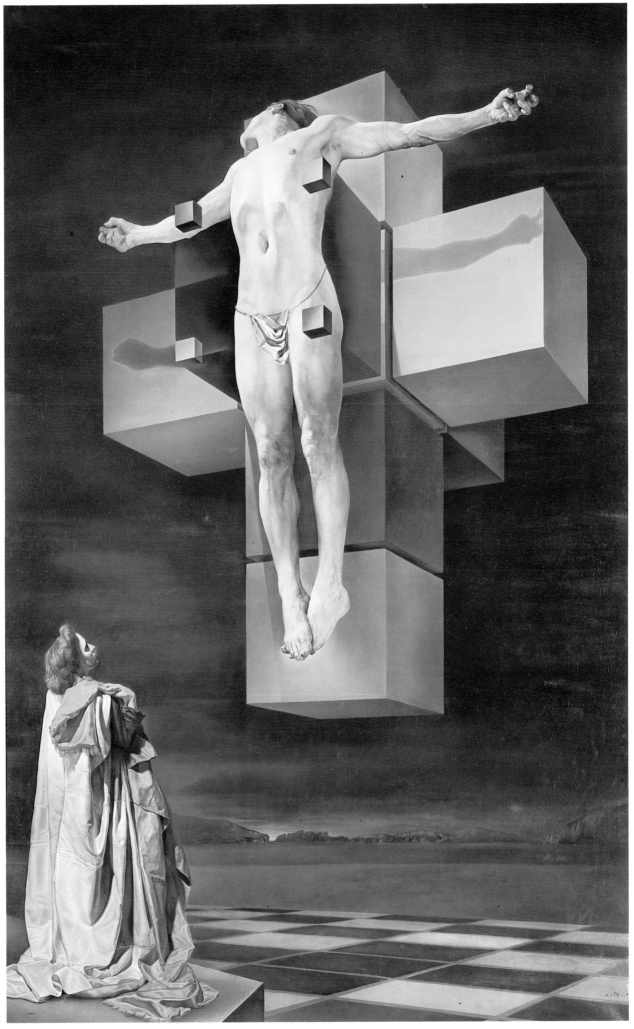

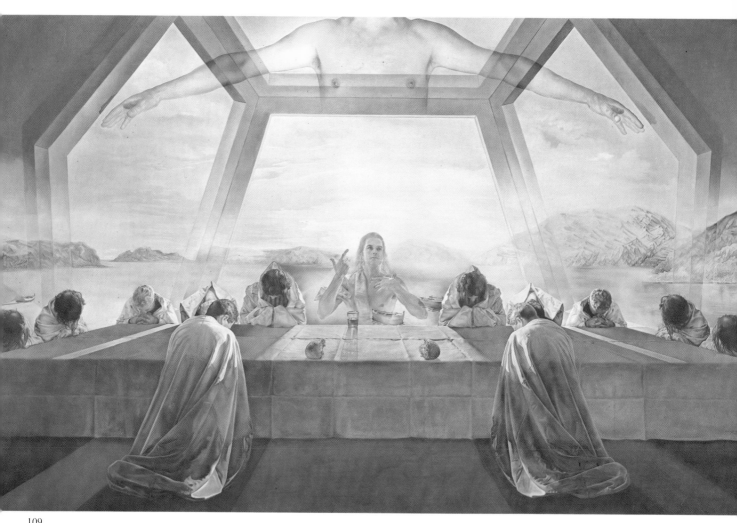

109

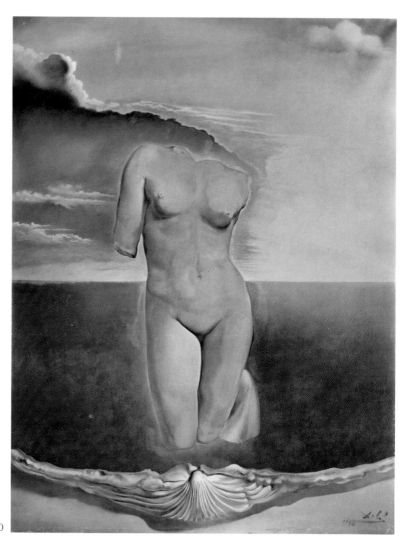

110

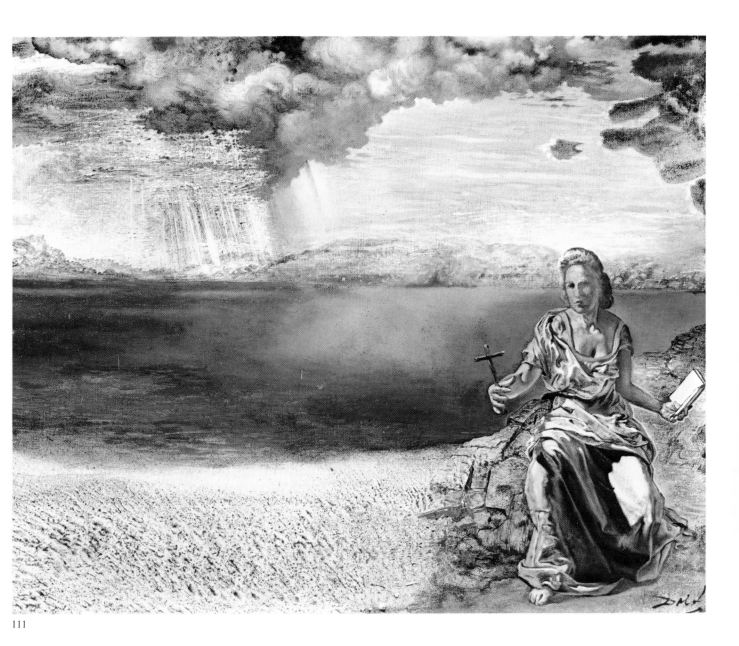

111

109. *The Last Supper*. 1955.
 Oil on canvas, 167×268 cm.
 National Gallery of Art, Washington.
 Chester Dale Bequest.

110. *Rhinocerotic Gooseflesh*. 1956.
 Oil on canvas, 93×60 cm.
 Bruno Pagliai Collection, Mexico.

111. *Saint Helen in Portlligat*. 1956.
 Oil on canvas, 31×42 cm.
 Collection: Mr. and Mrs. A. Reynolds Morse.
 Loaned to The Salvador Dalí
 Museum. St. Petersburg, Florida.

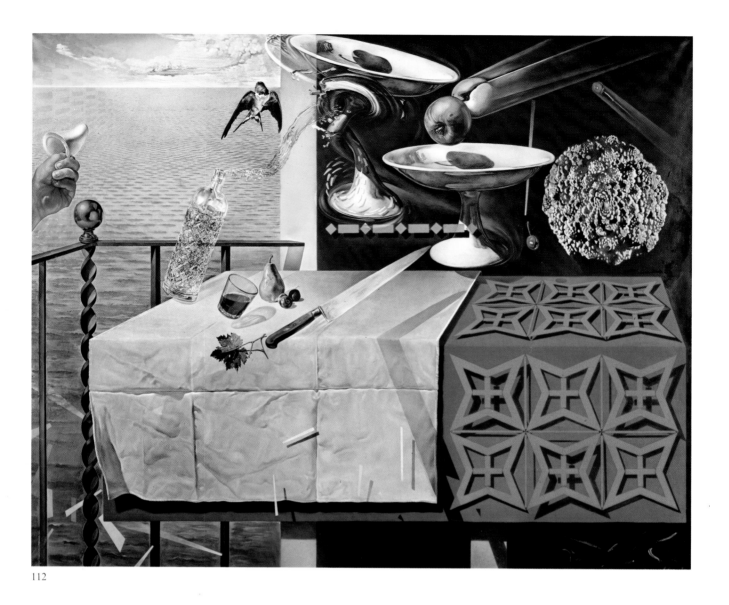

112

113

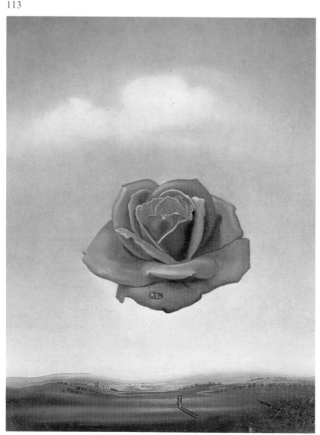

114

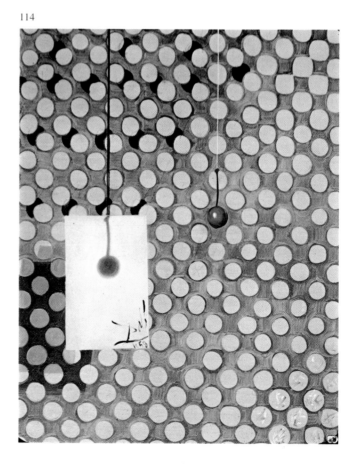

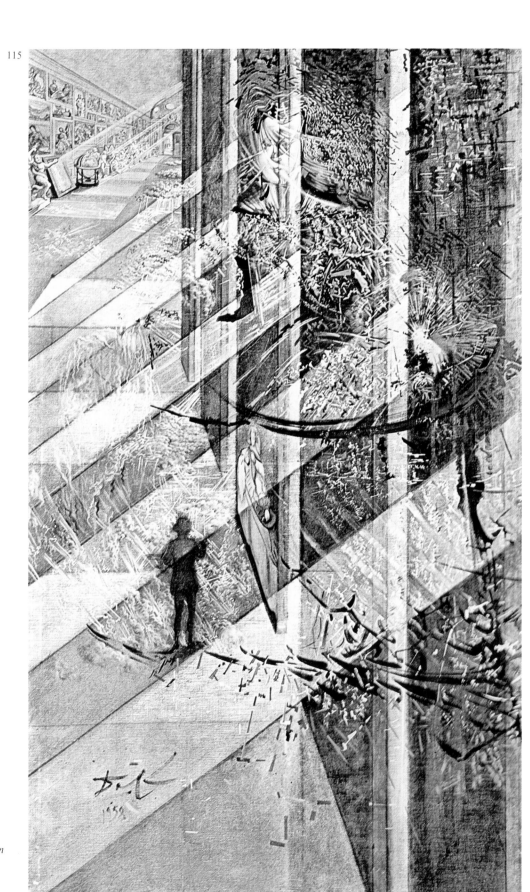

115

112. *Living Still Life*. 1956.
Oil on canvas, 125 × 160 cm.
Collection: Mr. and Mrs.
A. Reynolds Morse. Loaned to
The Salvador Dalí Museum.
St. Petersburg, Florida.

113. *Meditative Rose*. 1958.
Oil on canvas, 36 × 28 cm.
Mr. and Mrs. Arnold Grant
Collection, New York.

114. *Sistine Madonna* (detail). 1958.
Oil on paper, 223 × 190 cm.
Henry J. Heinz II Collection,
New York.

115. *Velázquez Painting the Infanta
Margarita, Surrounded by the
Lights and Shadows of Her Own
Glory*. 1958.
Oil on canvas, 153 × 92 cm.
Collection: Mr. and Mrs.
A. Reynolds Morse. Loaned to
The Salvador Dalí Museum.
St. Petersburg, Florida.

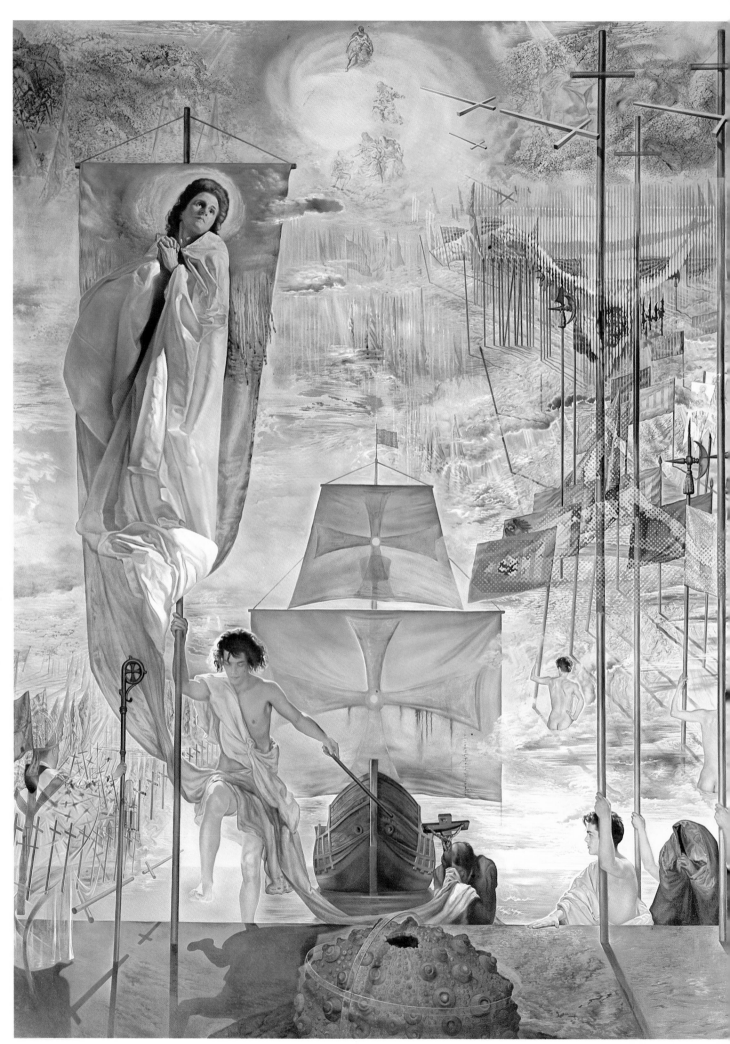

116. *The Dream of Columbus.* 1958-1959.
Oil on canvas, 410.2 × 284.8 cm.
Collection: Mr. and Mrs.
A. Reynolds Morse.
Loaned to The Salvador Dalí
Museum. St. Petersburg, Florida.

117. *Virgin of Guadalupe.* 1959.
Oil on canvas, 130 × 98.5 cm.
Alfonso Fierro Collection, Madrid.

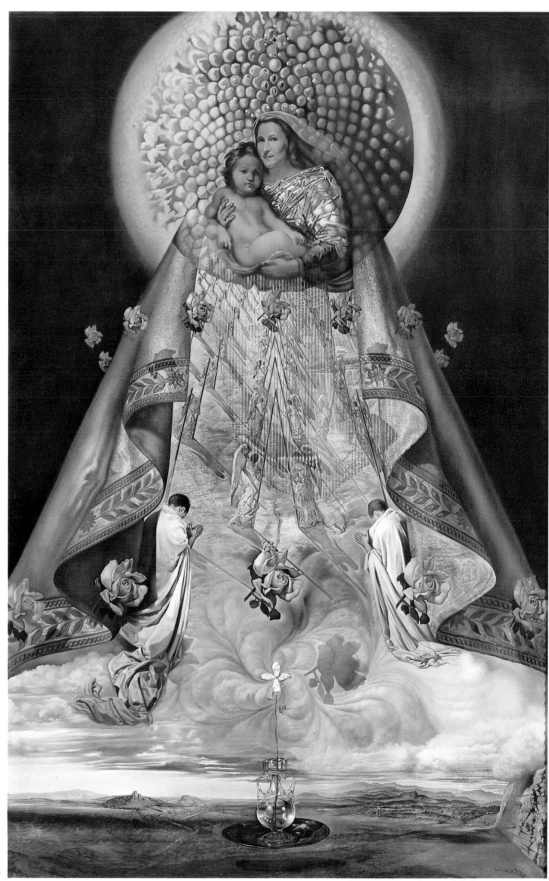

118

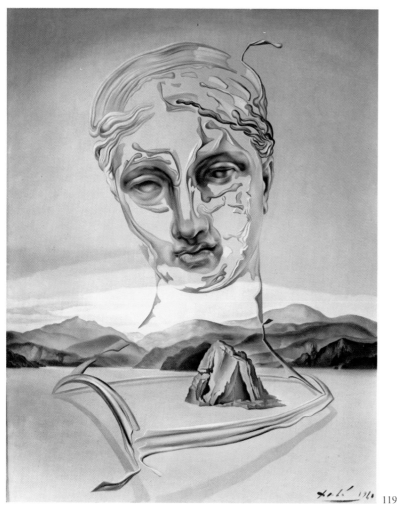

119

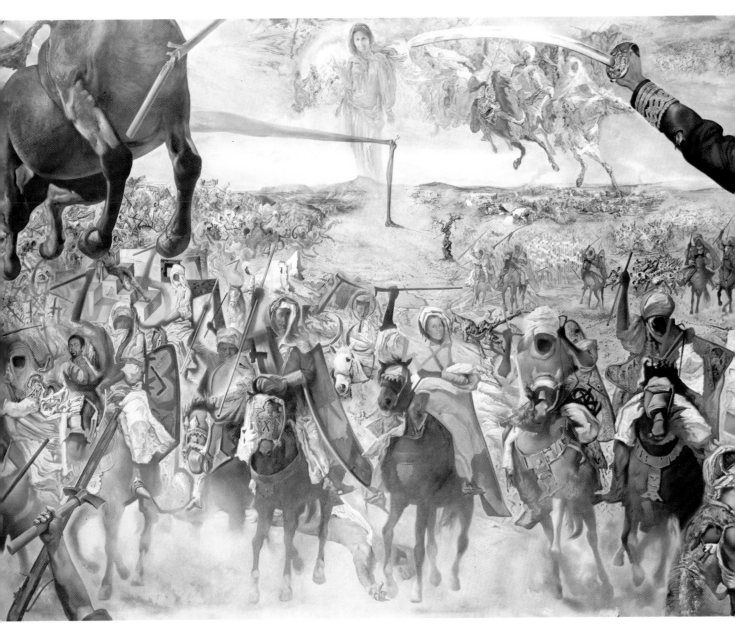

120

118. *Gala Nude from Behind Looking in an Invisible Mirror*. 1960.
 Oil on canvas, 42 × 32 cm.
 Dalí Museum-Theatre, Figueres (Girona).

119. *Birth of a Divinity*. 1960.
 Oil on canvas, 36 × 26 cm.
 Mrs Henry J. Heinz II Collection, New York.

120. *The Battle of Tetuán*. 1962.
 Oil on canvas, 308 × 406 cm.
 David Nahmad Collection, Milan.

121. *Salvador Dalí in the Act of Painting Gala in the Apotheosis of the Dollar, in which One may also Perceive to the Left Marcel Duchamp Disguised as Louis XIV, behind a Curtain in the Style of Vermeer, which is but the Invisible though Monumental Face of the Hermes of Praxiteles.* 1965.
Oil on canvas, 400×498 cm.
Peter Moore Collection, Cadaqués (Girona).

122. *The Station at Perpignan.* 1965.
Oil on canvas, 295×406 cm.
Ludwig Museum, Cologne.

123. *The Tunny Catch.* 1966-1967.
Oil on canvas, 304×404 cm.
Paul Ricard Foundation, Bandol, France.

121

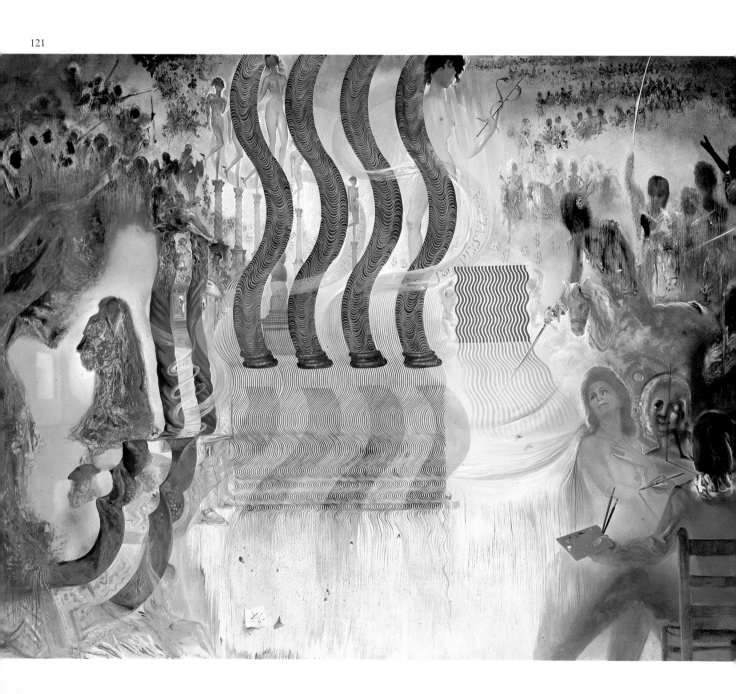

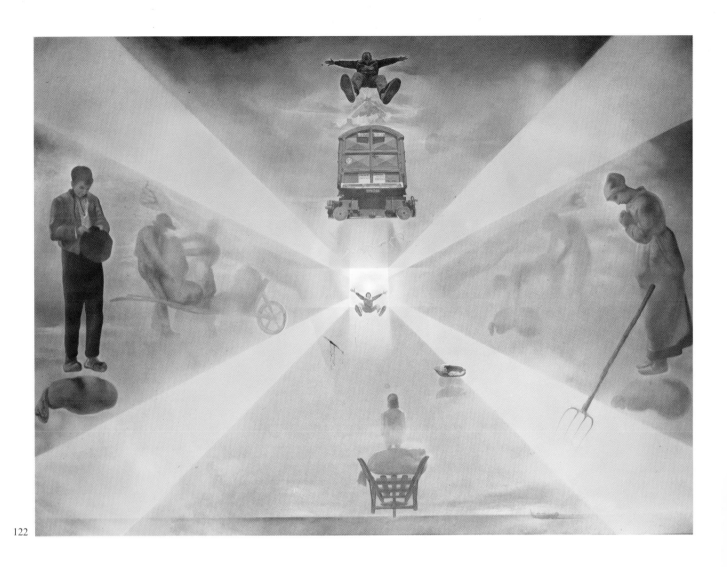

122

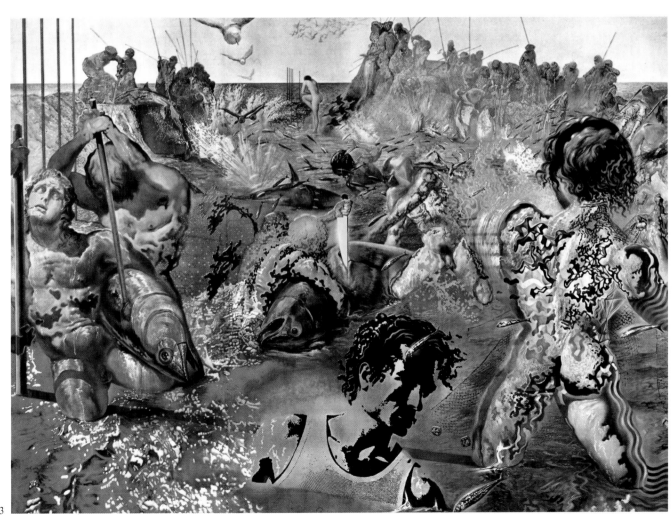

123

124

125

126

124. *Cosmic Athlete.* 1968.
Oil on canvas.
Zarzuela Palace (Spanish
National Trust), Madrid.

125. *Hallucinogenous Bullfighter.*
1969-1970.
Oil on canvas, 400×300 cm.
Collection: Mr. and Mrs.
A. Reynolds Morse. Loaned
to The Salvador Dalí Museum.
St. Petersburg, Florida.

126. *Hour of the Monarchy.* 1969.
Oil, diameter 3 metres.
Ceiling in the Palacete Albéniz,
Montjuïc, Barcelona.
Property of the Town Hall of
Barcelona.

127. *Op Rhinoceros* 1970.
Special plastic invented by Dalí,
14.5×18 cm.
Private collection.

128. *Unfinished Stereoscopic Picture.*
1973-1974.
Oil on canvas, 60×60 cm.
Dalí Museum-Theatre,
Figueres (Girona).

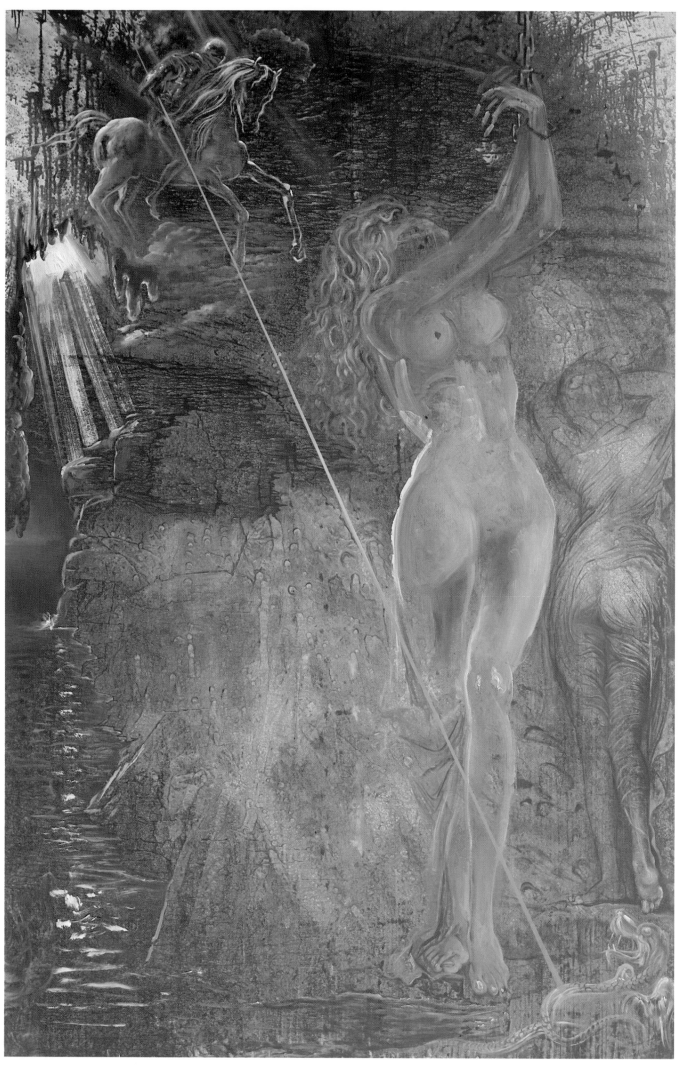

129. *Ruggiero Freeing Angelica.* 1974.
Oil on canvas, 350 × 200 cm.
Dalí Museum-Theatre, Figueres (Girona).

130. *Gala Looking at the Mediterranean Sea.* 1974-1976.
Oil on canvas, 240 × 182 cm.
Martin Lawrence Collection.

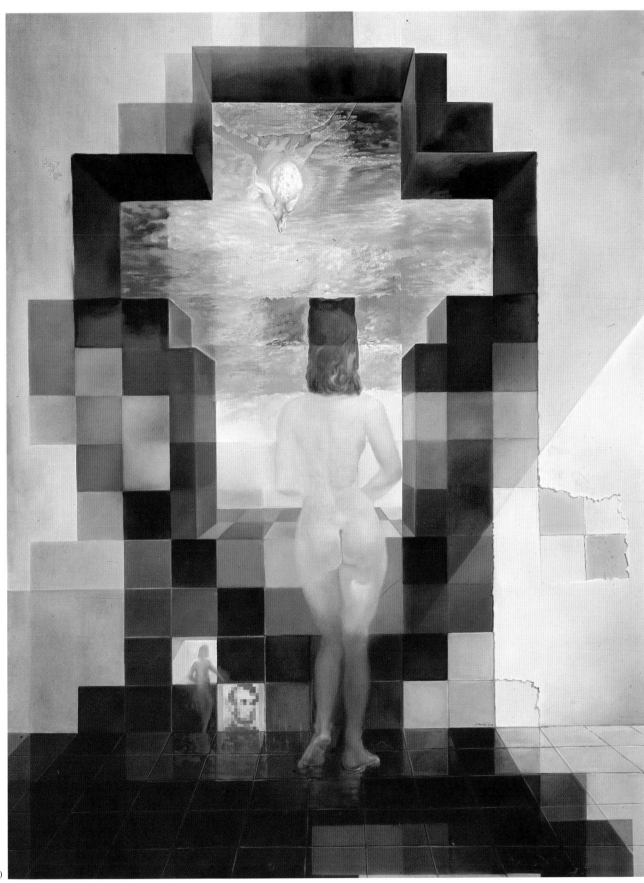

131

132

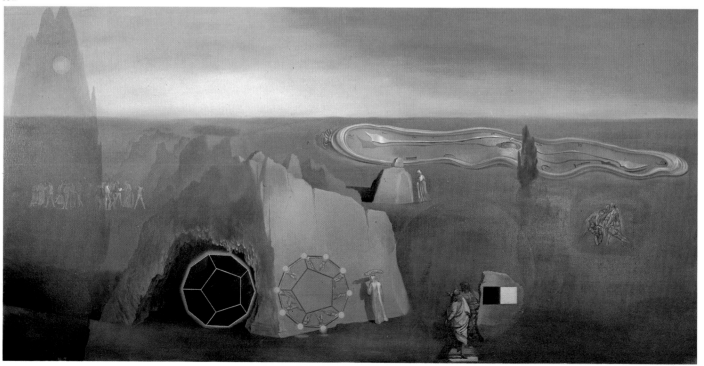

131. *Soft Monster in Angelic Landscape.* 1977.
Oil on canvas.
Vatican Museum.

132. *In Search of the Fourth Dimension.* 1979.
Oil on canvas, 122.5 × 246 cm.
Private collection.

133 & 134. *The Palace of the Wind* (Ceiling of the First Floor
in the Dalí Museum-Theatre in Figueres).
Oil on five canvases fastened to the ceiling. Central
canvas: 255 × 840 cm. Side canvases: 8.4 and 11 m. at
the base and 1.70 m. in height. Joining canvases:
5.75 and 2.3 m. at the base and 1.3 m. in height.

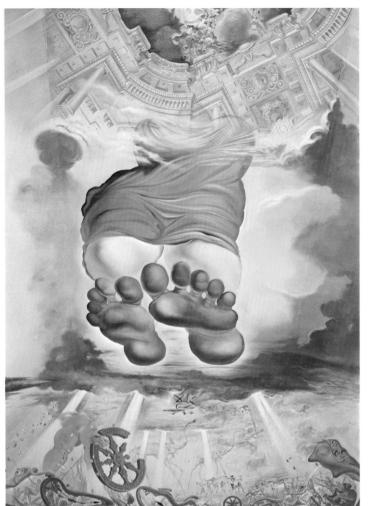

133

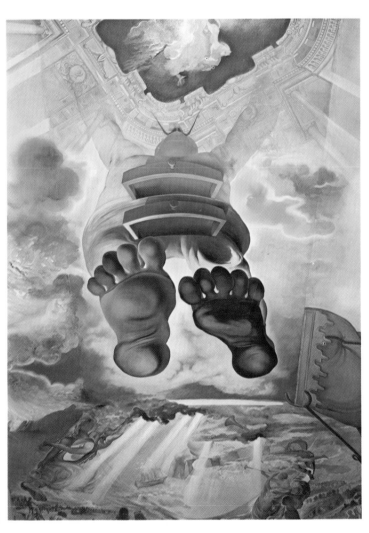

134

135. Patio-Garden of the Dalí Museum-Theatre in Figueres.
Opened on 28 September 1974.
In the foreground, a sculpture by Ernst Fuchs.

136. *The Road of the Enigma.* 1981.
Oil on canvas, 140×94 cm.
Dalí Museum-Theatre, Figueres (Girona).

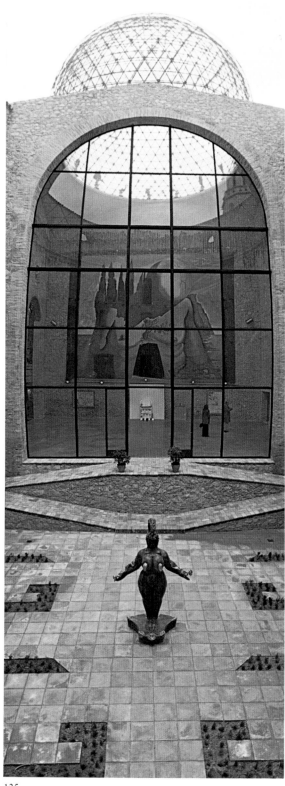

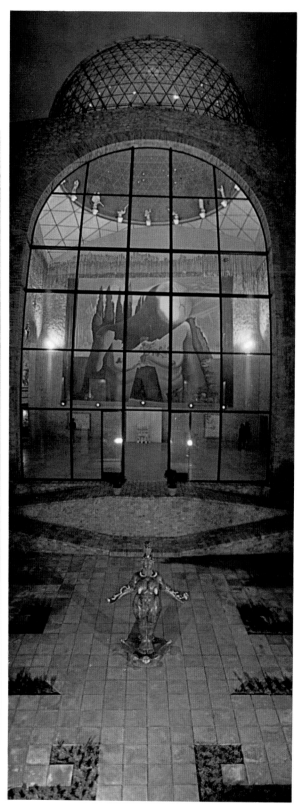

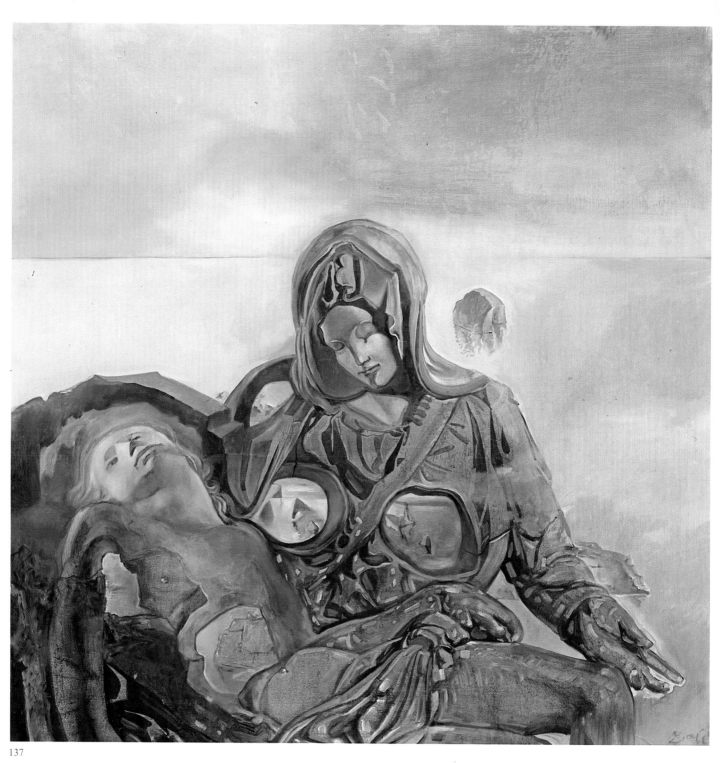

137

138

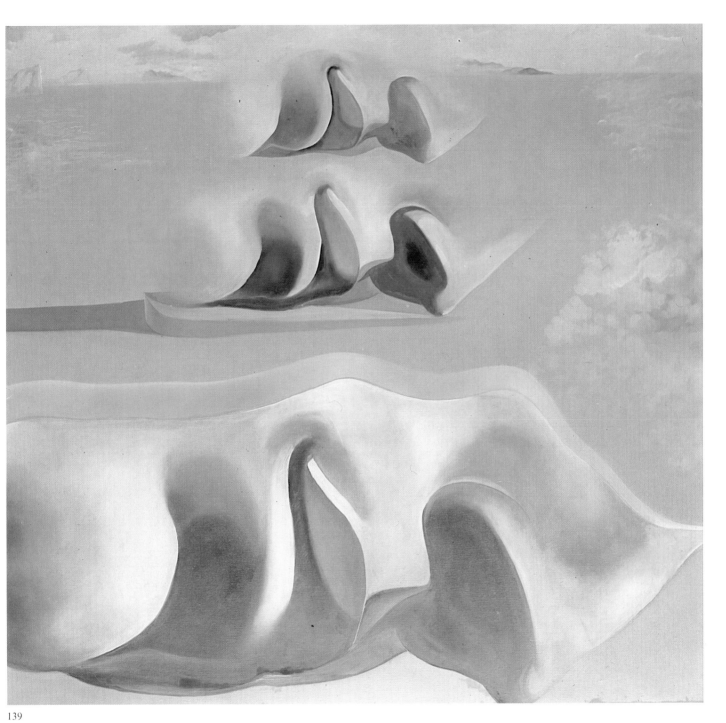

139

137. *La Pietà*. 1982.
 Oil on canvas, 100×100 cm.
 Dalí Museum-Theatre, Figueres (Girona).

138. *Othello Dreaming Venice*. 1982.
 Oil on canvas, 100×90 cm.
 Dalí Museum-Theatre, Figueres (Girona).

139. *The Three Glorious Enigmas of Gala*. 1982.
 Oil on canvas, 130×120 cm.
 Spanish Museum of Contemporary Art, Madrid.

INDEX OF ILLUSTRATIONS

41. *First Portrait of Gala.* 1931.
Oil on cardboard, 14×9 cm.
Albert Field Collection, New York.

42. *The Persistence of Memory (The Soft Watches).* 1931.
Oil on canvas, 26.3×36.5 cm.
The Museum of Modern Art, New York.

43. *Gradiva Finds the Anthropomorphous Ruins.* 1931.
Oil on canvas, 65×54 cm.
Thyssen-Bornemisza Collection, Lugano-Castagnola, Switzerland.

44. *Shades of Night Coming Down.* 1931.
Oil on canvas, 61×50 cm.
Collection: Mr. and Mrs. A. Reynolds Morse. Loaned to The Salvador Dalí Museum. St. Petersburg, Florida.

45. *Agnostic Symbol.* 1932.
Oil on canvas, 54.3×65.1 cm.
The Philadelphia Museum of Art, Philadelphia.

46. *Partial Hallucination. Six Apparitions of Lenin on a Piano.* 1931.
Oil on canvas, 114×146 cm.
Musée National d'Art Moderne, Paris.

47. *Meditation on the Harp.* 1932-1934.
Oil on canvas, 67×47 cm.
Collection: Mr. and Mrs. A. Reynolds Morse. Loaned to The Salvador Dalí Museum. St. Petersburg, Florida.

48. *The Invisible Man.* 1929-1933.
Oil on canvas, 143×81 cm.
Private collection.

49. *Babaouo.* 1932.
Wooden box with painted glass panes, 25.8×26.4×30.5 cm.
Perls Galleries, New York.

50. *The Phantom Wagon.* 1933.
Oil on wooden panel, 19×24.1 cm.
Edward F. W. James Collection, Sussex.

51. *Gala and Millet's Angelus Preceding the Imminent Arrival of the Conical Anamorphoses.* 1933.
Oil on plywood, 24×18.8 cm.
National Gallery of Canada, Ottawa.

52. *Millet's Architectural Angelus.* 1933.
Oil on canvas, 73×60 cm.
Perls Galleries, New York.

53. *Masochistic Instrument.* 1933-1934.
Oil on canvas, 62×47 cm.
Private collection.

54. *Gala with Two Lamb Chops Balanced on her Shoulder.* 1933.
Oil on plywood, 31×39 cm.
Private collection.

55. *Archaeological Reminiscences of Millet's Angelus.* 1933-1935.
Oil on wooden panel, 31.7×39.3 cm.
Collection: Mr. and Mrs. A. Reynolds Morse. Loaned to The Salvador Dalí Museum. St. Petersburg, Florida.

56. *The Spectre of Sex-appeal.* 1934.
Oil on wooden panel, 18×14 cm.
Dalí Museum-Theatre, Figueres (Girona).

57. *Enigmatic Elements in a Landscape* (detail). 1934.
Oil on wooden panel, 61.5×58.5 cm.
Sulzberger Collection, Paris.

58. *Weaning from the Food Chair.* 1934.
(Notice that the landscape of Portlligat is inverted in this work).
Oil on wooden panel.
Collection: Mr. and Mrs. A. Reynolds Morse. Loaned to The Salvador Dalí Museum. St. Petersburg, Florida.

59. *Apparition of My Cousin Carolineta on the Beach at Roses* (detail). 1934.
Oil on canvas, 73×100 cm.
Martin Thèves Collection, Brussels.

60. *The Ship.* 1934-1935.
Oil on canvas, 29.5×22.5 cm.
Private collection.

61. *Atavistic Traces after the Rain.* 1934.
Oil on canvas, 65×54 cm.
Perls Galleries, New York.

62. *Portrait of Gala* or *Gala's Angelus.* 1935.
Oil on canvas, 32.4×26.7 cm.
The Museum of Modern Art, New York.

63. *The Rider of Death.* 1935.
Oil on canvas, 65×53 cm.
F. Petit Collection, Paris.

64. *Perspectives.* 1936.
Oil on canvas, 65×65.5 cm.
Kunstmuseum, Basel.
Emmanuel Hoffman Foundation.

65. *The Anthropomorphic Chest of Drawers.* 1936.
Oil on wooden panel, 25.4×43.1 cm.
Kunstsammlung Nordheim-Westfalen, Düsseldorf.

66. *The Chemist from Figueres who is not Looking for Anything at All.* 1936.
Oil on wooden panel, 30×56 cm.
Edward F. W. James Collection, Sussex.

67. *White Calm.* 1936.
Oil on wooden panel, 41×33 cm.
Edward F. W. James Collection, Sussex.

68. *Soft Construction with Cooked Beans (Premonition of the Spanish Civil War).* 1936.
Oil on canvas, 100×99 cm.
The Philadelphia Museum of Art, Philadelphia.

69. *Women with Flowers for Heads Finding the Skin of a Grand Piano on the Beach.* 1936.
Oil on canvas, 54×65 cm.
Collection: Mr. and Mrs. A. Reynolds Morse. Loaned to The Salvador Dalí Museum. St. Petersburg, Florida.

70. *Geological Justice.* 1936.
Oil on wooden panel, 11×19 cm.
Boymans-van Beuningen Museum, Rotterdam.

71. *The Great Paranoiac.* 1936.
Oil on canvas, 62×62 cm.
Boymans-van Beuningen Museum, Rotterdam.

72. *Solar Table.* 1936.
Oil on wooden panel, 60×46 cm.
Boymans-van Beuningen Museum, Rotterdam.

73. *Cannibalism in Autumn.* 1936-1937.
Oil on canvas, 65×65.2 cm.
Tate Gallery, London.

74. *Lighted Giraffes.* 1936-1937.
Oil on wooden panel, 35×27 cm.
Kunstmuseum, Basel.
Emmanuel Hoffman Foundation.

75. *The Dream.* 1937.
Oil on canvas, 50×77 cm.
Edward F. W. James Collection, Sussex.

76. *The Enigma of Hitler.* 1937.
Oil on canvas.
Private collection.

77. *The Invention of Monsters.* 1937.
Oil on wooden panel, 51.2×78.5 cm.
The Art Institute of Chicago, Chicago.

78. *Spain.* 1936-1938.
Oil on canvas, 91.8×60.2 cm.
Boymans-van Beuningen Museum, Rotterdam.

79. *Metamorphosis of Narcissus.* 1937.
Oil on canvas, 50.8×78.2 cm.
Tate Gallery, London.

80. *Transparent Simulacrum of a False Image.* C. 1938.
Oil on canvas, 73.5×92 cm.
Albright-Knox Art Gallery, Buffalo, N. Y.

81. *Impressions of Africa* (detail). 1938.
Oil on canvas, 91.5×117.5 cm.
Boymans-van Beuningen Museum, Rotterdam.

82. *Palladian Corridor with a Dramatic Surprise.* 1938.
Oil on canvas, 75×104 cm.
Segialant Anstalt.

83. *Beach with Telephone.* 1938.
Oil on canvas, 73×92 cm.
Tate Gallery, London.

84. *The Image Vanishes.* 1938.
Oil on canvas, 55.9×50.8 cm.
Private collection.

85. *The Infinite Enigma.* 1938.
Oil on canvas, 114.5×146.5 cm.
Private collection.

86. *Slave-market with the Apparition of the Invisible Bust of Voltaire.* 1940.
Oil on canvas, 46.5×65.5 cm.
Collection: Mr. and Mrs. A. Reynolds Morse. Loaned to The Salvador Dalí Museum. St. Petersburg, Florida.

87. *Spider of the Afternoon, Hope!* 1940.
Oil on canvas, 41×51 cm.
Collection: Mr. and Mrs. A. Reynolds Morse. Loaned to The Salvador Dalí Museum. St. Petersburg, Florida.

88. *Soft Self-portrait with Grilled Rasher of Bacon.* 1941.
Oil on canvas, 61×50.8 cm.
Private collection.

89. *The Eye of Time.* 1941.
Jewel-watch.
The Owen Cheatham Foundation.

90. *Jewel (gold, rubies and pearls).* 1941.
The Owen Cheatham Foundation.

91. *Dream Caused by the Flight of a Bee around a Pomegranate a Second before Awakening.* 1944.
Oil on wooden panel, 51×41 cm.
Thyssen-Bornemisza Collection, Lugano-Castagnola, Switzerland.

92. *Half a Giant Cup Suspended with an Inexplicable Appendage Five Metres Long.* 1944-1945.
Oil on canvas, 50×31 cm.
Private collection, Basel.

93. *The Bread-basket.* 1945.
Oil on wooden panel, 37×32 cm.
Dalí Museum-Theatre, Figueres (Girona).

94. Design for the film *Spellbound,* starring Ingrid Bergman and directed by Alfred Hitchcock. 1945.

95. *Portrait of Picasso in the Glory of the Sun.* 1947.
Oil on canvas, 64.1 × 54.7 cm.
Private collection, New York.

96. *Interatomic Balance of a Swan's Feather.* 1947.
Oil on canvas, 77.5 × 96.5 cm.
Private collection.

97. *The Three Sphinxes of Bikini.* 1947.
Oil on canvas, 30 × 50 cm.
Galerie Petit, Paris.

98. *Atomic Leda.* 1949.
Oil on canvas, 60 × 44 cm.
Dalí Museum-Theatre, Figueres (Girona).

99. *First study for the Madonna of Portlligat.* 1949.
Oil on canvas, 48.9 × 37.5 cm.
Marquette University Committee on the Fine Arts, Milwaukee, Wisconsin.

100. *Dalí at the Age of Six, when he Thought he was a Girl, Lifting the Skin of the Water to see a Dog Sleeping in the Shade of the Sea.* 1950.
Oil on canvas, 80 × 99 cm.
Comte François de Vallombreuse Collection, Paris.

101. *Landscape of Portlligat.* 1950.
Oil on canvas, 58 × 78 cm.
Collection: Mr. and Mrs. A. Reynolds Morse. Loaned to The Salvador Dalí Museum. St. Petersburg, Florida.

102. *Raphaelesque Head Bursting.* 1951.
Oil on canvas, 44.5 × 35 cm.
Stead H. Stead Ellis Collection, Somerset.

103. *Christ of St. John of The Cross.* 1951.
Oil on canvas, 205 × 116 cm.
Art Gallery, Glasgow.

104. *The Angel of Portlligat.* 1952.
Collection: Mr. and Mrs. A. Reynolds Morse. Loaned to The Salvador Dalí Museum. St. Petersburg, Florida.
Oil on canvas, 58.4 × 78.3 cm.

105. *Galatea of the Spheres.* 1952.
Oil on canvas, 64 × 54 cm.
Private collection.

106. *Portrait of Gala with Rhinocerotic Symptoms.* 1954.
Oil on canvas, 39 × 31.5 cm.
Private collection.

107. *Disintegration of the Persistence of Memory.* 1952-1954.
Oil on canvas, 25 × 33 cm.
Collection: Mr. and Mrs. A. Reynolds Morse. Loaned to The Salvador Dalí Museum. St. Petersburg, Florida.

108. *Crucifixion ('Hypercubic Body').* 1954.
Oil on canvas, 194.5 × 124 cm.
Metropolitan Museum of Art, New York.
Chester Dale Bequest.

109. *The Last Supper.* 1955.
Oil on canvas, 167 × 268 cm.
National Gallery of Art, Washington.
Chester Dale Bequest.

110. *Rhinocerotic Gooseflesh.* 1956.
Oil on canvas, 93 × 60 cm.
Bruno Pagliai Collection, Mexico.

111. *Saint Helen in Portlligat.* 1956.
Oil on canvas, 31 × 42 cm.
Collection: Mr. and Mrs. A. Reynolds Morse. Loaned to The Salvador Dalí Museum. St. Petersburg, Florida.

112. *Living Still Life.* 1956.
Oil on canvas, 125 × 160 cm.
Collection: Mr. and Mrs. A. Reynolds Morse. Loaned to The Salvador Dalí Museum. St. Petersburg, Florida.

113. *Meditative Rose.* 1958.
Oil on canvas, 36 × 28 cm.
Mr. and Mrs. Arnold Grant Collection, New York.

114. *Sistine Madonna* (detail). 1958.
Oil on paper, 223 × 190 cm.
Henry J. Heinz II Collection, New York.

115. *Velázquez Painting the Infanta Margarita, Surrounded by the Lights and Shadows of Her Own Glory.* 1958.
Oil on canvas, 153 × 92 cm.
Collection: Mr. and Mrs. A. Reynolds Morse. Loaned to The Salvador Dalí Museum. St. Petersburg, Florida.

116. *The Dream of Columbus.* 1958-1959.
Oil on canvas, 410.2 × 284.8 cm.
Collection: Mr. and Mrs. A. Reynolds Morse. Loaned to The Salvador Dalí Museum. St. Petersburg, Florida.

117. *Virgin of Guadalupe.* 1959.
Oil on canvas, 130 × 98.5 cm.
Alfonso Fierro Collection, Madrid.

118. *Gala Nude from Behind Looking in an Invisible Mirror.* 1960.
Oil on canvas, 42 × 32 cm.
Dalí Museum-Theatre, Figueres (Girona).

119. *Birth of a Divinity.* 1960.
Oil on canvas, 36 × 26 cm.
Mrs Henry J. Heinz II Collection, New York.

120. *The Battle of Tetuán.* 1962.
Oil on canvas, 308 × 406 cm.
David Nahmad Collection, Milan.

121. *Salvador Dalí in the Act of Painting Gala in the Apotheosis of the Dollar, in which One may also Perceive to the Left Marcel Duchamp Disguised as Louis XIV, behind a Curtain in the Style of Vermeer, which is but the Invisible though Monumental Face of the Hermes of Praxiteles.* 1965.
Oil on canvas, 400 × 498 cm.
Peter Moore Collection, Cadaqués (Girona).

122. *The Station at Perpignan.* 1965.
Oil on canvas, 295 × 406 cm.
Ludwig Museum, Cologne.

123. *The Tunny Catch.* 1966-1967.
Oil on canvas, 304 × 404 cm.
Paul Ricard Foundation, Bandol, France.

124. *Cosmic Athlete.* 1968.
Oil on canvas.
Zarzuela Palace (Spanish National Trust), Madrid.

125. *Hallucinogenous Bullfighter.* 1969-1970.
Oil on canvas, 400 × 300 cm.
Collection: Mr. and Mrs. A. Reynolds Morse. Loaned to The Salvador Dalí Museum. St. Petersburg, Florida.

126. *Hour of the Monarchy.* 1969.
Oil, diameter 3 metres.
Ceiling in the Palacete Albéniz, Montjuïc, Barcelona.
Property of the Town Hall of Barcelona.

127. *Op Rhinoceros.* 1970.
Special plastic invented by Dalí, 14.5 × 18 cm.
Private collection.

128. *Unfinished Stereoscopic Picture.* 1973-1974.
Oil on canvas, 60 × 60 cm.
Dalí Museum-Theatre, Figueres (Girona).

129. *Ruggiero Freeing Angelica.* 1974.
Oil on canvas, 350 × 200 cm.
Dalí Museum-Theatre, Figueres (Girona).

130. *Gala Looking at the Mediterranean Sea.* 1974-1976.
Oil on canvas, 240 × 182 cm.
Martin Lawrence Collection.

131. *Soft Monster in Angelic Landscape.* 1977.
Oil on canvas.
Vatican Museum.

132. *In Search of the Fourth Dimension.* 1979.
Oil on canvas, 122.5 × 246 cm.
Private collection.

133 & 134. *The Palace of the Wind* (Ceiling of the First Floor in the Dalí Museum-Theatre in Figueres).
Oil on five canvases fastened to the ceiling. Central canvas: 255 × 840 cm. Side canvases: 8.4 and 11 m. at the base and 1.70 m. in height. Joining canvases: 5.75 and 2.3 m. at the base and 1.3 m. in height.

135. Patio-Garden of the Dalí Museum-Theatre in Figueres. Opened on 28 September 1974. In the foreground, a sculpture by Ernst Fuchs.

136. *The Road of the Enigma.* 1981.
Oil on canvas, 140 × 94 cm.
Dalí Museum-Theatre, Figueres (Girona).

137. *La Pietà.* 1982.
Oil on canvas, 100 × 100 cm.
Dalí Museum-Theatre, Figueres (Girona).

138. *Othello Dreaming Venice.* 1982.
Oil on canvas, 100 × 90 cm.
Dalí Museum-Theatre, Figueres (Girona).

139. *The Three Glorious Enigmas of Gala.* 1982.
Oil on canvas, 130 × 120 cm.
Spanish Museum of Contemporary Art, Madrid.